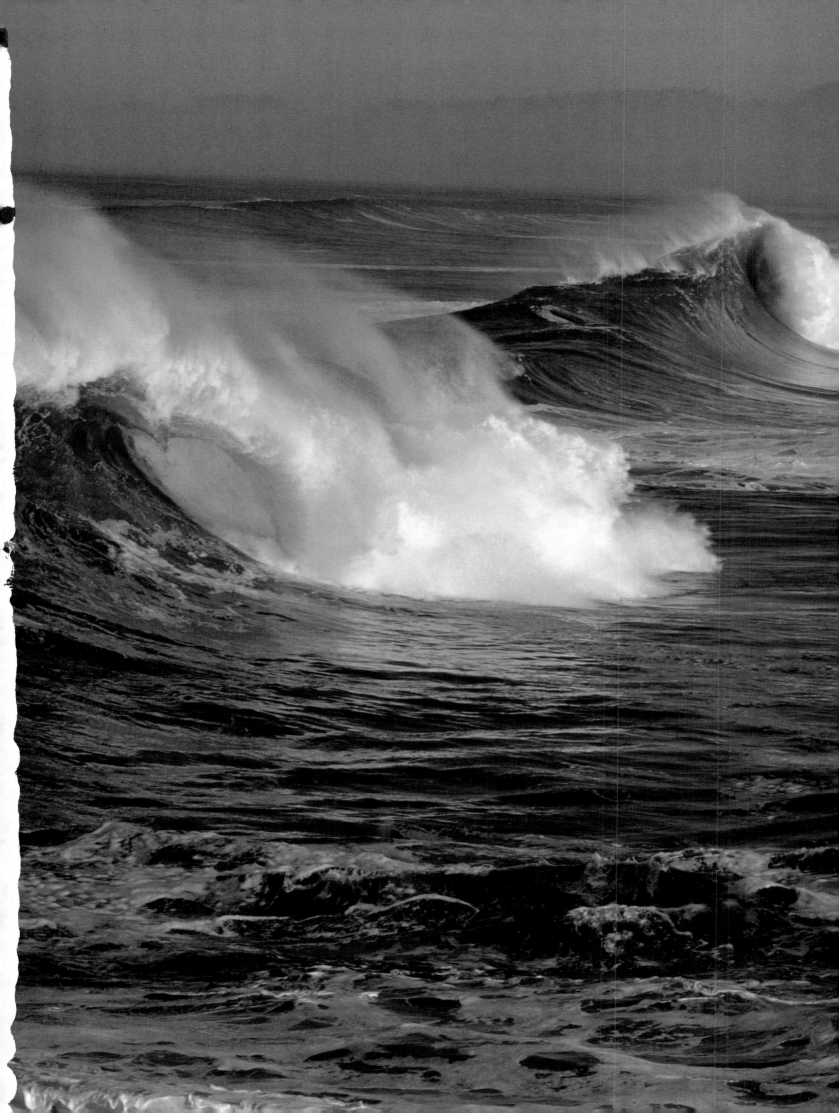

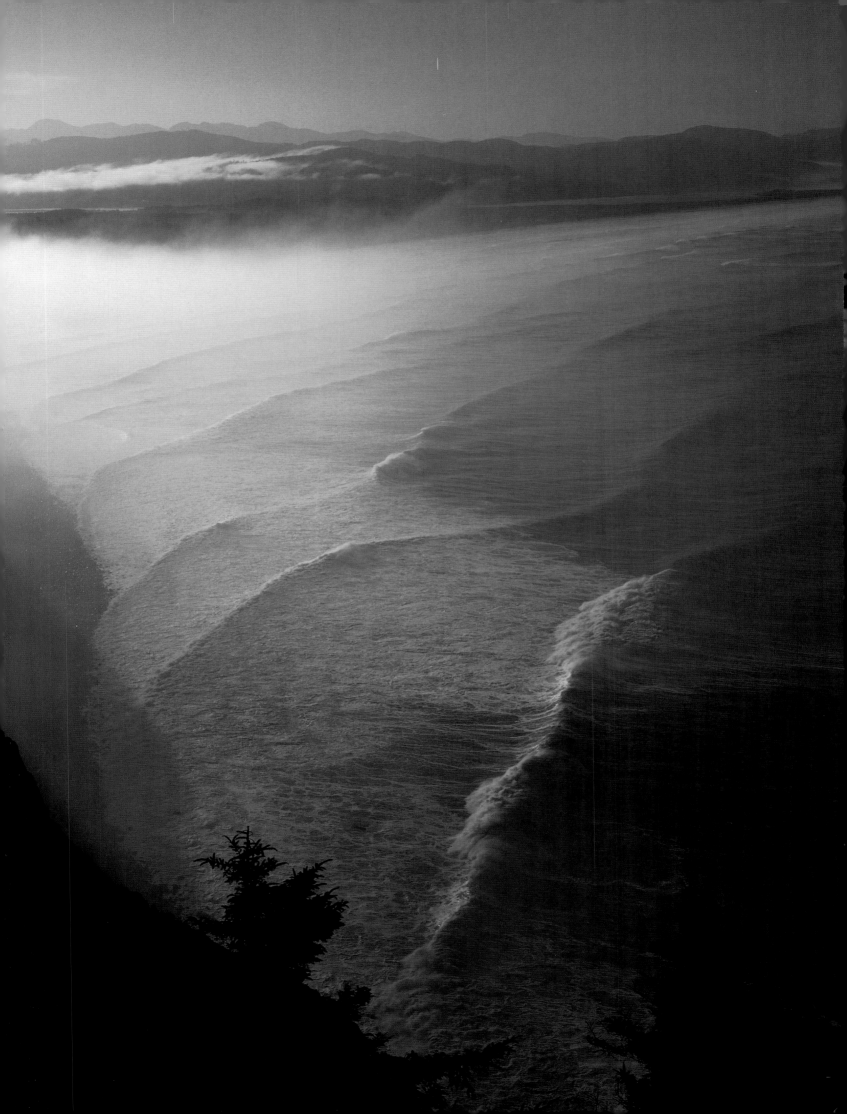

wind on the waves

Photography by Ray Atkeson
and Rick Schafer
Stories by Kim R. Stafford

Graphic Arts Center Publishing Company, Portland, Oregon

To the memory of Ray Atkeson,
whose spirit will continue to live in the photographs
which have inspired us for so many years.

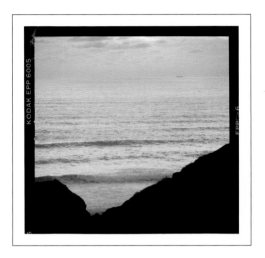

International Standard Book Number 1-55868-090-X
Library of Congress Number 92-70122
Text © MCMXCII by Kim R. Stafford
Photographs © MCMXCII by Graphic Arts Center Publishing Company
P.O. Box 10306 • Portland, Oregon 97210 • 503/226-2402
All rights reserved.
No part of this book can be reproduced by any means
without written permission of the publisher.
President • Charles M. Hopkins
Editor-in-Chief • Douglas A. Pfeiffer
Managing Editor • Jean Andrews
Designer • Robert Reynolds
Color Separations • Agency Litho
Typographer • Harrison Typesetting, Inc.
Printer • Dynagraphics
Bindery • Lincoln & Allen
Printed and bound in the United States of America

CONTENTS

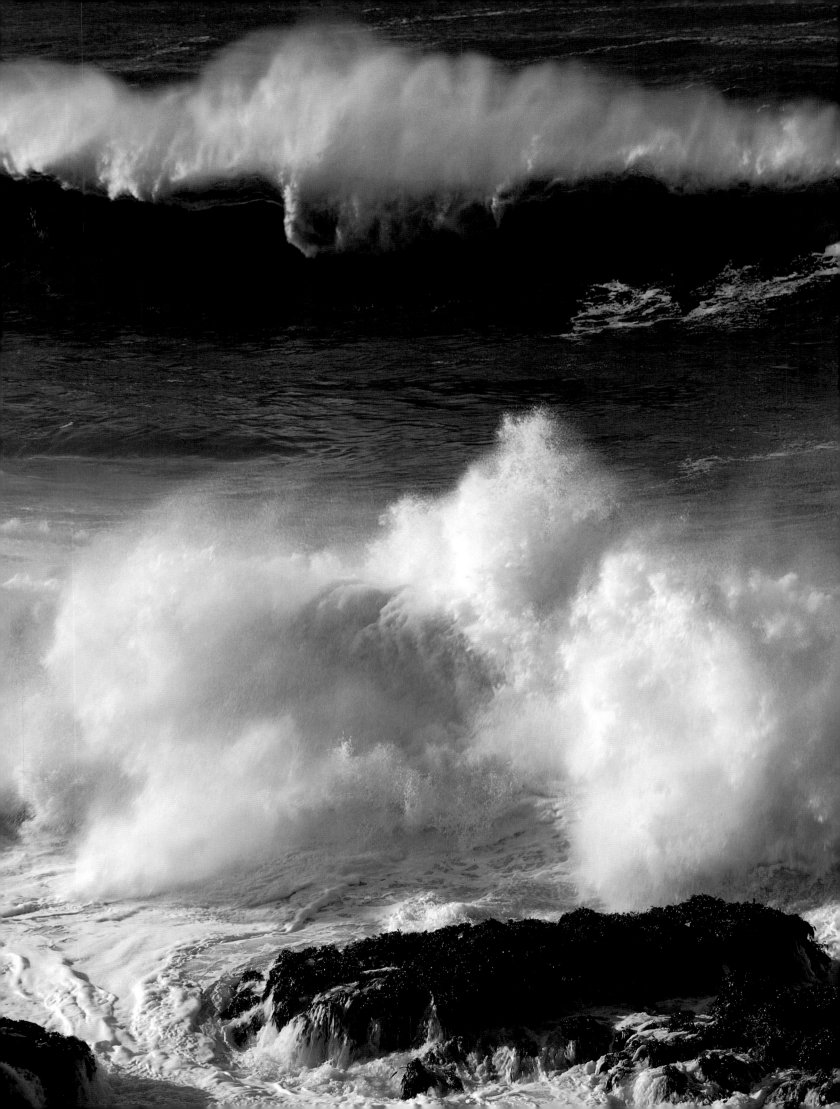

My friend, you wanted to be wind on the waves —
not the schooner, or even the sail that bellied and
caught it. You wanted to be the wind itself. You
wanted to dance and scamper, to be the spiral
that hugs the planet, the wisp of travel that nudges
sand, the local everywhere, tireless, fervent,
invisible, unstoppable you.

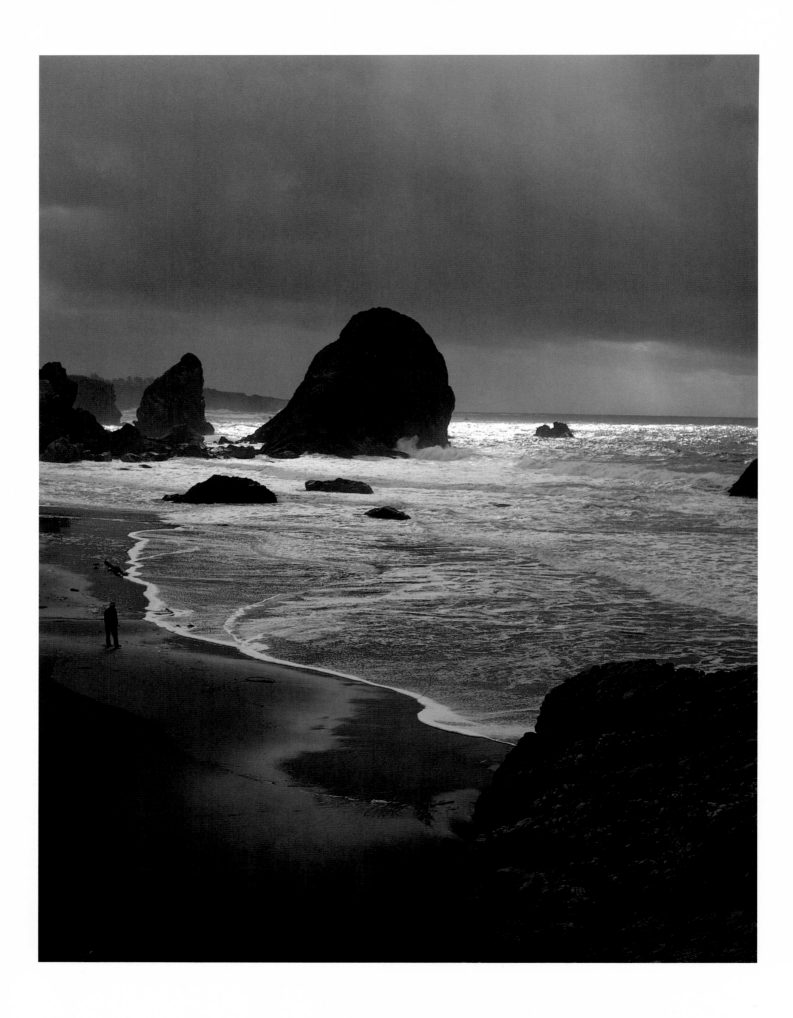

She woke in room number seven, heard the waves, and had to be there. Her candle must have gone out. It smelled of burnt wick. Her book lay wedged where it had tumbled by the pillow. From bed, she couldn't hear a car, or a voice, not even TV. Through the wall, she could just catch the low breathing of the surf, pushing, and sliding away.

She fumbled on jeans and a sweater, stepped into her damp tennis shoes, took the key, and went out. She had to find danger, not this longing for love. Love was good, but longing was tough. You could wait forever, and wither. Like the sea, longing could take you out and give back bones. Forget that. Feel the cold and be strong.

Fog drifted around a streetlight. It settled in her hair, in the wool folds of her sweater, softening everything. Gravel nibbled her shoes' thin soles. At the road's end, feeling with her feet, she found the stair to the beach and went down, her hand gripping tight on the punky wood of the rail, her eyes closed to know it better, until with a gasp she took the last long step to sand.

To be with no one could be this. Every sound belonged only to her. Her body tingled. She labored, she panted through the low dunes, down toward the surf, its white line. On the flat sand, she kicked, and phosphorescent sparks spit from her feet, scattered, and grew dark. She kicked harder, and the glimmer shot from her foot over the tide's highest reach. Farther on, the surf shimmered. Everything was blur and salt and chill. She turned south, toward the dusky shadow.

Waves came from two sides, nuzzling around the rock. Out there, the dark waves rumbled and sucked that deep throaty groan. She clipped her hair back from her face. Salt dusted her cheek, the wind so thick with sound it brushed her like a hand. Her whole body felt it, trembled. Low tide, and dim lines of breakers booming. She felt the double thud of a heavy wave, the blow fingering to her feet through sand. She felt wind stroke her shoulders, fingering through the sweater. She felt it chill her belly. She couldn't tell how far out the waves hit, or how fast they came. Somewhere, they broke basalt. They pawed sand. They dug and churned. They wanted inside everything.

A wave pushed at her ankles, stinging cold, then shoved at her knees, then higher, higher, swinging around, yanking toward the deep. The cold made her gasp, the invisible yearn of the wave. She leaned against it, just in balance, as the pure shout came from her mouth. Her shout fit the wind snug as rain. The wave drained away, she staggered to safer ground. It was all right to step back now, for she had entered the cold, and it had touched her deep as anything.

She had given her body to touch it there. What good did it do to be afraid? Sometimes, you needed the edge, just to know where you stood. The sound and the cold and her breath all tugged in one place. Fiercely into the din, with the clarity of a bird, she spoke her own name, over and over.

ROGUE WAVE

I've often gripped the bow when we pitched into a trough, and the thrum of wood thrilled me, the waves parting, sprawling, and slamming shut, the boat cresting and heeling over, the yaw and mauling of seas climbing without a plan, towering, and tumbling down. You think of land then, of the blossoming fields, of friends planted firm, and the face of a dear one beckoning. But then you banish that, single and frantic while you cling and batten, as the keel takes a brawl from the deep, the hull shudders, lee rail awash, suffering in the clamp of one green wave and bracing for the next.

One time our storm came sudden from the south, keened in the rigging, building a long swell aft that quickened, and the swell began to break, until the wind rose to snatch off the crests of the waves and drive us. Something sprung in the hull, and the pumps were called for, but we grew heavy, running with the wind, slow at righting after a crusher. I peeped out on deck in time to see a wave astern taller than any deserved, closing fast. The blast shattered her crest to rain. The cry went for all to hold tight. The stern climbed up the fore edge of that rogue wave, too big to move fast, the bad grind of ballast shifting when the hull stood tall, and every one of us slammed against a bulkhead or dropped across the cabin.

You see it all in a flicker then, a flood of recollection, a flash of all you have loved snatched past your fingertips. I saw my lady in sun, my child in clover, bedded between my fingers sprawled across the teak of the wall. I writhed and clung. We could have gone keel up, but by some blessing didn't. By some whim of the wave we crested her, and she slid past, dropped us down her own aft slope and left us living. We rode out the rest, and limped home to port, each to fare again if we dared.

I've tried to deserve that blessing since. You on land, do you hear me? No one knows who has not been there how the balance hangs, and each wave hurls against you, the wind gnaws your breath to nothing, and the boat is but a perch for your soul's frenzy.

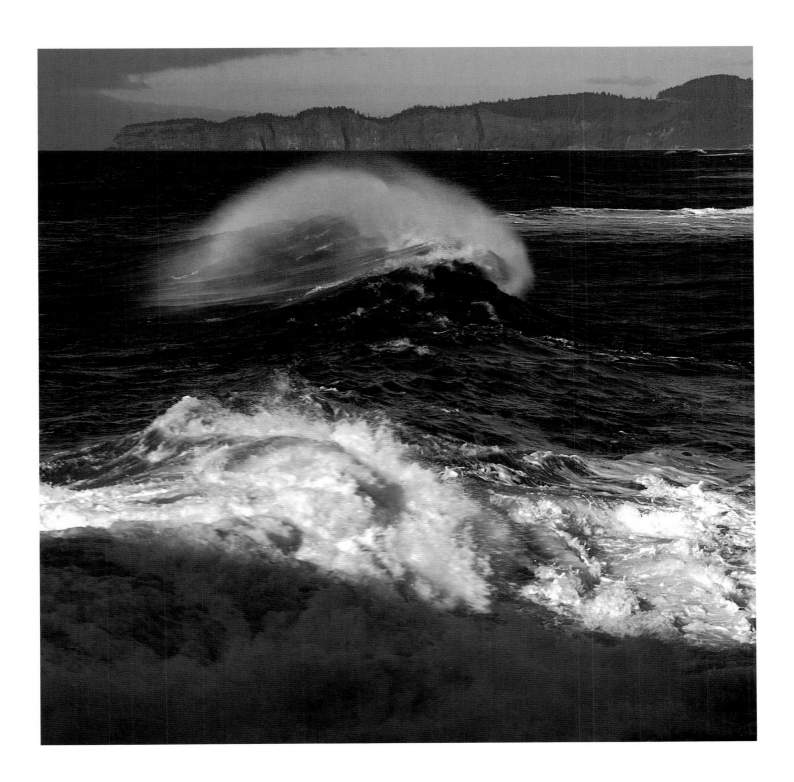

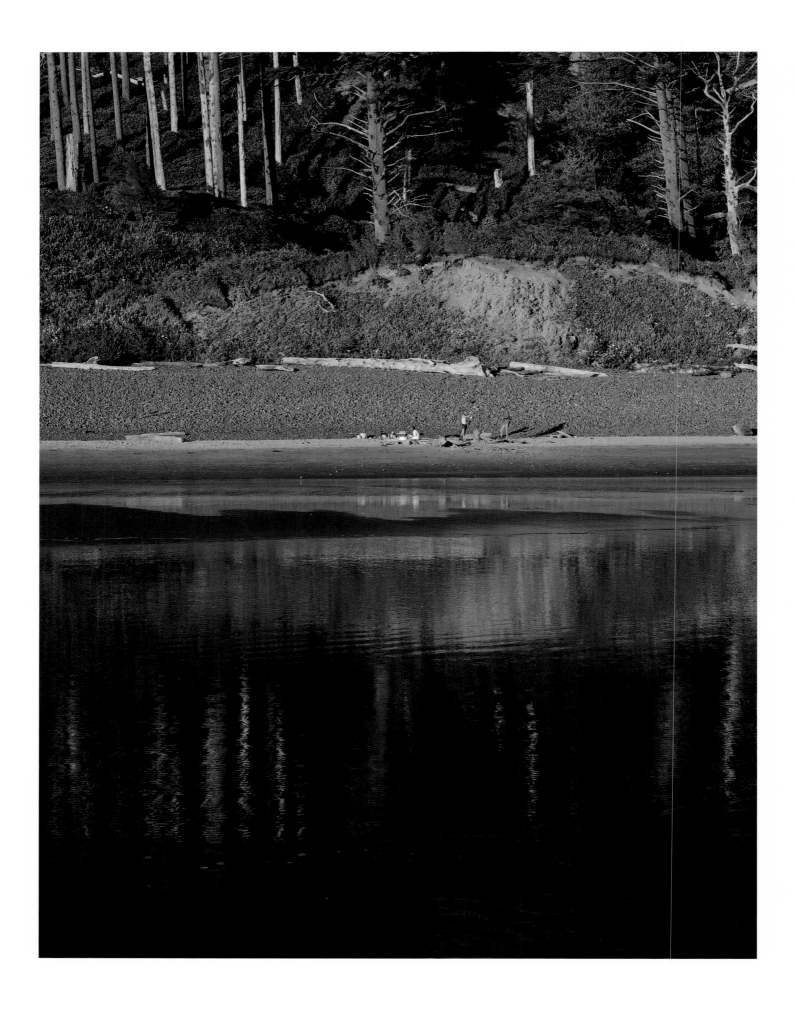

So one time me and Miles had our boards down to Indian Beach when the waves were high? You know how great that can be. Beach slants so steep your waves build up fast, and you can catch a ride. We got our boards off the car, and only saw one ahead of us, on the water way out beyond the breakers.

"Who's the dude?" Miles says. We got our suits on. You know Miles wears that weird camouflage trip, that polyester body suit in browns and swirls, all worn to a fuzzy nap like fur. You can pick him out in a crowd.

"I'm going for the dude," says Miles. He loves top dog. But when we got in the water and worked out through the waves, we saw her long hair. Slender thing, but a looker. She was riding easy on the swells. Didn't glance our way at all.

Now Miles, you know Miles, he's gonna show this lady how to ride a wave. First decent swell, he's up and dancing. Bebop on the board, he's pushing the crest off his tail, fooling around, swaying along the line, flying like a bird, the wave-crest spray in a halo around him. He's got so much style it doesn't seem fair. His feet kiss the wave and the board glides. And every so often, you can see him glance over his shoulder to see if she sees him. It's a good wave, and he takes her all the way in. Me, I'm just watching. But she's not. She's on the low swells, looking out to sea, the sunlight gleaming off her suit, sleek and strong. Her wet hair long down her back, she's rocking on the water.

I know the feeling. There's a rush riding a big wave, you know, and that's what gets you there. But some days—I think you're with me— the swell out past the breakers is what's best about it, riding easy, looking around.

There were some sea lions out that day, rolling and diving. They were crazy about it. Maybe it was the mating season or something, the way they went to nipping each other and fooling around. The big male would roll against a female, rub against her brown fur, and take her down. But the gulls were swooping, and the air had that sweet tang and warm. You didn't want to be anywhere else. You felt like you belonged in your body, and your body belonged in the water.

This lady was into it, I could tell. She watched the gulls soar high, swing away, and her eyes flashed my way one time, like she knew I felt it. That was kind of a thrill. The waves shut us off from all the people sounds. I liked that.

But Miles, he never goes for that stuff. He's into power rides, man. And here he comes flying back out, thrashing hard with his hands, smashing through the waves until he gets to me, and then he shouts loud enough for her.

"Real nice," he says, "that baby was sweet. So why sit around, buddy? Let's go for it!"

"Miles," I said, "I'm liking it here."

"Suit yourself, wimp." And he's off to grab another wave. There's nothing subtle about Miles. He's gonna get this lady's attention. But I notice when he stands, he hasn't tied his ankle thong. He's in a hurry, but that's dumb. If the board cuts loose from him, it's gone and he's swimming. But he hasn't really wiped out today, so I watch him go.

Now Miles, you know he lives to show off. But when he doesn't get the attention he expects, he flips into another dimension of performance, and that's what happened then. He's gonna let this lady know where it's at, or die trying, so he's shooting the line, throwing his body around. And in the middle of his rush he takes a long look back at her. She's watching this time, over her shoulder, and that holds his gaze just a little too long. He grins, and his board tip dips into the wave, and he's into a cartwheel. He even does that in a beautiful way, spinning and going down, but the board catches the crest and keeps going, with him behind the wave, dog paddling, shaking water off his head, looking around.

It's then I notice the sea lion, the big one, rolling pretty close to Miles, then diving. I feel the bottom drop out of my gut. It all happens in slow motion then, like the rush of a really big wave, like the slow turn when you lose it, and the green wall coming down. I'm reaching for water to start his way, when I see that sea lion sidle up to Miles the way he did to the females, swirl around him and nudge him under.

The lady is fast. By the time I get in gear, she's flying over the water like a loon. There's a long, steady power in a wave, and that's how she moves toward Miles. He's up and sputtering, crying like a kid, trying to stand on the water, and the big sea lion swimming circles on him, rolling and turning.

It's like she says something to the sea lion, and it dives. I'm up close by then, and Miles grabs my board. His teeth are chattering, and his knuckles go white as he heaves himself up. The lady has pulled back, watching us. She's beautiful, breathing hard, her mouth open, her eyes steady on Miles, but quiet. I thank her, but she doesn't say a word, and Miles just stares at her, then looks away.

That's the last time I did Indian Beach. Miles has been pretty busy in town, and when I went to see him he didn't even have the board in the living room like he used to. He keeps it in a corner of his bedroom now. Weekends, he likes to travel alone. We used to go together every chance we got. That's all changed. Once I drove down without my board, just to walk, listen to the waves. I thought I might see her. Miles didn't want to go, and you know, I just sat on the beach while the waves got tall and good.

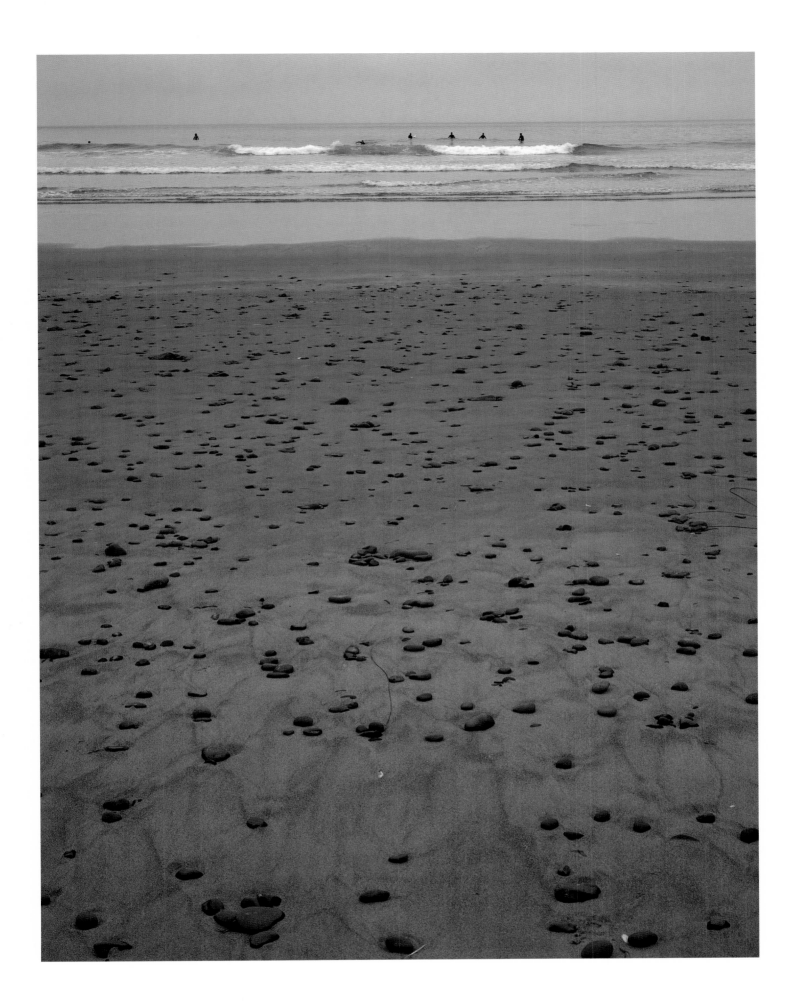

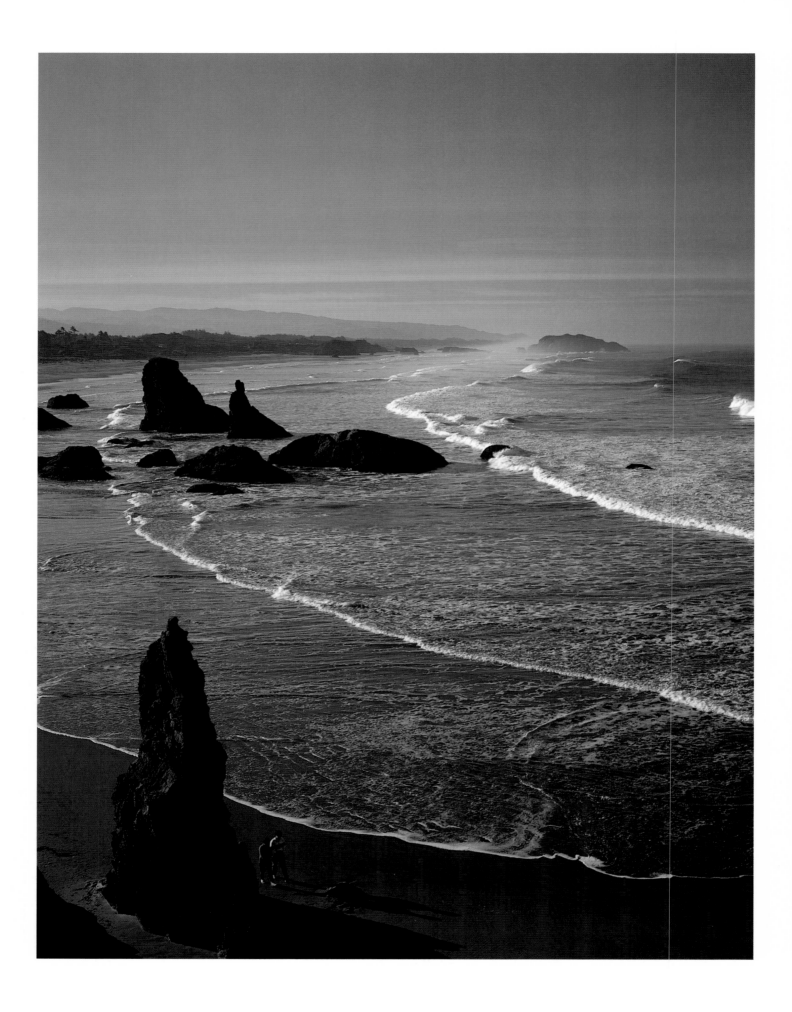

Joel said, "Susan, looks like a good storm coming. You ready?" I said yes. We rode it out sleeping in the car, Joel on the front seat and me on the back, him talking, me saying yes, until I fell asleep. Maybe it's rheumatism someday, what I felt, tangled into myself in a little blanket. The car rocked like a cradle, and dawn came slow in a drizzle. We sat up, clambered side by side, started driving. The sun came out. By some trees we picked up a hitchhiker who said his name was Miles, and he had money. He seemed like a nice kid, he bought gas, and that kept us rolling. Crawled down to a cove at Boardman Park to find fancy rocks. I found them. Joel carried. We'd left the hitchhiker in the car to take a nap, heard the engine start up, kid must have hot-wired it, and we were afoot. I shouted and we ran, but then he was gone and something got us laughing about it. Joel can do that to me.

Crossed the Pistol River with our thumbs out, walking backward, watching the crows do spirals and flips, and finally got a ride in a pickup load of firewood, with the pitchy smell of fir whipping around us where we snuggled in the back, clear to Gold Beach. We got to get a pickup, Joel shouted to me. I shouted yes, a red one, like that, just as a crimson truck passed us on a curve, with a wild-eyed woman at the wheel, long hair flying. Joel grabbed me good-bye, but she got past and back in her own lane and we lived.

Guys left us at the south edge of town, where it strung out long. We were going to report our old car stolen, wandered around looking for the police station, but then we found the car itself in an alley behind some trees, full of gas, no sign of the kid, so we kept on.

We drove north over Humbug Mountain to that windy place where the bay trees grow. Got lucky and caught old Miss Hamilton, a friend of Joel's, at home in Port Orford, and she fed us tea. She was a good enough friend for a loan. We felt we had extra then, and took a side jaunt out to Cape Blanco. Found some pretty straight boards on the north side beach, strapped them on top with fishnet rope Joel untangled. Maybe build a house some day, Joel said. I told him yes.

On up through that town called Denmark, we took the long straight run. Had a flat tire in Bandon, spent half the loan getting it fixed, but at least it was sunny, so we watched the sunset, and I told Joel I love that soft light, and he said a whole tangle of sweet things I wish I wrote down, but then the rain came up and we rolled north. We followed the dark stretch up past Coos Bay, North Bend, Umpqua River. Finally conked out and slept at some logging road in the hills near Tahkenitch. My turn sleeping in the front seat, and that one windshield leak got my feet wet, so driving on through the morning fog we stopped, built a fire on the beach at South Jetty, watched the swans stand around. Some old ladies were out there feeding them grain. Said their names were Aunt

Billie and Bea, and they were going to say more, but then they got the giggles, and the swans wouldn't leave them alone. Fog cleared, so we went on into Florence for breakfast, stood on the sidewalk with our clothes steaming, and then we headed north.

Got a little woozy on the coast road climbing past Devil's Elbow, but then the road straightens, and we pulled off. Got lost trying to follow a trail to the beach, ended up standing still holding each other, holding our breath in this pine thicket until we could hear a truck on the highway, and fought our way somehow back to it. Stood by the crazy waves at Perpetua, like standing on a stone drum, Joel said. Got the dizzy feel of driving too long. Seems like we sat still in the car and the road slid under. So we bought two apples in Yachats and had a party on some beach without any name and went on, not quite so starved to hurt.

Road construction out of Waldport, and Joel didn't want to idle the engine too long, so he pushed and we coasted every time the line moved. Other cars gave us plenty of room, until the man with the flag waved us forward, and we all rolled on. Found some more boards at Ona Beach, strapped them on top, and then we tried to drive for an hour without stopping but couldn't because the sun was out, and we had to walk on the sand. Found a rock with a hole in it and looked through at the ocean, just as the mist rolled in. Through that rock I thought I saw a shaggy old woman-shape down by the rocks. Then it got too foggy.

Then I got too sleepy, and there was a twisty part I don't remember after Newport, and then Lincoln City and Pacific City and another flat tire north from Tillamook. We put on the spare, sat listening for leaky air, just heard the waves, and went on. Driving those snake curves up around Neahkahnie Mountain, with Joel asleep and me at the wheel, I spotted a woman hitchhiking, holding a cat, and we gave her a ride. Said her name was Sylvia. I kept thinking she would say more, but she just smiled. The cat liked sitting by my neck, purring, lady liked to hum to herself, and we let them off at a trail into the woods, middle of nowhere.

Holding hands like kids we walked the Seaside arcade, drank a quart of milk on our last dollar, and rolled into Astoria at dusk. I pulled us over at the foot of the bridge. I could see Joel's face by streetlight. Rolled the window down, smelled the water and the fish. Joel reached over, put a smooth rock in my hand. He looked at me and he said, "Now that's our coast, Susan. Now we can call it our coast, and we still love each other, and we have what we need, which is not much but sunsets and wind and waves and a road of places we found, and a patched spare, and me, and rain, and you."

I got him to write that down, just like he said it, because I want it here in my book where I can find it.

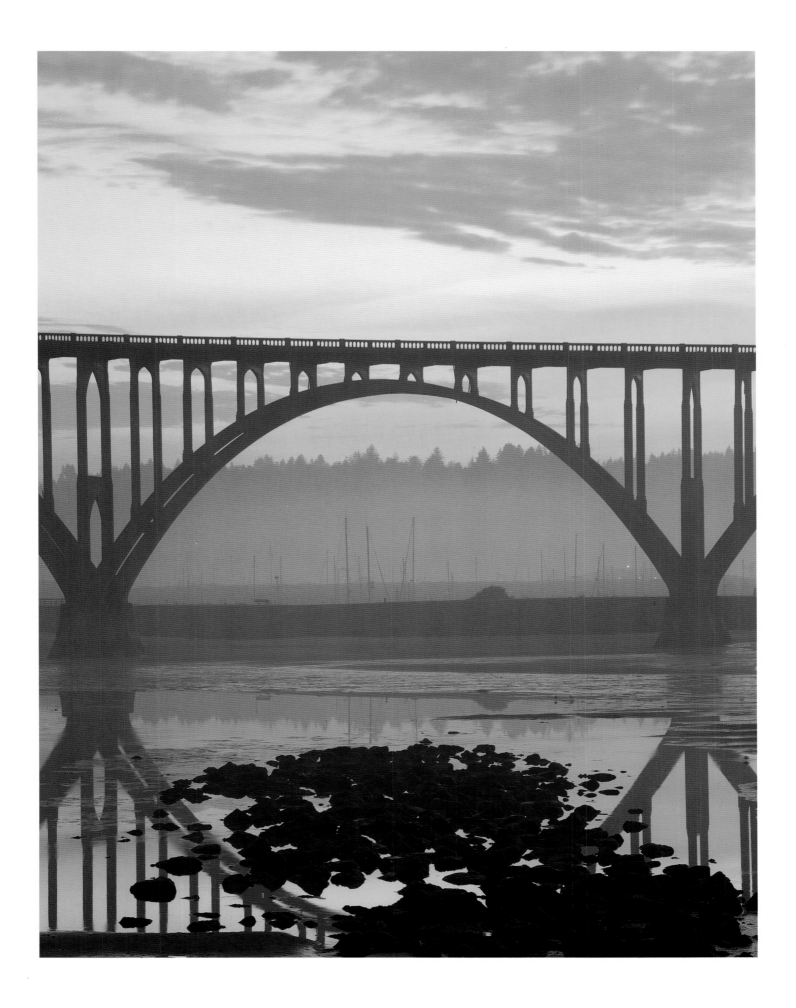

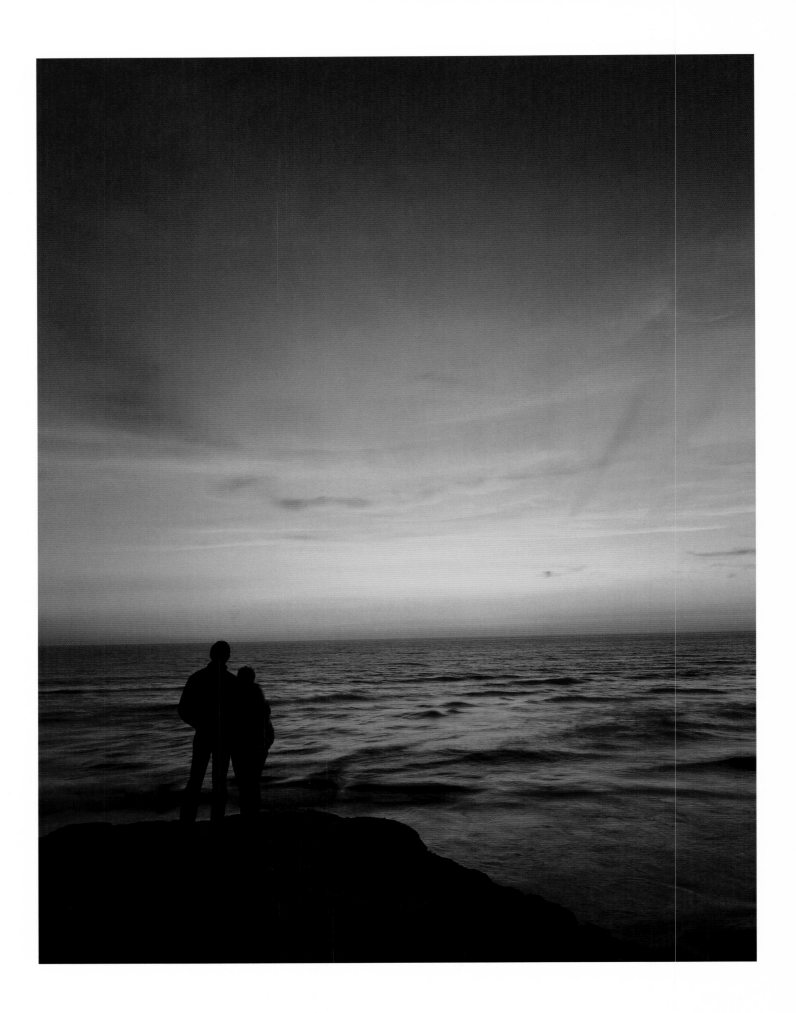

"It's a relief not to have my camera," he said. "The light is so fine right now, I'd be scrambling to catch it."

"You're not sorry?" she said. They watched the waves, their purple curl, the amber veil of the spray.

"I'm not sorry," he said, "for once. For once, I'm just going to stand here with you, and look. Hey, look. You can see why we call this time sweet light, just after the sun goes down. Feel that hush. So. Watch how the gulls settle. This is the moment of calm for all of creation, but the frantic rush for the photographer. I've dreamed this moment so many times—how the wave comes up, and the light brightens, and the whole swirl comes into that peak of energy. But then I wake up, or by daylight something is always slipping away just as I see its power. It only lasts a few moments, when the skin of light on everything is perfect. You want to show it around. You want it on the print, want to stroke it with your gaze. When I'm on assignment, this is make-or-break time now."

"I know," she said. "You don't have to tell me about that rush. I've lived it, too. It's odd to see you stand so still. What's it like? When you're not on assignment, can you see the sweet light without longing?"

"It is all about longing," he said. "Look at those rocks. They each have a halo, a fuzz of color from inside, and the sand a kaleidoscope, with every grain a prism." He pointed to the horizon. "See where the sun went, and left that dome of pastel? That's all about longing."

"What do you long for, with this sweet light?" She touched his sleeve.

"I long to do my work," he said. "I want it in my fist. I want to have all the colors of the world boxed in the camera. I want it caught. In a few minutes, the sky will fade to gray, and that's a loss I feel. It's no good telling me the world will be bright tomorrow. I feel the loss now. It slips. I want to hold on."

"Hold on to me," she said. He turned to her and she looked in his eyes.

"I love holding you," he said. "I'll be holding while you go gray, I go gray, just more slowly than the sky."

"Go with me," she said, her fingers tight on his shoulder. He held her, and they looked where the sky had deepened, and suddenly the waves were loud. The breeze freshened. A star burned, a ray and a glimmer of blue light.

"What a night we picked, sweetheart." The tires hissed, rain slapped the windshield, and the wipers flailed. "I'm glad I know this road," she said. "I love driving this road, no matter what."

"But mom, don't you get lonely sometimes?" Andrea fidgeted, then touched the cool mist on the window beside her.

"Sure, I get lonesome. But if I can't keep to myself sometimes, get down to the coast and spend time, I get lonesome for the part of me that only happens there."

"Are you glad I'm coming along tonight?"

"Yes, my girl. There are plenty of ways to be lonely, but missing you is one of the worst. Of course I'm glad we planned this time together. But do you know what I mean? It's something your father could never understand, but I think you do."

Way off through the dark, a spot of light glimmered and grew, dividing into a pair of headlights, widening into a glare that lit their faces, then roared past and was gone. Their car drifted along through a hush of heavy rain and engine rhythm. Andrea touched the glass again, cool at her fingertips.

"Mom, are you still sad?"

"Sad?"

"Yeah, mom, you seem so quiet."

"Sweetheart, the older I get, the harder it is to name how I feel." She reached from the wheel for a rag to rub a clear circle on the inside of the windshield. "I wouldn't say sad. I'd say full—I feel full of all that's happened. You want to wipe your side?"

"Thanks, mom." The spring was jammed on Andrea's seat belt, and she had to strain to reach the glass before her, wipe it clear. "Are you ever just happy, mom?"

"I'm happy when I'm with you, and we've decided something we want to do, and we do it. And I'm happy when I'm alone, too, and can feel the whole flavor of who I am."

"It's been three years."

"Three years? Oh, yes, three years."

Andrea was quiet, and when the next car came toward them, as the light grew, the mother could see how the girl had folded her hands, pressed her lips tight together, and sat staring forward along the road, with the attention of a driver, not a passenger. Her concentration was frightening, and beautiful. And between them, in them as long as they lived, there would always be this night, the rush of the rain, the meditative drift of the car obedient to its road, their words, and their silences.

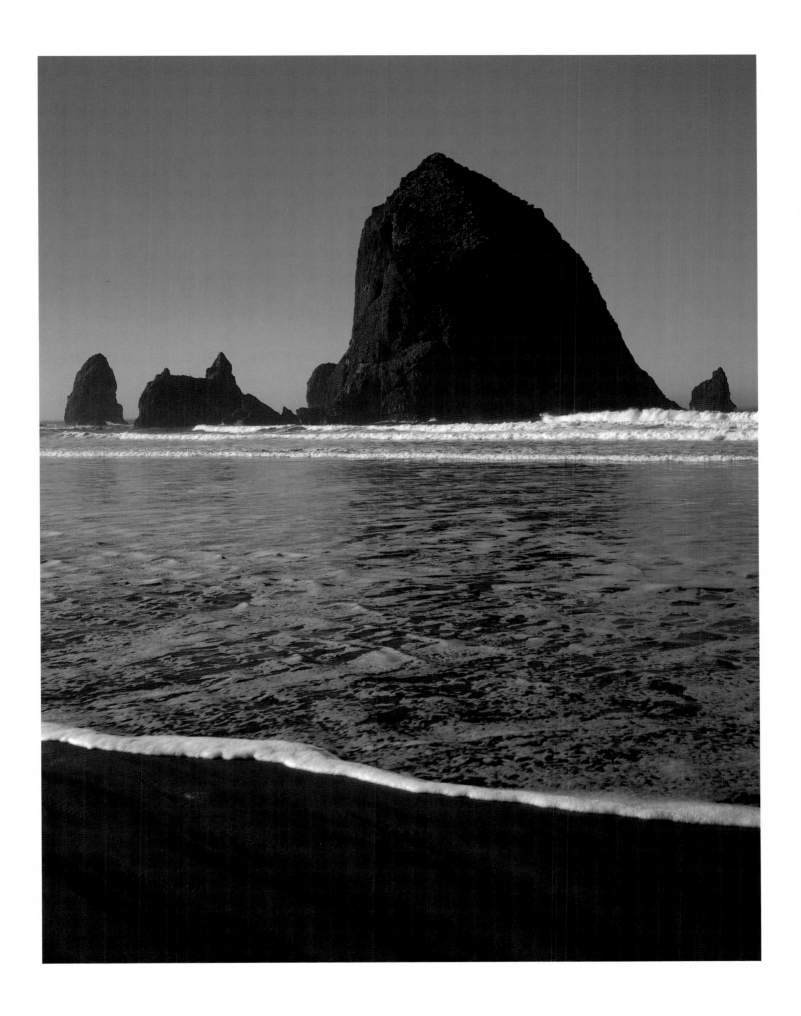

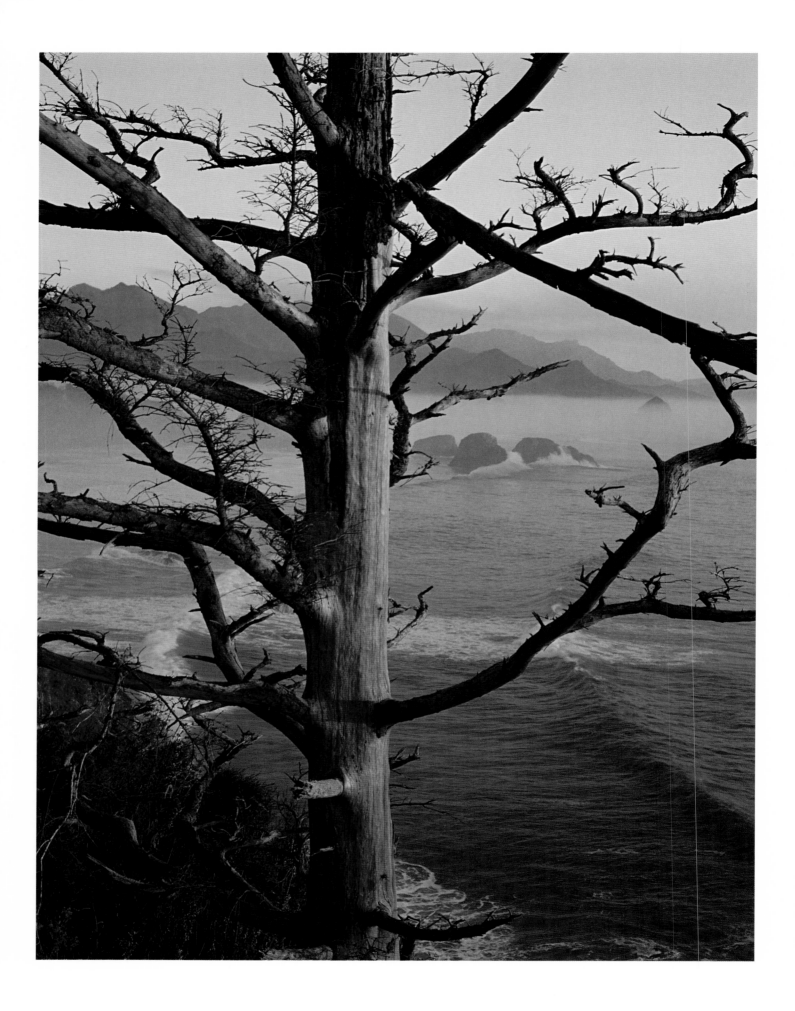

They called him Brother Wind because he never stayed around long. He'd blow into town on a weekend, and by the time they woke up Monday morning, he was gone.

Now Brother Wind one time was drifting up the coast, sniffing around his old stomping grounds here and there—Cape Blanco, Arago, Perpetua, Kiwanda. He stopped off at Cape Lookout to visit his friend Rocky, and they got to talking about good times.

"Brother Wind," said Rocky, holding out a mug of yarrow tea, "you never were one to wait around long. Think you'll ever settle down?"

"Rocky," said Brother Wind, wincing as he sipped hot tea, "I'll tell you something. My soul has habits that keep me on the move. My power is a weakness for seeing new things. Things that writhe and blossom catch my eye. I never can pass up a pretty woman without a good look, especially if she has long hair. I can't seem to stay out of that long hair. Know how it jumps around on a lively one? I love a storm that stands and sways like that."

"Brother Wind," said Rocky, "you change so often, you never change."

"Rocky, it's my way, and it's an old way. I haven't yet met the cure. But I hope to. You just watch. My cure's going to be someone fine." Brother Wind stared out Rocky's cracked window at the waves that shattered themselves to spray, down there below the bluff. The soft light of it all put him in a misty mood.

"One time," said Brother Wind, "I was hitching north up 101, and nobody's stopping to give me a ride. Nobody. It was raining, blowing hard, of course. I wasn't much to look at, if you're doing fifty-five. I got so disgusted waiting, I crawled in under a cedar to sleep. Everything got real still the minute I lay down. I drifted off, damp and cranky. But then, in the middle of my deep dreaming, this red '49 Ford pickup pulls over, with a woman at the wheel. One glance from her bright eyes, I catch my breath. I stagger out of my cedar tree and climb in on the passenger side. It's a cherry old truck, original chrome buffed to gleam, but red ball fringe over my head, and a crack in the windshield with a pretty star pattern that gave the world a twist on the passenger side. She had the original dashboard plain and fine, with a modern music system fit under it.

This driver has wild, dark eyes, and I see she has a long hank of hair to her knees, the whole rope of it knotted once at the shoulder

and coiled loose across her lap. She's in neatly faded jeans and a Guatemalan shirt, she has her legs spread wide, and a fist on the eight ball as the engine hums.

"Stranger," she says, "where you bound?"

"North," says I, "until I change my mind."

"Do you mind your music loud?" she says.

"Love it," says I. Well, she revs the engine, cranks the stereo volume to the max, pops the clutch for a squeal, and we're gone. No use talking in that cab. She had thunder in her system, but I could just make out the words. Sounded like her own deep honey voice in a throaty wail:

> When the wind comes down the valley
> And the weather's turning cool,
> You won't take me for a ride,
> You won't take me for a fool.
> I've been around too long to give
> Much truck for what you say.
> We all know your habit here
> To love and drift away.
> > Brother Wind, we have a secret
> > That you will never know.
> > Brother Wind, pack up your longings.
> > It's time for you to go.

I see I don't have much to lose with this woman, so I reach to turn down the volume on her system, and I ask her straight, "Woman, who unties that knot in your long hair?"

"Nobody," she says, looking me in the eye, "nobody yet."

"And where you bound?" says I.

"Bound for glory," she says, "bound for trouble, bound to sing and praise. They call me Wild Woman. I'm looking for home." And about that time, I felt rain dripping into my ear and wake up under the cedar tree.

"So, Rocky, my friend, I'm traveling. I'm going to meet that woman in a sweeter mood. I just keep rambling along with that song ringing in my ears, and the tingle of that lady's long hair teasing my fingertips. It seems to be the only thing I know how to do."

"You know how to tell good stories," Rocky said, "and you dream good dreams. I hope you'll stop to see me, next time you're passing through. I'm always good for a cup of tea, and a listen."

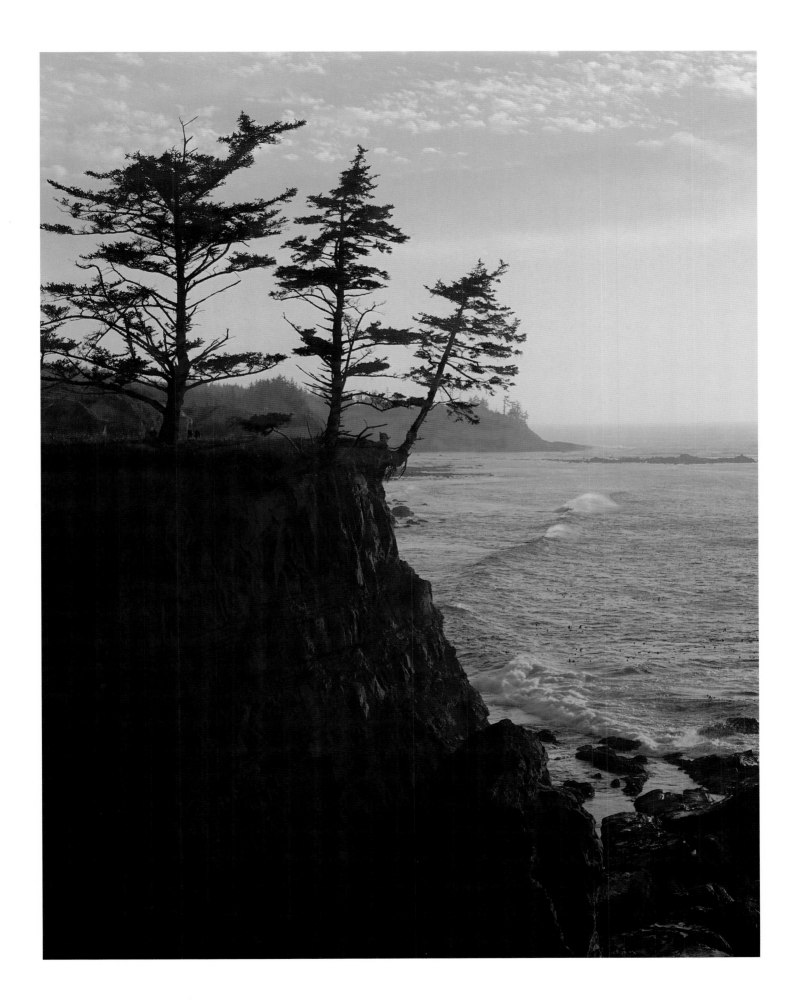

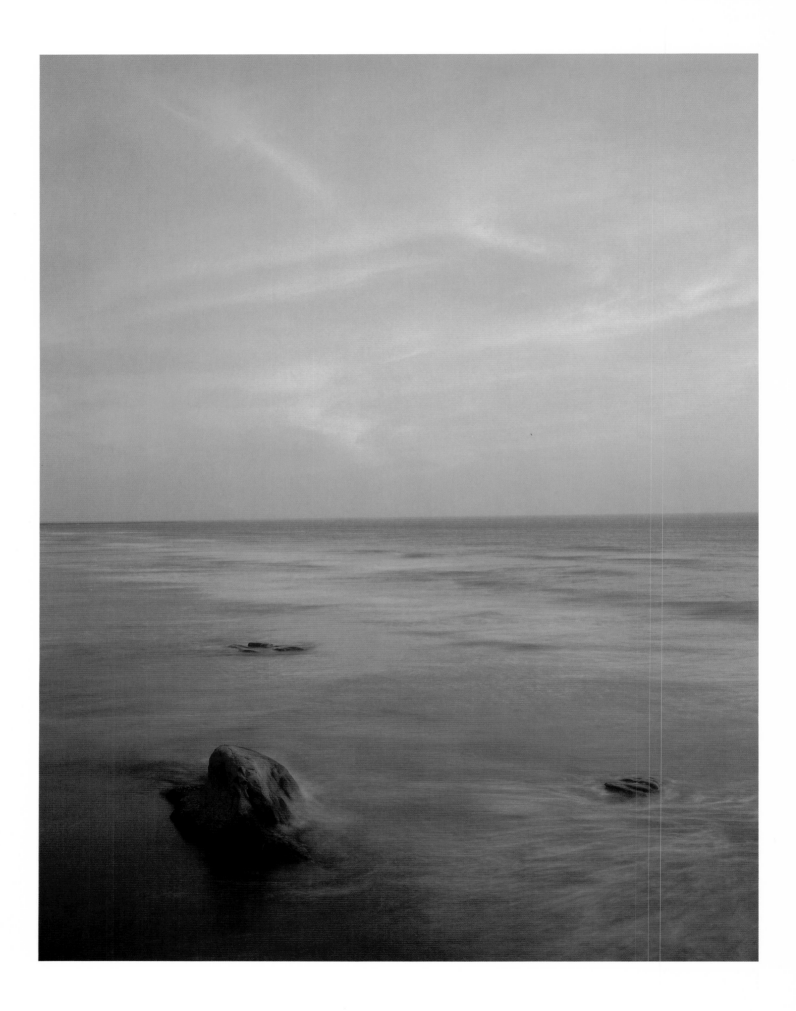

"Simplify. I want to simplify," Teresa said. "Will you go the coast and give me a few days' space?" She looked at him through the steam of her coffee. "See the play there," she said. "It's an odd one you'll like, just right for you. In fact, I got you a comp ticket. I know the company, and they'll know you." She sipped her coffee. "Sit through it," she said. "Stay over. Get lonely. Wander around and live some weather, then we'll talk again."

"So your friends will give me a show," said James.

"They'll give you answers to questions you almost know," she said.

"What's that supposed to mean?"

"You'll see."

So James went to that snug little town in the evening, found the building and came in from the rain-slicked streets to the volunteer theater in the round. The girl who took his ticket smiled, tilted her head. She led him to a front row seat on the far side. "You must be James," she said. "This is yours." And she left him.

There was a faint smell of damp and coffee. He was tired as he eased down into the seat, a dizzy kind of tired like a sip of wine. The day gathered into one long breath, and he let it go. He could see a few dim faces, on the other three sides of the stage, but then the room began to blur. He dozed. He slumped into himself. Then the silence woke him. They had brought down the lights, and they left the house dark for a good ten beats. Then one light came up slow, one dusty shaft of color, and there was a creak of boards. One dim figure came forward, an old man, and James could feel his own breath come steady, and he could hear every word. The tall one stepped out into the blue light, and looked at him, straight into his eyes.

"Hey, you," said the old man, "Mr. Music, you. Mr. Rhythm, you. Mr. Dances Alone." James felt a prickle on his neck. The old man really seemed to be speaking to him alone. "What you been dreaming all these years?" the man said. "What you want now? You want to be rich? I can't help you. You want to be loved? That's beyond me. Want something you can have, okay?" The old man pointed to the ceiling above his head. "You wake in the middle of the night," he said, "and listen to rain. It does not have a message of words for you. Don't try to decipher it. You just listen."

The old man stepped back, folded his hands, turned away like a curl of smoke. The theater grew dark. James wondered what the old man knew about him. But he was an actor with a script. This wasn't about James. It was about everyone. He settled back. Then the lights came up on an old woman, and she beckoned to James. She beckoned, and it seemed she knew him. She'd been told things.

"If you want to be a dancer," she said, "if you want to dance with another, you will listen to moving water. You will start with pure flow, then learn steps." She stepped aside, as if another stood by her. "Find a boulder in a fast stream," she said, "and watch what water does to get

by. That is your dancing way. Do it like so." She avoided the path of something silent raging past. Then she seemed to flow backward into the dark, blurred to gray, but then another came close. James could feel his palms sweat. Someone coughed. But the light direct on this hobo's face caught James.

"If you're gonna live," said the bum, shuffling forward, "if you wanna love, you gotta listen to water move, man. Water's the oldest traveler on the world. Ever think on that? Do it now, buddy. Close your eyes, you'll see it!" He whirled to the others, his body clenched and dancing with a thrust and feint. "Water got a home wherever it moves," he said, hopping forward, "but it don't stay. Trap it, it sneaks away on you. 'Vaporates. Put the heat on, she steams. Just keeps going. You want a home? Why? You want a home, you want something water don't want and you don't need. It's not our purpose to stop. Destination? Tarnation! It was rain on a boxcar roof brought me to God."

The traveler stepped back, twisted like a whirlwind receding. James stared at the ceiling, listened to the waves there. Was it waves? The roof of the theater creaked like a ship's hull. Maybe it was only rain. Simple rain. Then there came a whispering at his ear. It always gave him a chill when the actors came down the aisle behind him. But then he saw she was a wispy one.

"You wish make beauty?" said the gardener, leaning on her hoe, holding a straw hat in her hand, bending over him where the spotlight caught them both. She looked into his eyes. "You wish beauty," she said, "you listen rain. Bean seed listen rain. Pumpkin seed listen." She turned to the whole audience from the middle of the tiny stage. "Everybody listen small rain," she said. "You listen, and you know how small thing get big."

The woman turned away, and the lights went black, but a voice went on. It seemed to James to be his own voice talking out of the dark, or maybe his grandfather's voice, some kin.

"Small thing gets big," the voice said, "small comfort grows. A little song becomes your whole voice, the root of everything you have to say. To be a healer," the voice whispered huge, invisible, "you will need to know how water heals itself without a seam or a scar. Don't know how it works? You go down to the waves. You're tired? Watch the waves work." There was a silence, eight beats of silence, then the voice went on "Take a chair to the high tide line and watch a twelve-hour cycle of tide. The whole time, breathe like a wave breathes. No rush, friend. Easy. You want to live a hundred years? Watch how water does it."

James heard a creaking of boards as the healer stepped away through the darkness. The healer was gone, gone somewhere with the others. Gone inside him. He could feel them getting a grip on his soul. It all went on forever, voice by voice, face by face staring into him, and he was lost in the words that stormed him. They were talking straight to him and left footprints on a road in his head, left a twisted place in him like old trees grown crooked, and then it was suddenly over. The houselights came slowly up. No actor bowed. It was done.

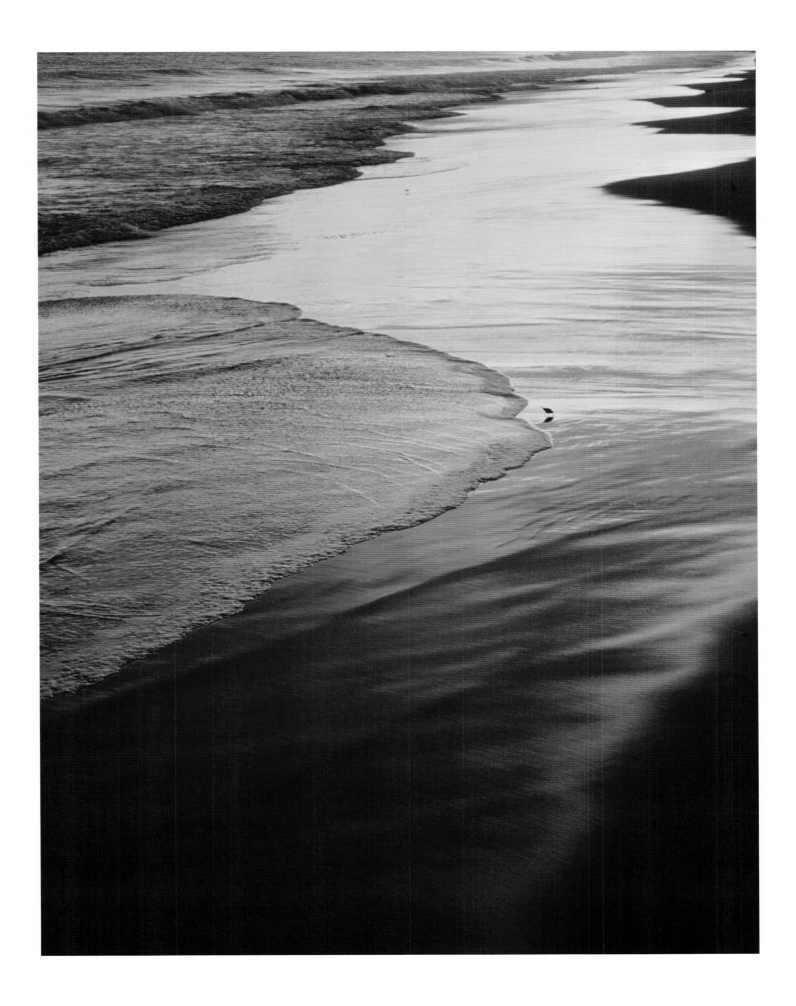

"I want to know how she survives," Aunt Bea said. "That woman gives like a pear in bloom. She's open to everyone. She doesn't hold back a thing for herself. Now, I'm all for generosity, but it leaves her so fragile, you know. And then we have to scurry around and kind of pick up the pieces of her. It's just not fair to her close friends, the way she's so mindlessly giving of herself. Here we are worrying about her today, when we have things to do of our own. That woman just shows more flower than leaf, that's all."

"Aunt Bea, what would you have our Nancy do?" The younger woman reached to pour more tea into Aunt Bea's bone china cup. The porcelain was so thin, she could see from the side when the cup was full."

"Thank you, dear. Tea's good on a blustery day. And this old pot— bless our Belle for leaving it. What would I like? Well, Billie, I'll tell you. I'd like that Nancy to act her age, I guess. I'd like her to show a little of the selfishness more typical of a twenty-eight year old. A young woman has to take the world into herself and toughen her reserves. Leave it to us old biddies to fret and reach out. If you don't mind my saying so, Billie, when you reached seventy yourself, I noticed a change. You're still as feisty as ever, but you started taking on causes like me. That's appropriate at a mature age."

"Aunt Bea, you're the one I worry about. I like your figure about it: more flower than leaf. Frankly, I couldn't say where you're rooted sometimes, you have given so much to your neighbors. Who do you suppose taught our Nancy to be what she is?"

"I don't know about that, Billie. But now she's taken this pneumonia, just from driving herself into the ground. Did you know she was

volunteering her nights and weekends at the school? She gives so much to those children."

"Aunt Bea," said Billie, "I want you to stop complaining and tell me how you happened to come by this particular worry. Or better still, tell me how you became such a ruthless volunteer out of your own life spirit."

"Simple, Billie. I'm at the end, that's all. But I want the young ones to go on. I'm at the end, but my spirit goes way back, I guess. My own grandmother taught me that joy comes always from a sense of abundance. It's that plain, she said. If you aren't given abundance, you have to find it or make it yourself. Her way was the big garden, the cellar jammed with the fruits of the earth in quart jars, all in a gleaming row. Put a dent in my memory the first time she took me down cellar to see all those garden colors in the winter. Dakota winter, too. Tough times.

"But then me, I came to the coast, here to Oregon, to find this great abundance of green. This abundance of rain, I never will get used to. I love the storms, even, all the life of the lakes, the birds. Do you know I saw our swans going over town the other day, and just couldn't believe what they did to my soul. But I find it in small things, too. I can't go now, but do you remember last time we were in the woods I was stricken with joy by the smallest thing there was? One lady slipper. One little bloom all alone in the moss. I got down on my hands and knees to study that. Then I could hardly get up. You almost had to give me final rites where I knelt there by that flower."

Billie drained her tea and gave the other woman a long look. There was a click as she set down her cup. "Nancy will do well in time," she said. "She's like your lady slipper. The flowers that know how to bloom, Aunt Bea, they do fine."

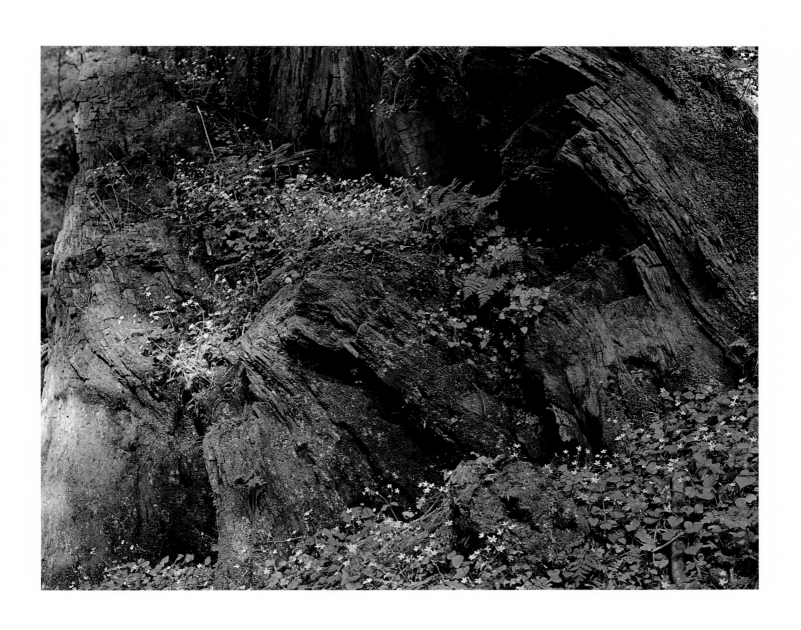

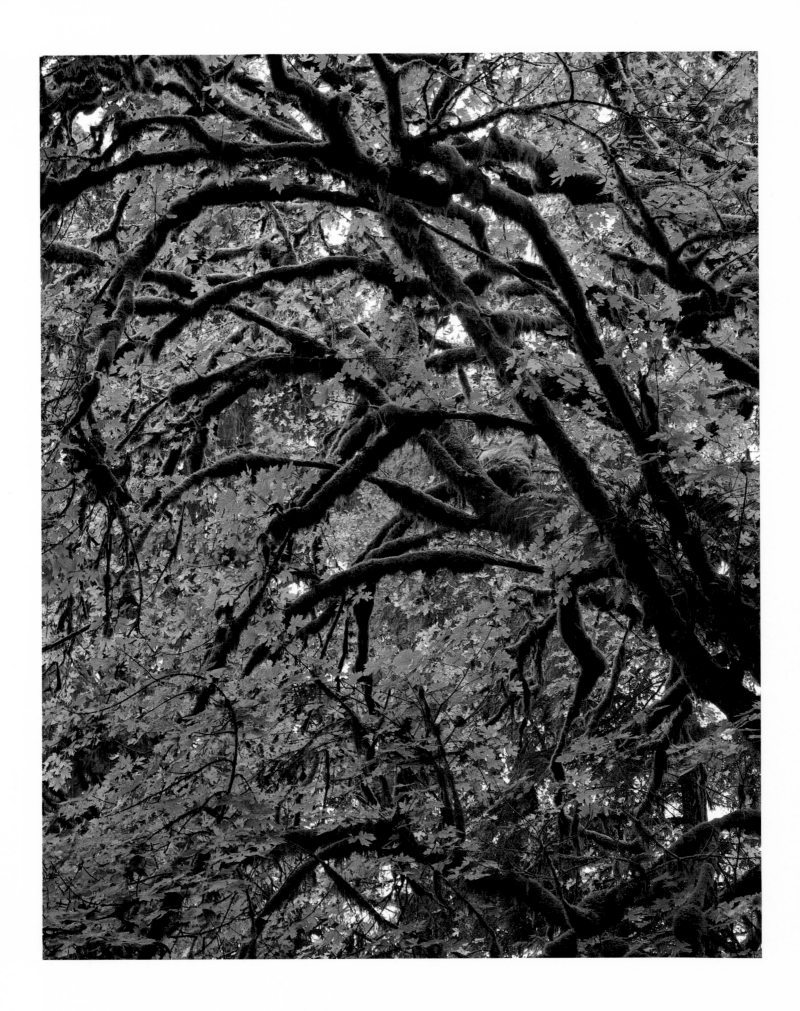

Oh, Nancy? You just caught me greasing the pans. I got butter on the phone here, and it keeps slipping off my shoulder. Forgive me. Here's the deal. You need a weekend alone, our cabin's empty, and its yours. I just need to go over a few things, little details. You know where we hide the key, right? You don't? I'm sorry, I thought you had been there before. That's okay. There's a rusty tin can by the woodpile, in there somewhere behind the kindling. Harold keeps moving it, you know. That's our security system. The key's inside that can, and it only fits the back door. It's rusty. You have to jam it into the lock, and twist hard. But don't break it, or you have a real problem. And the door sticks, but it's fragile, so be careful with it, okay?

Take a flashlight if you plan to arrive after dark. Watch out for the ax, though, when you reach for the key. Harold keeps it sharp. And there are spiders in the woodpile, too, and splinters. After you open the door, take the key right back and put it in that can. If you lock the key inside the house, we can't help you. I keep telling Harold to make a spare.

Darn phone keeps sliding off my shoulder, squirting around like a pumpkin seed. But your shoes. Be sure to take off your shoes. You can leave them on the porch. Take slippers. I always do. Once I forgot, and had cold feet all week. Harold is very particular about sand in the house, you know. Always has been. Wants it all shipshape inside, without a single grain of dirt. He lets the exterior go to heck, but keeps it speckless inside. So remember, no sand. Just light the stove. You'll find newspapers there for tinder, and kindling split in the bin, and logs outside. Be sure to open the flue. Water? There's only cold.

Your rent for the weekend is six hours of work. You'll see what needs doing. We put on a new roof, but everything else could use some fixing. Harold can't leave the place alone, you know. I walk on the beach and don't care. He says I don't care about him. The place is a wreck, really, but Harold loves a wreck, so there it stands. We got it cheap twenty years ago. If it looks like he fixed something, but botched it, better leave that alone. Concentrate on fresh fixing–loose shingles, weeding. You'll find all the tools you need, but don't mess up the workbench. Harold's real particular about his tools.

It's primitive, but I know you'll love it. You always were soft for things like that. Most of our guests sleep in the loft with the window wide. You can wedge it open with a stick so it won't bang in the wind. I always set some kindling against it, and tie it snug with a string. On a clear night, the stars are fine. And we love the sound of the waves. Just lie there listening. That's the cure-all sure.

Hope you have a good time. If you light the kerosene, keep that lamp out of the wind. We don't have insurance. Do you?

"When I was little," she said, "when I used to play pirate with my brothers, we always thought the perfect place to live would be on an island in a freshwater lake on an island in the sea. I'm still looking for that."

"Where are you looking?" Catherine said.

"I'm looking west," said the old woman. "I'm looking in the atlas. But I don't find much. Two years ago, the closest I came was standing on a stump in a swamp on the high ground of our estuary slough."

"That's not very close," said Catherine.

"It's not, but it's something. It's a place to work from."

"Tell me about these brothers," said Catherine.

"They're gone."

"But what were they like? Were they older?"

"They were like my uncles, good men all. Aaron and Earl, Oscar and Harrison. They made a hay crew! You should have seen them sweep a field with those long blades, swinging together at every stroke. Then they'd turn at the corner and go on round, unless I was there with the water bucket. They would drink and pass the ladle back to me, just a sip for me after they were done. Then they'd go on round, round, until there was just an island of grass at the center of the field."

"And they saved that for you?"

"That was mine, my house, with the hay bent over a nest for me."

"Your island?"

"My island. They raked the rest, then came out to get me. By then, I had the best china there, filched from the house, the pot filled with my wild clover tea, a sip for each. I was youngest, and wildest. When we got in trouble, it was generally my doing."

"And when you did something fine, like dreaming up that island in the lake on the island, was that your doing, too?"

"We all came on that idea together. Once we were sitting around a stick fire we had made, off by the pond, and we all came to that idea. I kept it past their death. That's why I lived on the houseboat as long as I could. When I got into my bathtub there, I felt I was close."

"Not real close," Catherine said.

"But close, my dear: in a pool on a boat in the salt. That's pretty sweet. Water's the magic of the earth, you know.

"I think people like you are the magic of the earth."

"Bah. I can't walk. How will I find that island, child?"

"I think your brothers did."

"That way was never our plan. I want water and rock and brothers, not a dream."

"Water," said Catherine. "You should have your water. I'm supposed to remind you." In the dim light, she helped the woman sit up, and sip, bowing over her glass. The glass was tall and clear where they held it together.

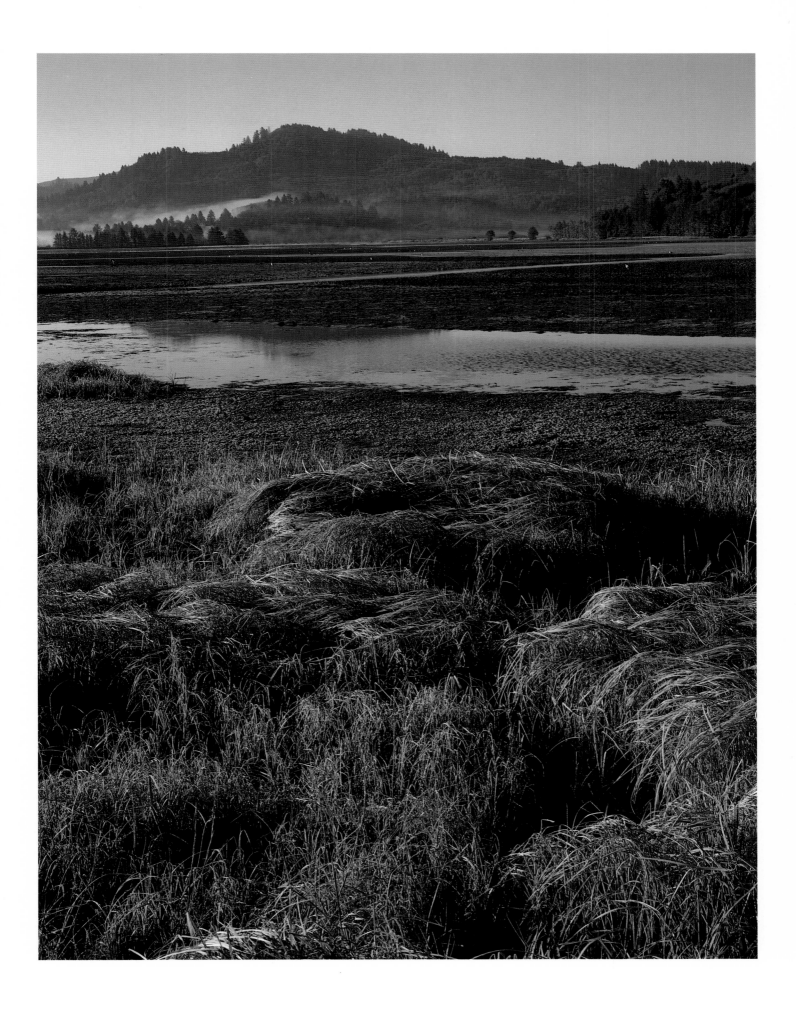

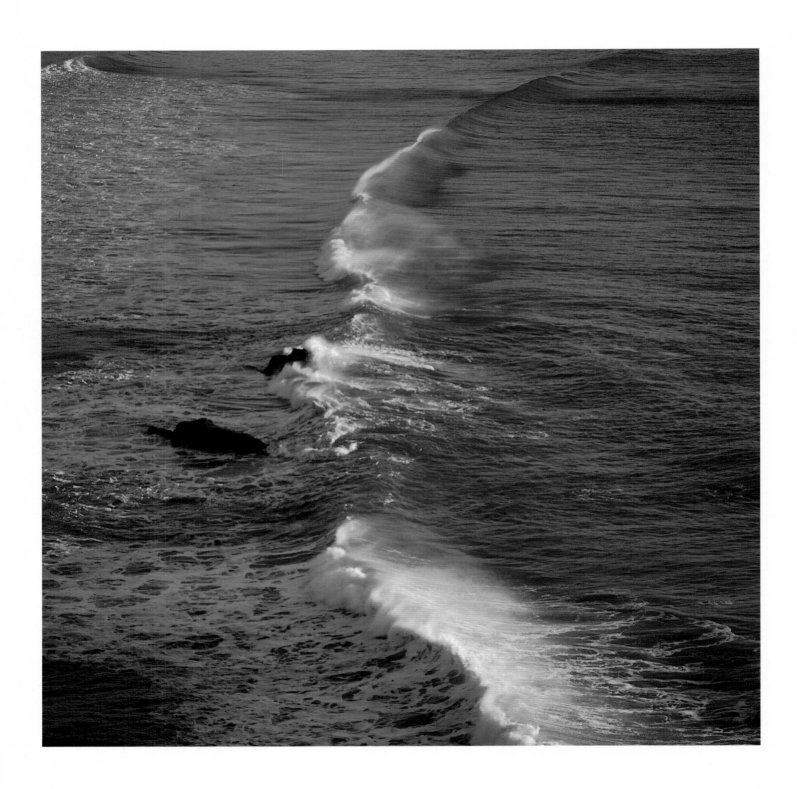

COFFEE AT THE EAVESDROP CAFE

Sylvia came to listen every afternoon, when most of the booths were empty. She ordered coffee, black. She pretended to read, her book always the same battered novel with the cover gone. Her eyes moved back and forth in the general vicinity of her book, but we noticed she rarely turned a page. Joanne the waitress knew her wish, and seated the most interesting people near her. The silent types were steered to distant corners, but every garrulous sort got plopped down with a back to Sylvia, and treated fine.

One day Sylvia didn't open her book at all, and she let her coffee grow cold. It was raining hard, and business was slow. People just wanted to get where they were going and be snug. Joanne sat at the counter, watching the rain slash at the window facing south, watching traffic pass in a blur. Then the door gave its bell a jangle, and a sharp-eyed, white-haired woman stepped into the room, with a young man following, shaking rain from his bushy hair.

"Coffee?" said Joanne.

"Two," said the young man. And she left them, in the booth by Sylvia, but listened. They talked, and loud. The hard of hearing give their stories generously.

"The ocean has always been my solace," said the woman, holding out the sugar bowl to the man, "and I hope this rain will let us walk today. I've found a quiet, walking by the sea, ever since I was young."

"Was that L.A.?" he said.

"Yes," she said, "Los Angeles. Your funny old aunt used to sit on the beach and watch people have a good time. It was a very troubling passage in my own young life. I worked for Dr. Hopewell then, you know, the psychiatrist. I worked for her, and she gave me little scraps of

advice, now and then, when the office was quiet. Once, she told me we stand in a stream of life that pushes us, pushes everyone with a force they can't stop. If you enjoy the current, she said, you survive. If you try to stand still, hold out against it, you fail."

"It's just too strong?"

"It's stronger than anyone, Dr. Hopewell said. True strength is knowing what to do about that fact, how to bend, go with it. And so, I would go down to the water and be lonely, and watch others with their friends, and feel that current of life knocking at me, beating my heart." She stirred her cup, lifted out the spoon, and watched the coffee turn.

"One day," she said, "I must have been about eighteen, and I was watching people swim in the surf. I saw this big strong man try to stand still against the waves. He was knocked down, but proud. He tried again, and just tumbled. But beside him, his girl had a way of turning toward the wave, and diving through it just as it was about to break. I loved her grace about it, coming up on the other side, shaking her hair and laughing.

"Just like Dr. Hopewell told me, you have to turn toward the wave," she said. "You never finish. There is always another."

The sun broke through, and the parking lot steamed. The young man and his aunt paid for their coffee, and went out. They made their way slowly to their car and drove away at a moderate speed.

Joanne came to Sylvia's booth. "Do you need a warm-up?" she said, holding up the pot. "Just a splash?"

"No," said Sylvia, folding shut her book, "I think I've had enough for today." She set a crumpled dollar on the counter, and smoothed George Washington's face with her hand. She seemed to have forgotten Joanne was there at all, as she studied the face of George. She held one corner of the bill with her fingertip, and moved her thumb across it again, driving a ripple to the end.

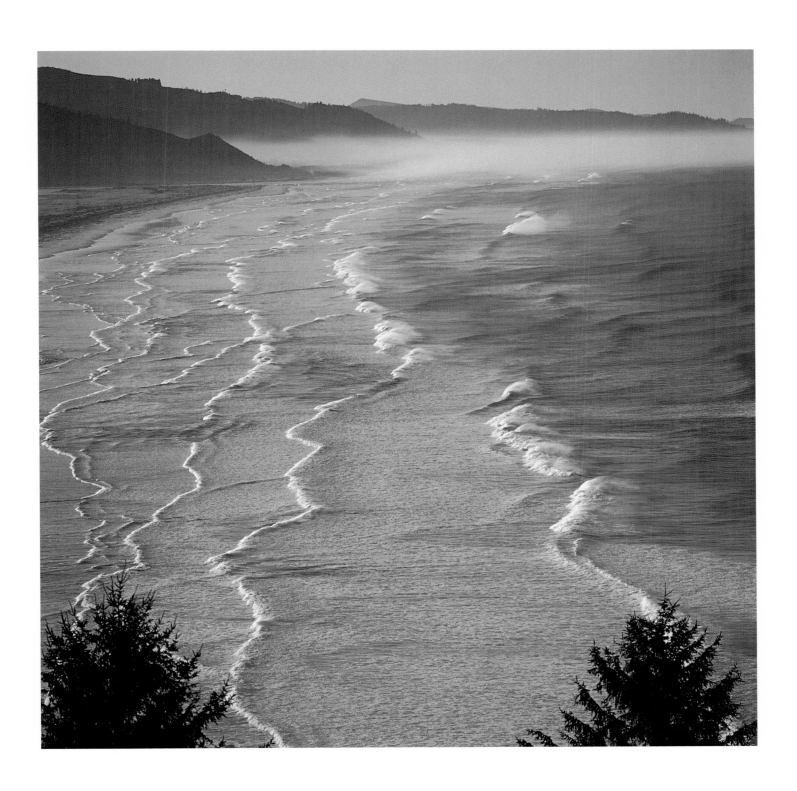

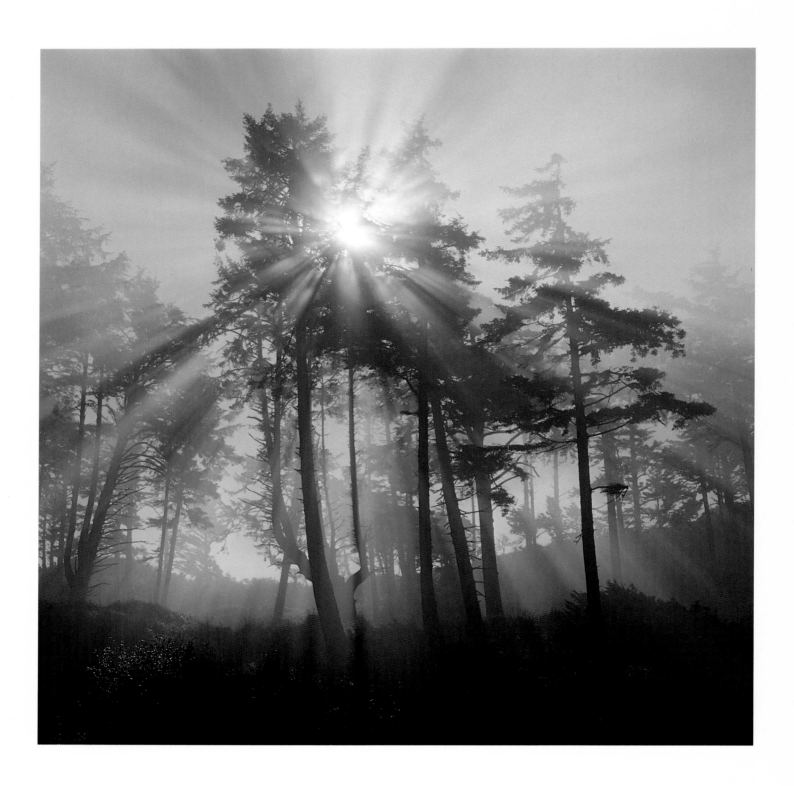

Steve met him on the beach at Bandon, but never learned his name. The old man had stories to tell, and they found themselves sharing a log at the high tide line in the afternoon sun. The waves curled a long gleam over, crashed, and flattened onto the sand. They got to talking about the old days, good days and hard changes, and how certain places keep the old days new. He told Steve about his favorite place, but later, Steve could never find it, because the old man made up his own names. He could rave about his place without ever giving it away.

"I take the Road That Forgets Why," he said, "up to the Trail Where Huckleberries Blur. In August, I have to change its name, call it Walking Drunk. I never make very good time in August. I get sticky, happy. I ramble along, eat and sleep and get dizzy. The land drops steep from Sky Knife Ridge, but I can make it, watching my footing, chewing on sour. I've got to be sober then. Then I come to Hawk Down Trail. I call it Hawk Down because it dives like a hawk, and because of the day I found it.

"I was there just at dawn, when I saw something white, flickering at me. Would you believe it was a hawk feather pasted to an alder leaf with dew, waving like a little flag? And just behind that sapling, I could see a deer trail leading off through the spruce thicket, steep and rocky down. The feather's gone now, but the Hawk Down Trail leads me, on my hands and knees sometimes, down to Wind Wave Union. You come out through a salmonberry thicket, little purple flowers and thorns, and there's that run of steep stones rattling down after every wave.

"The waves and the wind have a kinship in that cove I've not seen anywhere else. There's a place out on the water I call Taste Each Other, because of how the wind whips and water spits up around the rocks. The wind spins past the headland, and the waves lurch and boil. Wind

and wave is a single principle in that spot. When I smell salt there, I understand. You taste what's given, and be grateful.

"I am grateful. Was down in that cove I met Lisa on a minus tide. She claimed it was the full moon got her there, though it's not a common means of transport. But Lisa's not your common woman. I guess she had her own trail. She appeared, we explored, she vanished. It fits the place.

"She told me she lives by the triangle: her music, her stories, and her zoology. Triangle keeps her safe, she said. We shared a few tide-pools, risked fat waves to peek for octopi. She showed me the scarlet creations of the secret world down there, the weave of the deep sea life. She made the long leaves of the seaweeds part, and the armored fishes rise up, fiery in their crimson and purple scales. I thought I had touched the mysteries before, but she showed me I'd been sorting dry leaves. I'd just been handling rags before Lisa. Along in the evening we shared a fire, and she sang. I haven't heard such singing before or since.

"I've met strangers with gifts, that's the practice of the road. But I never met another with Lisa's gift. If a whole tree could grow in a night, that's what her stories did to my soul, sapling and blossom and fruit in one rush. She was a wise one, and gentle. I'm an old man now, but that night and that meeting is a young place in me yet."

Where Steve and the stranger sat on the drift log, the sun had touched the horizon, and they were silent as it settled deeper. The sun fattened, divided into slats of fire, and winked away. The air turned cool.

"How can I find this place," Steve said, "if you don't mind telling me?"

"It's not easy," the old man said with a light in his eye, "but it's possible. Just follow Road That Forgets Why, and you'll find it. If you follow, you'll find the place you are supposed to be, not mine but yours, right down there somewhere, secret at the water's edge. And say, friend, if you meet my Lisa, will you give her my best wishes? I can't quite do that trail these days, but I expect she's there."

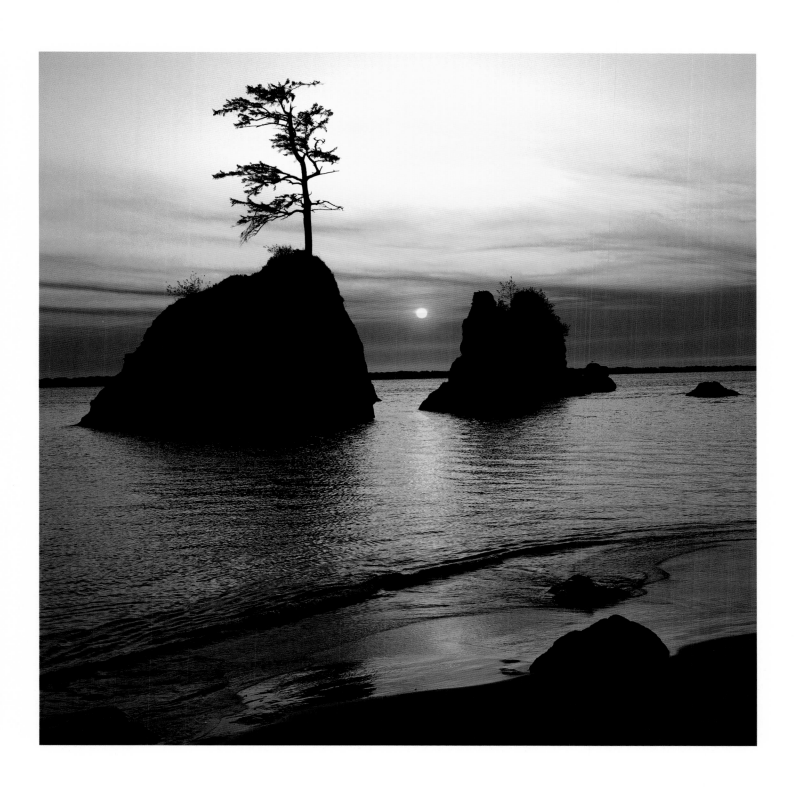

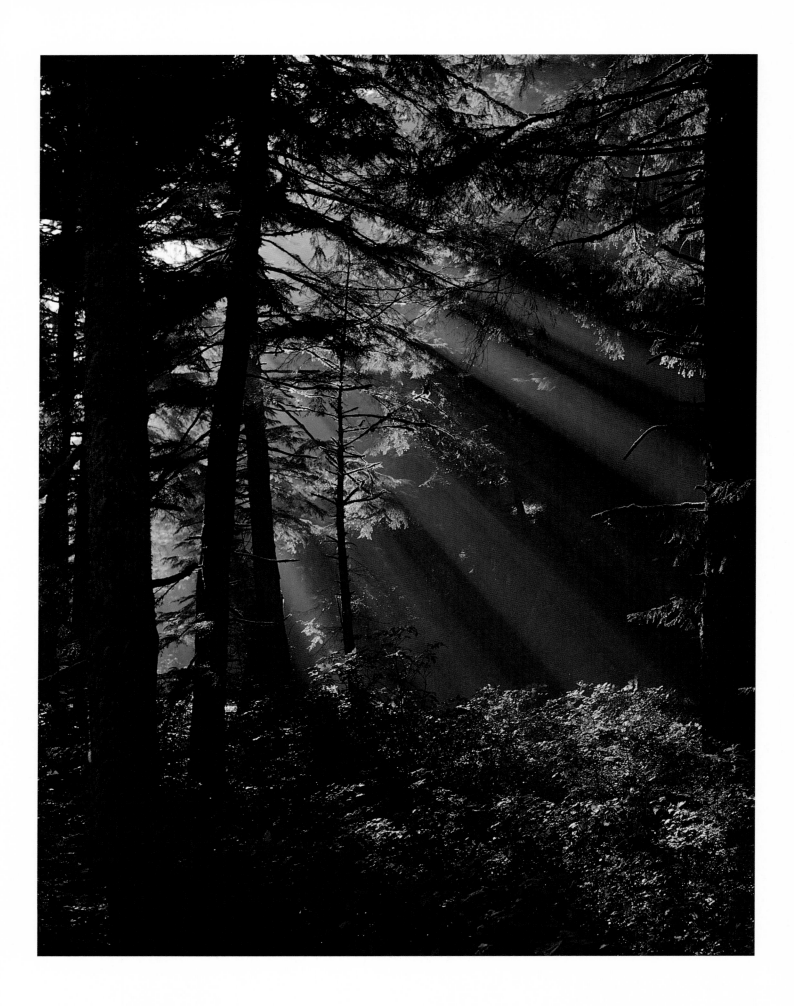

Had to sleep on the mountain. Loved his friends, but had to sleep somewhere by the trail, under spruce, above the foggy sound of waves. Had to find the trail by feel, without light. Had to say a blessing there.

His car stumbled up that rocky road, headlights piercing the fog and finding the luminous night green of the leaves. And then he was on the trail with slicker and sleeping bag, treading slow, finding each step's place where his foot came down, settled, and took his weight. A fine mist of rain pressed against his face, and he sensed the wave sound just at the boundary of his hearing, down there beyond the shadows of the spruce. He chuffed and reeled with fatigue, drifting up the trail.

At the third switchback, he turned once around and said a blessing for an old friend of that place. One time she left the trail with him, went into the wild there, lay down in the sun. The pollen swarm of that afternoon took him, warmed him for a moment, and then he came to himself in the dark, wished her well, went slowly up the trail again, threading the path by starlight above the fog.

By starlight, too, he found a hollow on the slope and slept there, fit to the rocky ground, dreaming and breathing low, waking at first light, his bed dense with little stone and stick. The air smelled of earth and fog. Waking into the world at such a place, he gathered his things and rambled upward, gathered glimpses of the mountain's creatures as he walked, of branching spruce and creeping centipede, of foggy web stretched between foxglove stems, of wren flickering over the meadow to the thicket's shelter, of wind drifting through the grasses, the grasses swaying, the path itself narrow, leading upward to the peak.

Fog drifted below, at the mountain's foot. The coast reached a long sweep south, where waves crawled and whispered, where the sun quilted the sea clear to the west horizon. There, at the first rays of sun, he thought of the blessings in his life, the creatures he had been— the brother, the son, the father, lover, vagabond, bum. At that place, on the rocks of the pinnacle, a strange urge came over him to dance. He was not a dancer. He was awkward, and yet he had to dance. He had to dance the creatures he had met and lived. His body became a trunk that reached. His fingers reached. His body became a web that spangled and sprawled. He stretched. His body swayed with stems of grass, shivered forward as the wren flew, tentative, shrugging, quick. His body swayed and shivered. His arms swam past all obstacles with the centipede's flow, took the path's own ribbon through time. His head turned with a blessing from night to dawn. His hands tried to find the moving shape of the dove's call that opened, and closed, sounded, and was still. His arms shaped the shimmer of sound from the waves, opened, folded, and closed. His body was not his body, but the mountain. He felt the comfort of many things together in one place, many gathering, many summoned and wished in one body. He felt like wind, like water, then a stem, then wood. The dance left him like smoke.

She wrote from Nebraska, asking for a room. Something about her letter told him—though she never said so—that she had never seen the sea. The letter smelled faintly of lavender and wheat dust.

"I would like the room for a week," she wrote, "the plainest you have."

She turned up with a small suitcase, a straw hat, and a head of white hair braided and pinned into a snug cap.

"I've heard so much about Oregon," she said, "and here I am, and it's not raining. Perhaps they lied, or perhaps I should be patient." He took her bag, which seemed to be filled with air, and showed her to the room upstairs.

"Towels in the cupboard," he said, "a bathroom down the hall, and a fire in the library downstairs each evening around 7:00."

Later that afternoon, he was weeding in the garden when he saw her step off the porch, her straw hat lashed fast to her head with a faded scarf. She disappeared down the street, a striding blur of purpose.

The wind died. The sun burned hot for a change. The pine tree did not tap on the eaves as was its custom. No breeze cooled his brow. On his knees early that morning, he had hollowed a ring about the root of each grape vine, around each clump of tomato, each blueberry bush, so he could pour a bucket of water there, and there, watch it gurgle and brim but hold to the exact perimeter of the plant, leaving the bare stretch of soil between plants dry. He bent now, tipping the bucket, watching the water arch and slide, gather at the soil and circle round to meet itself. The two strands of the water shook hands. And just as they did so, he glanced up through that low opening in the pine boughs, to the far gleam of the waves. He stood in that attitude of prayer a moment, then straightened and let the empty bucket ring against his knee.

He had most of the bindweed scraped from the cabbage row by the time she reappeared at the edge of the garden. She held her hat in her hand, and the scarf trailed loosely down. Perspiration held one strand of hair against her forehead.

"I won't be needing my room after tonight," she said. "It's a very nice room, and you have been most hospitable."

"Did you find your way to the beach?" he said.

"I did."

"And the ocean," he said, "was it. . . ?"

"It was very beautiful, in its way," she said, "but, frankly, I thought it would be bigger."

"Bigger?" He leaned on his hoe.

"The horizon of Nebraska," she said, "is bigger."

"I see," he said. "I've never been to Nebraska. I imagine I would find all that space a little frightening. But tell me, do you grow tomatoes there?"

"We do," she said, glancing at his modest plants. "We grow them big."

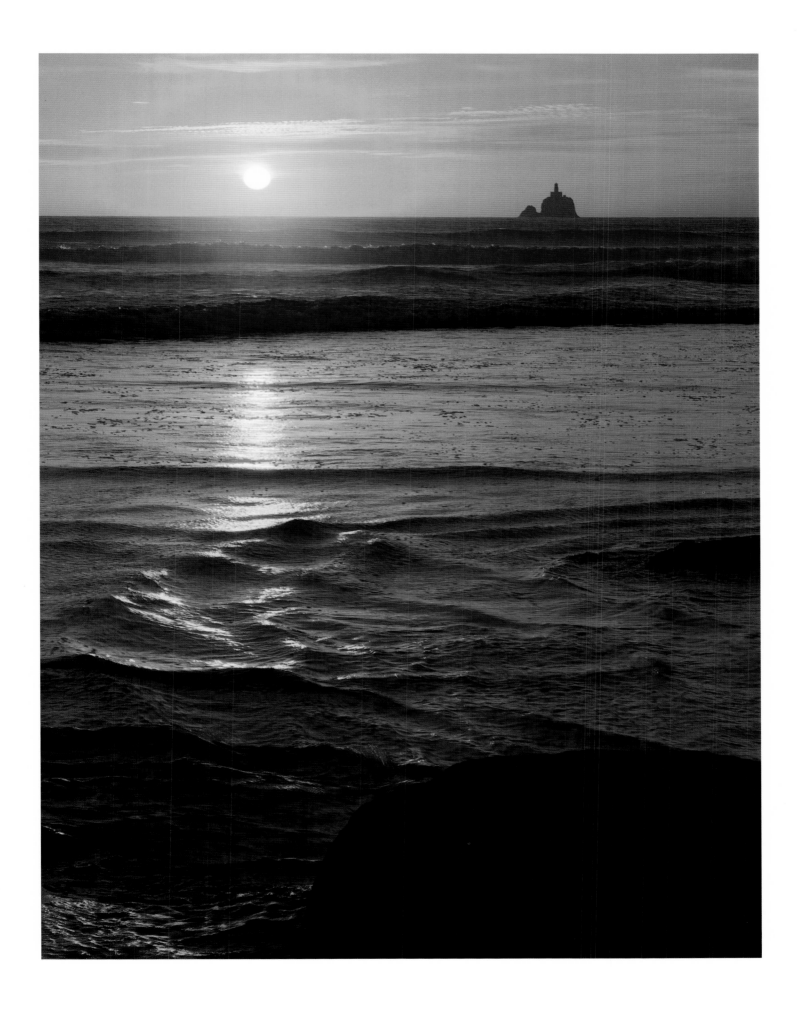

A BUBBLE CAN'T LAST LONG

Now you get settled in bed, I'll tell you a story. You get cozy and I'll start. Ready? So. Once there was a little fish in the deepest ocean, opened her mouth and let a bubble go. And at the same moment, a fist of cloud way high over the ocean squeezed out a raindrop. Way down in the deep, that bubble starts its journey to the surface, and way up high that raindrop starts down. Would you be afraid? I wouldn't be afraid. Nothing can hurt a raindrop. Nothing can hurt a bubble. They belong where they're going, just as you belong where you're going.

For a long time, that bubble rolled up through the water without a thought, bumping a fish belly, bouncing off a seaweed leaf, rolling silver through the blue, climbing up toward that big ceiling of light. And that raindrop was spinning, dizzy down, sliding along the shoulder of the wind, toward that silver field of the water. They took so long, falling down and soaring up, they dreamed. The bubble dreamed it was all water without a hollow of air. The raindrop dreamed it had a heart, a little voice held secret inside, just as you have a little voice secret inside.

Well, a bubble can't last long, and a raindrop, what's a raindrop for but to join the throng? Somehow they were aimed for the exact same moment in time, and they got there together. Then they were—what were they? The bubble opened, and was the whole sky, reaching as far as it wished. And the raindrop was the whole ocean, going where it pleased.

And little one, you are reaching what you wish, and going where you please. When you wake up, you will have all there is. Good night.

Up on the mountain, her friends were too sleepy to stay awake and watch the moon's eclipse, so the woman took her chair out on the porch alone. At that altitude, at that time of year, the air was cold in the evening, and she pulled her sleeping bag around her. She counted seven ridges of moonlight to the final horizon.

A thousand miles away, in the city, a man sat in the yard in his rocking chair, with a pot of tea in his lap, a blanket over his shoulders. The moon was so big and bright that night, only a few stars shone. Why was no one with him? There was room by the pear tree for two chairs, but his wife had no interest. She slept. Their child slept. The house lay silent behind him. And up there, the moon seemed to be swaying. It stared. The moon was a medallion, a door for him. He wanted to reach up, and nudge it open.

On the mountain, the woman wondered if she would ever meet someone as crazy as she was, as eager for this kind of solitude, this kinship with moonlight. Now the moon was climbing through a pine, making the limbs whisper and sizzle with light. She wondered how her friends could sleep at a time like this. Sleeping, their dreams could never be as good as this night itself. How could there be sleep, and such moonlight? How could there be woman, and no man?

In the city, the man watched the moon rise through the telephone wires, through his neighbor's TV antenna, glittering off the cross arms of the transformer pole. He rocked on the grass, and the joints of the chair squeaked and chirped. The only other sound was the soft rush of the freeway, and sometimes a truck's growl, climbing the long curve of the city interstate.

Wind came up her mountain, chilling her face just as the hard line of Earth's shadow first bit the moon, and the seven ridges darkened, the wind died, and her breath grew still. She could feel her heart pounding as the darkness grew, and her small breasts rose and fell. She lifted her hands, praying like a tree, a lover waiting, waiting. She watched that rim of darkness glide slowly over the moon, until the moon was only a ring of dusty light.

And somewhere, at the edge of the sea, the dark moon was pulling water toward the land, practicing the magnetism that brings all things to one, that invites a man's hand into a woman's, one life into another, when they manage to find each other, when the tide of sorrow rises, and goes down, and everything changes.

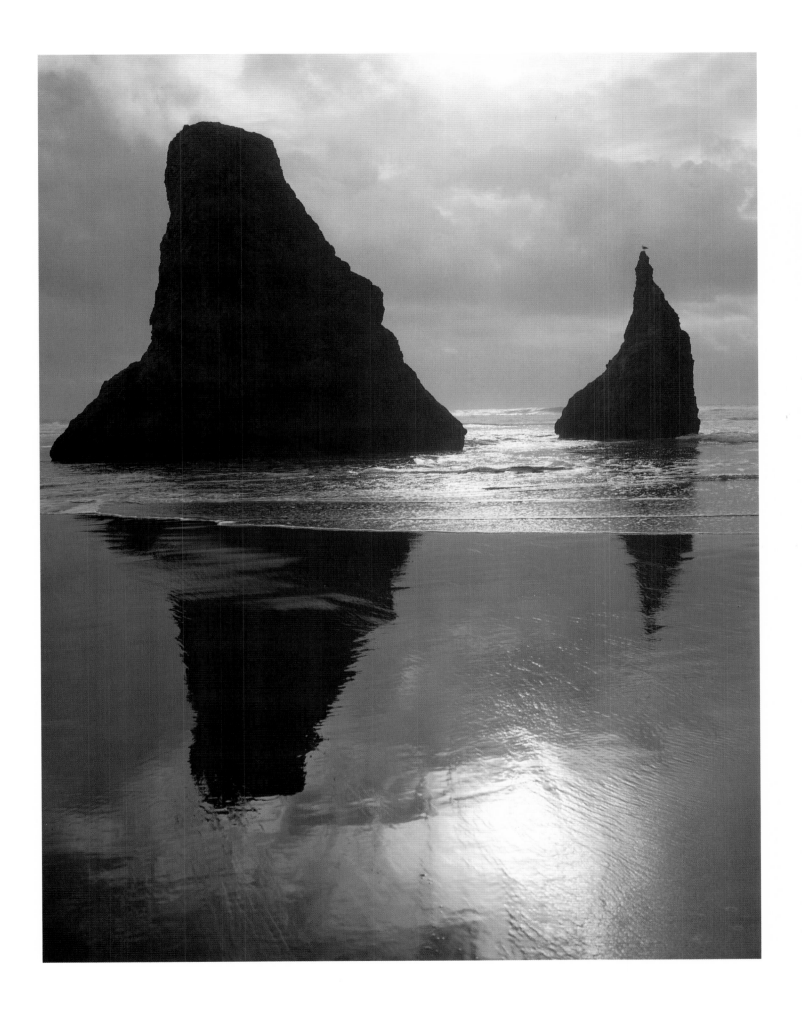

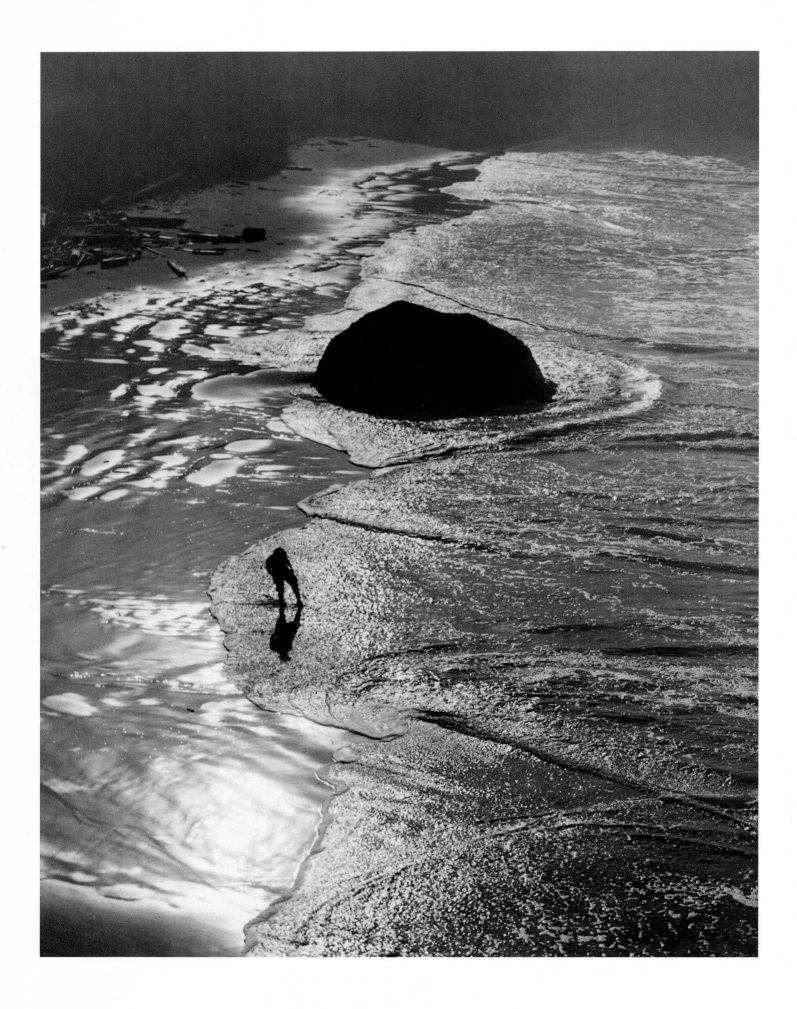

She was walking alone on the beach, carrying groceries home from the store, when she heard a voice calling her name.

"Michelle. Michelle, over this way." She hesitated. The grocery bags were heavy in her arms, but the sand was damp. No place to set them down.

"Michelle, over here. Michelle." The words came to her like a wave's whisper. Her shoes were already wet. A little wave had caught her. What did she have to lose? She waded round the point toward the voice, and saw a handsome man sitting on the sand in a sea cave. Somewhere, she had seen him before.

"Michelle," he said again, "I've been waiting for you."

"How do you know my name?" she said.

"Once," he said, "very early one morning, you danced alone."

"Where were you to see that?" she said. "It was foggy."

"It was foggy," he said. "That's how I see what I wish."

Michelle noticed then the tide had come up, waves nudged the rocks, and she couldn't return around the point. She looked at the man.

"Here's our boat," he said. And sure enough, a dory painted crimson was moored in a calm channel between two ridges of stone. The boat was beautifully fitted out, the mark of a good sailor. He held out his hand. She hesitated, but the tide was rising fast, and the first waves were swirling to her feet.

She settled in the stern of the boat, and watched as he cast off the line, coiled it quickly, and faced her. He leaned on the oars, glanced past her, and guided their boat west along the channel into the fog, spun round in the open water, and pulled for the deep. From somewhere, she remembered this part.

"Where am I taking us?" he shouted, over the roar of the waves. She gripped the gunwale. She held the grocery bag between her feet. In spite of the tall waves, not a drop of water touched her.

"To your father's house," she shouted, "where I will be welcome." The salt air fed her a tang she had never known. She grabbed a deep breath and held it. The waves seemed to slope down, to open. She blinked, and the fog swirled over them.

Years later, her brothers were walking on the beach. Out in the waves, they saw the head of a seal, watching them, with a young one beside her. The seal watched the brothers a long time, turning, troubled, and her eyes held a glistening, some deep story. The brothers called to her, and she started toward land, but something spooked her and she dove, and the pup went with her.

They told this story at Tillamook Bay, in a cedar house. They named her, Who Married Seal. Sometimes in the story, the woman comes back to visit, slipping off her fur skin to stand naked among them. Sometimes the brothers are cruel, shooting at her and at her pup, and she stays in the sea for good. They hear her, out there in the waves, calling. They call back to her, but then she will not come to them. They had their time with her.

The baby cried and cried, until they carried her to the upstairs room, and opened the window. Wind pushed through the pines outside, and its hush calmed her. They put her down in the crib, pulled the quilt over her. Then, when they stood still, the sound of the surf came through. The baby opened its mouth, opened its eyes, but looked toward the window. They saw her eyes brighten like little pools, fierce buttons in the dim light. Some wrinkled thought darkened her brow, and she closed her eyes, her face softened, and her breathing came then in the rhythm of the waves.

The curtains billowed. They looked at each other, and listened. His hand lay on the sill, hers on the cradle rail.

"You look tired," he said. "You should take a nap, too."

"I'm all right," she said. "I'll be fine." She leaned against the wall by the window. She seemed to sag, and then she took a deep breath, and straightened. "Do you remember the first time you heard the waves," she said, "how they sounded?"

"They sounded like breathing," he said. "My family camped, maybe at Tillamook. I remember listening in the tent that night, when everyone else was asleep." The child stirred between them, twitched, then settled. He watched his wife's shoulders rise and fall. Her blouse seemed to shimmer in the soft light of the room. She shone like candlelight.

I guess I first heard it in a shell," she said, "at Genevieve's. I think I was four then. When I got in trouble at home, I'd go stay. She had a drawer of treasures. I remember she picked up a shell and held it to my ear. I remember her hand on my cheek. She told me to breathe and listen, and I would hear the ocean."

"Genevieve," he said. "Did I know her?"

"She gave us the clock."

"The clock with the bells?"

"We haven't kept it going. It takes winding. I used to hear it chiming at night when I stayed at her house. I slept by the open window in her room. She let me keep the key for the clock by my bed. And I kept the shell under my pillow. She said it was my ocean lullaby, and I could hold it to my ear if I couldn't sleep." She put her hand to her ear, cupped it. Outside, they could hear the surf surge and settle, a hush with a beat.

"The waves," he said, "I forgot how they don't stop. They never get tired. They don't care about time at all." He moved closer to her. "They make me feel like you're still at Genevieve's," he said, "and I'm camping with my brother, and you and I have to grow up. We have to get old enough to meet."

"But now we have," she said. He put his hand on her shoulder, and she turned toward him. They leaned into each other. Her head settled against his chest. She closed her eyes, and they listened.

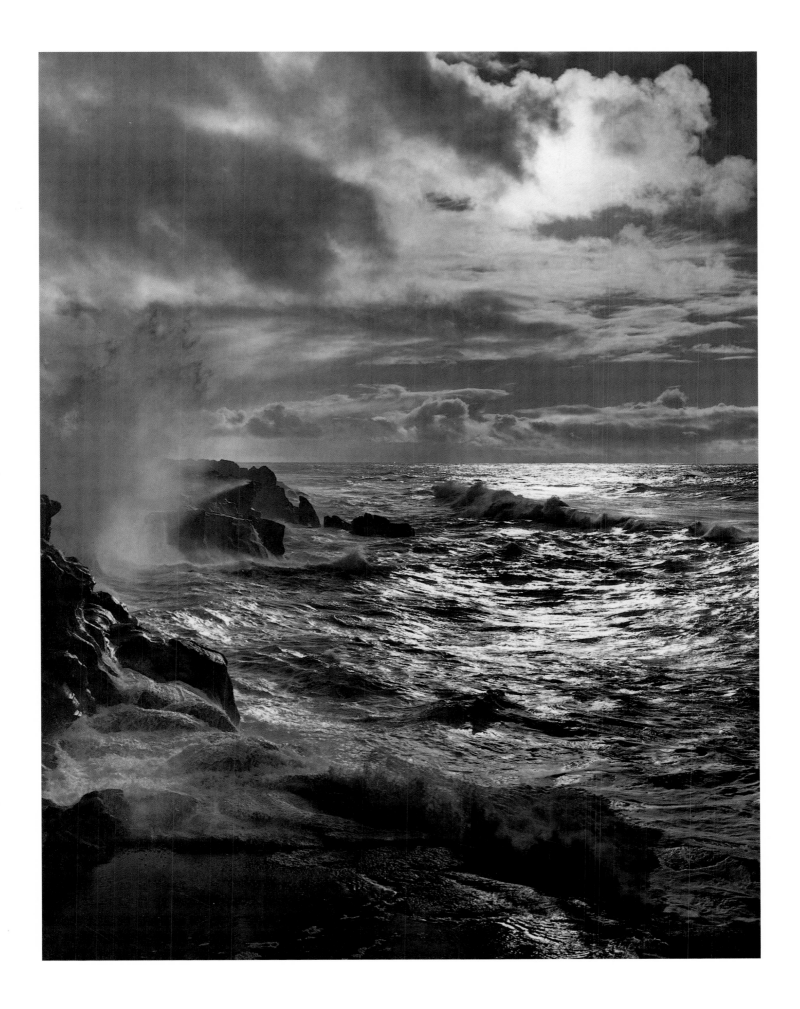

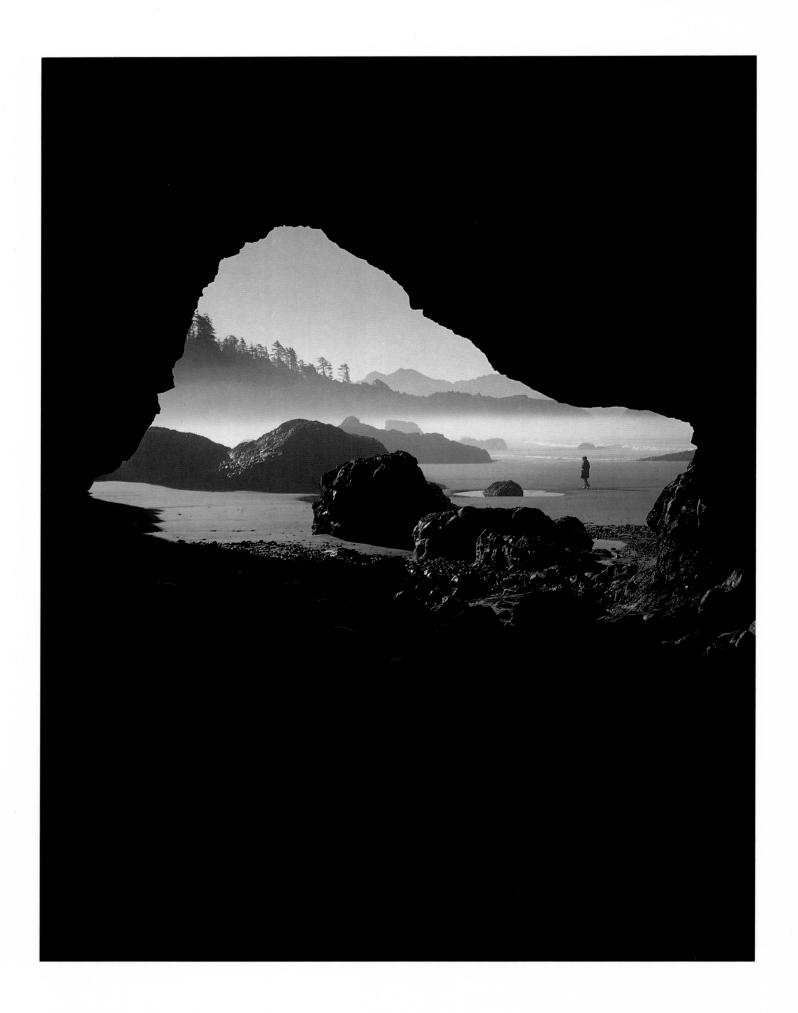

Gary found his favorite place on a whim, by turning from every trail, until he scrambled down the densest thicket of the headland to the water's edge. Why did the life of the world thicken where no people lived? The green wall opened, took him through. Devil's club and elderberry thronged from mud. He flickered through a wood that hummed with the glimmer of the wild. Gary was ghost of that place, visitor without a word. In a cove of silver beyond the trees, the waves climbed steep and settled back, breathing up and pulling back. He stood on a meadow the size of a single bed. At his feet, a snake with a red thread down its back swam over the flattened grass, then dove under and was gone. He stepped through a screen of alders into the open arena of the waves.

The steep stone beach was littered with fragments of buoys and plastic and bright blue line worn to a raspy tangle. He sat on a log and gazed about. Waves worked the tight crescent of the cove. Yellow monkey flower, thistle, yarrow hugged the protected slopes. At a pool, two crows faced each other. The smaller one had something, was coy about it, washing it while the other watched. Gary looked away, left them the privacy of their game. Beyond the end of the beach, where the waves climbed into the rocks, a small gray bird worked the crevices, skipping nimbly out of the way when the waves came snarling up.

A rock the size of a house had fallen from the south wall of the cove, and he went in under it, down a shaft where sunlight glanced. The cave was so dark, and the gold blade of sun so sharp, he could see the smallest pounded dust of water swirling up, up from where the waves seethed and settled back at the great rock's bed. He crouched there, felt the thrill of the hydraulic wave as it came surging up the fissures of rockfall, pushing its own wind against his face, then sucking back, rattling and dwindling away. Somewhere in the channels of darkness, water dripped, and hidden rooms and pools echoed, sloshed and drummed. He brushed his sleeve, and watched lint billow, red and blue molecular filaments spinning through a tissue of sun. Murky green crystals studded the ceiling, and a swarm of tiny insects explored his beard. Some kind of crimson lichen clung to the rock, and pollen-sized mites scrambled furiously over the wall's pebbly grain. The door to light was fringed with maidenhair fern, where a sheen of fresh water dripped from a seam in the cliff above.

It wasn't until he climbed out from the cave that he saw it, the print of the bear's paw in sand, where it had left the cave to slog away through the waves. How long ago? He pushed his own fingers into the sand. They made a crisp impression, the edge of his print crumbling like the bear's. The hair at the back of his head prickled, where he crouched on his hands and knees.

MORE CHILDREN

Maybe the raw plenty of the coast started it, as he tugged in the salt tang of each steamy breath, the prickle and flavor of rain. Where he stood, leaves of the alder and salal grew thick, jostled frantic in the wind, and the wind itself tasted like a salty food. Everywhere fern and fog. Everywhere a hug of rain. He rambled down the trail in a rush, humming in the rain, not sure how far he'd go.

Rain bent the branches of the red huckleberry bush across his path, rain and the thick blur of the berries, fat and crimson. As he ran, branches whipped away, and he dashed and smashed and dodged, slithered on mud and sprang over rivulets silver across the path. His lips tasted of salt sweat, and steam trailed behind him. The path lay virgin mud, and a green blur flashed around his rush. Running, he swung his head over his shoulder. With every step he left a print that filled and softened with rain. And the path ahead came sudden, bend by bend, a vivid green that split open, hazelbush, willowbush, Indian plum, and a slapped fist of berries tossing a handful of rain and swinging away where he careened. His belly burned with spunk, with hunger and lust for all the silver of the rain, for the rain shoulder, rain finger, the many bright eyes of rain. He ran and panted and steamed. He leaped and slithered and rolled and stopped to feast on the fruit of one great clusterbush leaning over, heavy with berries.

He pulled the branch to his mouth with his right paw, and nibbled berries, leaves, and rain. Rain scattered down onto his face as he pulled for more, as he suckled on rain, as he wrapped his lips around the red sour taste and crushed it, the sour nipple of the bush. Rain filled the berries, and the berries filled him, and he felt like bear, and wanted more. He wanted more flavor, more of the acid tang of this food. He wanted more days like this, more burning and fattening, more feasting. He wanted more children. He wanted to live this abundance into his own form, his own kind. He wanted rain and food and a tribe.

That night, staring into the hot light of the candle, into the shaking lick of the flame, he listened to the waves. Wind rattled branches against his tent. He knew it was a danger to feel this ready to marry.

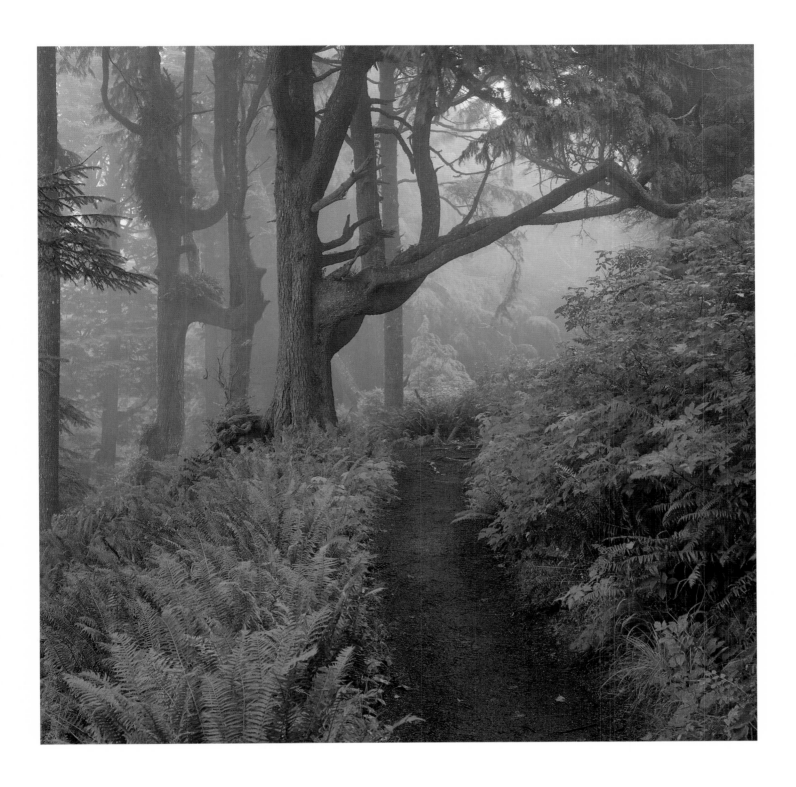

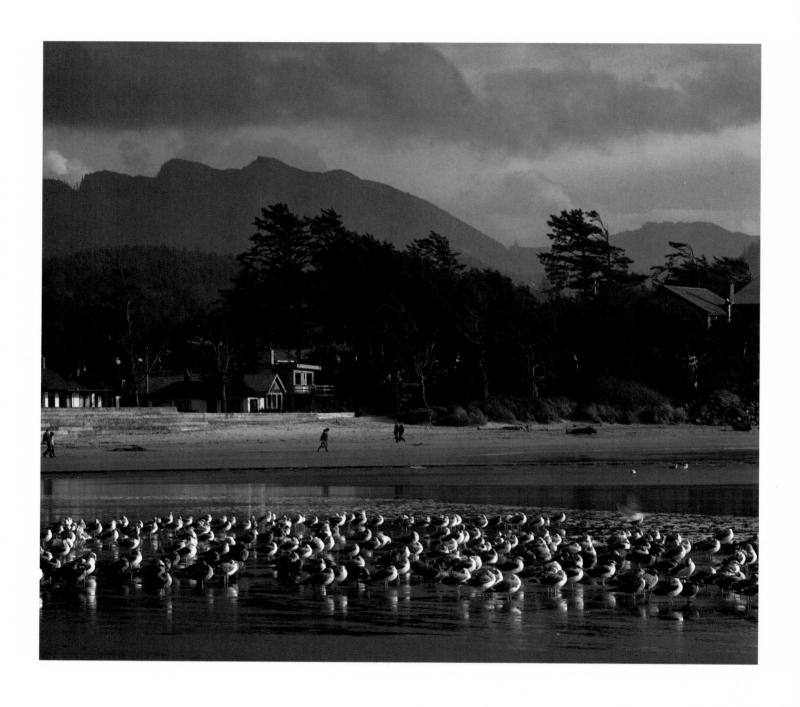

They decided to go to the coast: two women, three kids, one small sedan. There was the box of games, and noodles, cheese, extra clothes. There was the box of delicious books, for after the children were asleep, the bottle of wine. There were the sleeping bags, the road snacks, favorite cereals, sand toys, dry shoes, kite, tangle of string.

"Mom, can I take my pillow?"

"I want my pillow, too! And my bow and arrow. Is Ryder bringing his?"

"I don't know. Do you have your bowl and spoon? Jammies? Toothbrushes? Corkscrew!"

There were the jigsaw puzzles in their tattered boxes held with rubber bands, the deck of cards, the loaf and the peanut butter, the dog-gnawed Frisbee, the dog.

"Mom, when are we giving Possum a bath?"

"No time today, sweetheart. Are you all packed?"

There was the dog food to scatter into the Frisbee at night, the camp stove for economical motel life, the spatula and pan, the bag of carrots, the little boxes of raisins, the salt and pepper shakers with tape over the holes. They loaded their possessions into trunk and seat and floor of the car, and somehow managed to shoehorn the children into their car seats, with a little squeeze and a scream. There wouldn't have been room for a man, even if either woman had one.

"I smell it! I know I smell the ocean! How much farther, mom?"

"At the other end of your nap, my dear, we'll be there."

"I don't need a nap."

"You do need a nap, my dear. Now let mama drive. Adele and I have to talk a little, while you all sleep."

"Can I have another raisin box?"

"Good night, sweetheart."

It rained. Storms lashed the beach. The kids didn't care. Wet clothing hung from the motel furniture. They gave Possum a bath. They all fell asleep at 8:30. They never opened the wine. They never read their books. They got the puzzle half done. They never untangled the string. They talked about that weekend for the rest of their lives.

SKULL OF THE JELLYFISH

"Dad," said Rosemary, holding up the clear blue sphere in her hand, "sometimes you just find the skull of the jellyfish." They stood at the high tide line, where the tallest wave had sorted feathers and shells, twigs and stones, and jellyfish the size of jelly beans.

"What do you have there, little friend?" He touched the ball of light in her hand. It quivered and shone.

"The skull, dad. It's thinking about light. You can see that. And then it thinks about night, and then about stars and sparkles."

"Is it thirsty now, my friend? Time to go back in the water?"

"I'm going with it," she said, "just to the little waves." She waded in to her ankles, turned to look at him, then waded farther. A wave came churning to her knees, and he slogged closer. She dipped up a double handful of water, and studied the pool she held, her own little friend swirling there. The sun's reflection lit her face.

"Don't turn your back on the waves," he said. "They keep coming, even when you don't look." He stood close enough to grab her, but far enough so she could stand alone and feel the shove and drag of the water.

The skull of the jellyfish, he thought, the rib of the wave. A breaker rolled and tumbled, its arched back grooved and shining. His little one was watching, too.

"Dad," she said, "how old will you be when I'm a hundred?"

A fresh wave jostled her, and he held her arm, steadied her, then let go.

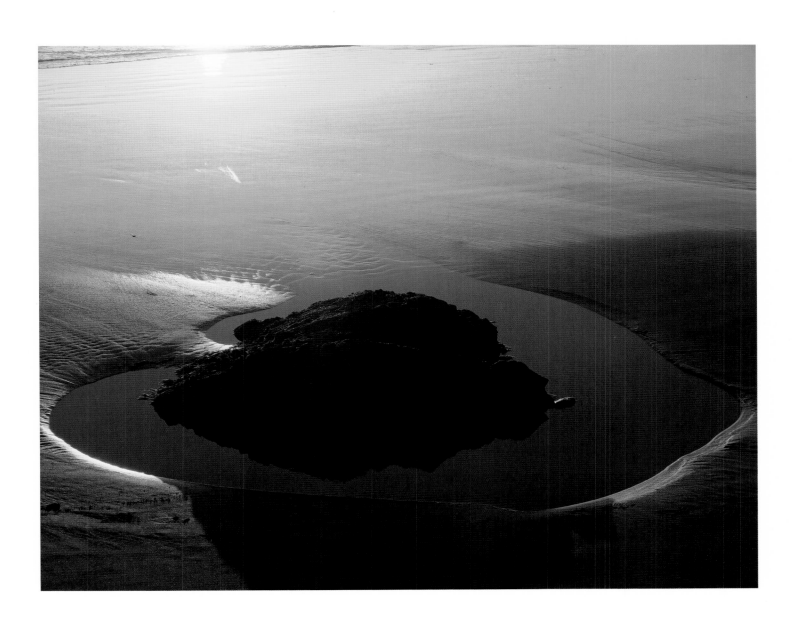

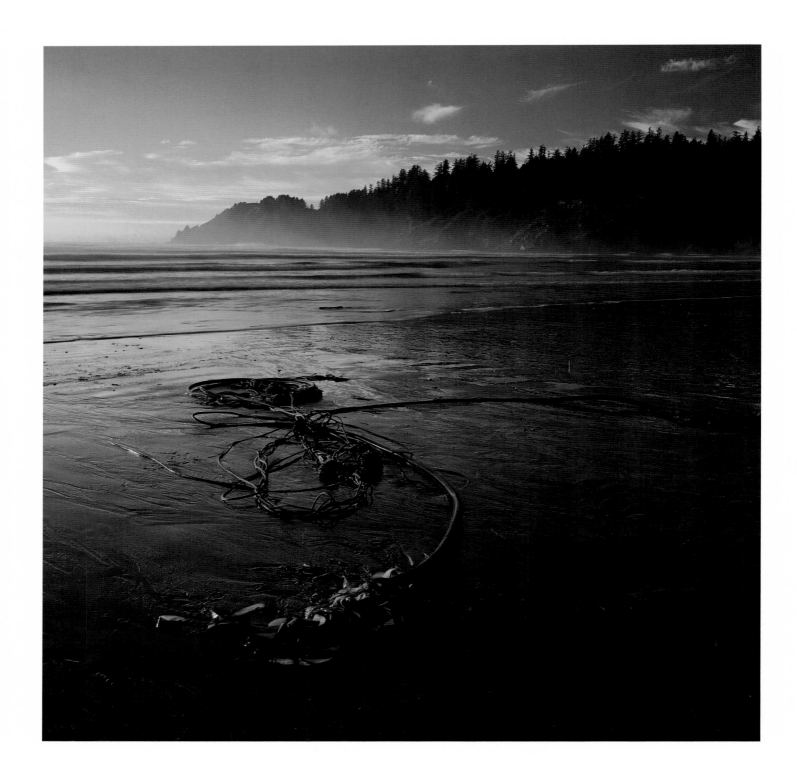

GRANDMA DEWEY

When he was a child, he thought Grandma Dewey's name came from the world of dawn. She glittered and laughed like dew, after all, and her hands touched him soft as clover. He remembered the time she told him about his grandfather, while everyone else was asleep. They sat together in the kitchen at midnight, sipping cocoa.

"Grandfather looked like you," she said. "He had trouble sleeping, too."

"Did he like shells like me?"

"That's why we came here, boy. He liked finding something so perfect free. I couldn't keep him off the beach. He'd wander up and down for hours. He had an old coat with a dozen pockets. When he got home, they all rattled and bulged. Now, boy, are you sleepy yet?"

"No," he said. "Do you miss him?" He looked into her eyes, and she looked back.

"I miss him," she said. "Now, sleep?"

"What did he do with all the shells?"

"He'd sit at the window on a rainy day, boy, cleaning his favorites with a toothbrush, running his thumbnail along a groove, testing the rim against his finger. His favorites took a polish beyond what a wave could give. He sorted them, made sets, gave them away. Mostly, he just marveled."

"And what did he do, before?"

"He was what they call a building engineer. He drew plans. He was a designer, and you're a sleepy boy." And she led him up the stairs, the dark closed around him, her hands tucked him in—and then he was grown, and she was gone.

He recalled her now, at his office in the city, because fog had closed in against the window early, and he longed to be at the coast, to listen and gaze. He longed to visit her house, but his father had sold it, and it had become a mansion with a turret, and broad, reflecting glass. He might like that house now, he thought, if it had not been hers, and small, and his memory.

He arranged the tools of the broker's trade on his desk: pencils keen as needles, yellow pad, calculator, a letter from his love tucked into

stationery from the firm. The computer arrayed his numbers, the screen showing a numerical rainbow that dazzled and invited him. He thought of Grandma Dewey's box of tiny shells, the particular set her man had left her. He remembered arranging them in rows on the window sill, sorting by color, then again by shape, then yet again by size, then by weight, and finally, in the strangest sorting of all, by beauty. He found their beauty by looking close. He arranged them in order then by the beauty of their increasing quirk, and vivid color, and swirl. Spirals had always been his prize. They came out of themselves, out of nothing, as numbers did, or the light in his love's eyes.

On his desk, the telephone buzzed. It was his love.

"This is a business call," she said. "Sit up and look serious—it's a deal worth millions: can we meet tonight by the river? I got a sitter for my little ones. Meet me there?"

"I'll be there," he said. He stared out the window, where fog swirled through shafts of sunlight, then at his screen of numbers. "And this weekend," he said, "let's forget the social calendar. Let's take your kids to the coast. We need to show them some weather, before they grow up. How about Honeyman, Tillamook, Oswald West? If the weather's bad, we'll get a room easy."

"Sounds fine," she said, "come rain or sun. It was beautiful in the storm with you alone. It will be wild with them, and fine. How's the numbers game, my love?"

He looked at the screen before him, the columns of lit numbers. "I'm sorting them by size," he said.

"I'll see you at the river," she said. "I'll bring the wine, and the cloth, and the blackberries. You bring you."

She grew still. The numbers on the screen before him shimmered. The numbers shone in an array of light, and the cursor pulsed. He listened to her listening, her silence he wanted to touch, and suddenly he knew he would be old with her. If they did it right, they would be. The years would sort them into one. He imagined the clover of her hands, the light of her eyes laughing at evening.

"Blackberries?" he said. "Better bring me some old clothes. I'll need to change."

"I'll bring the clothes," she said. "You bring the man."

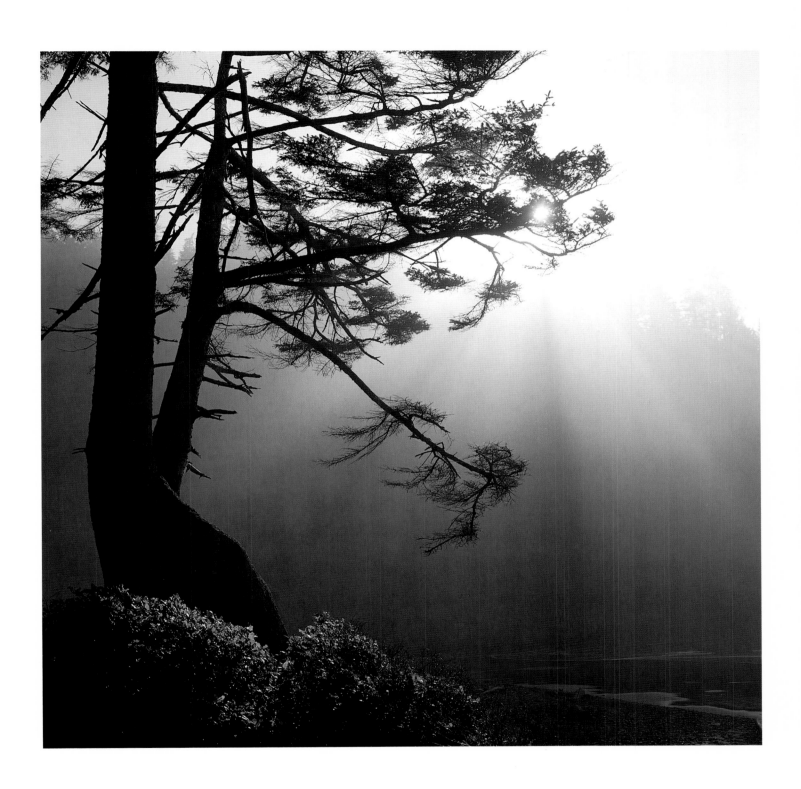

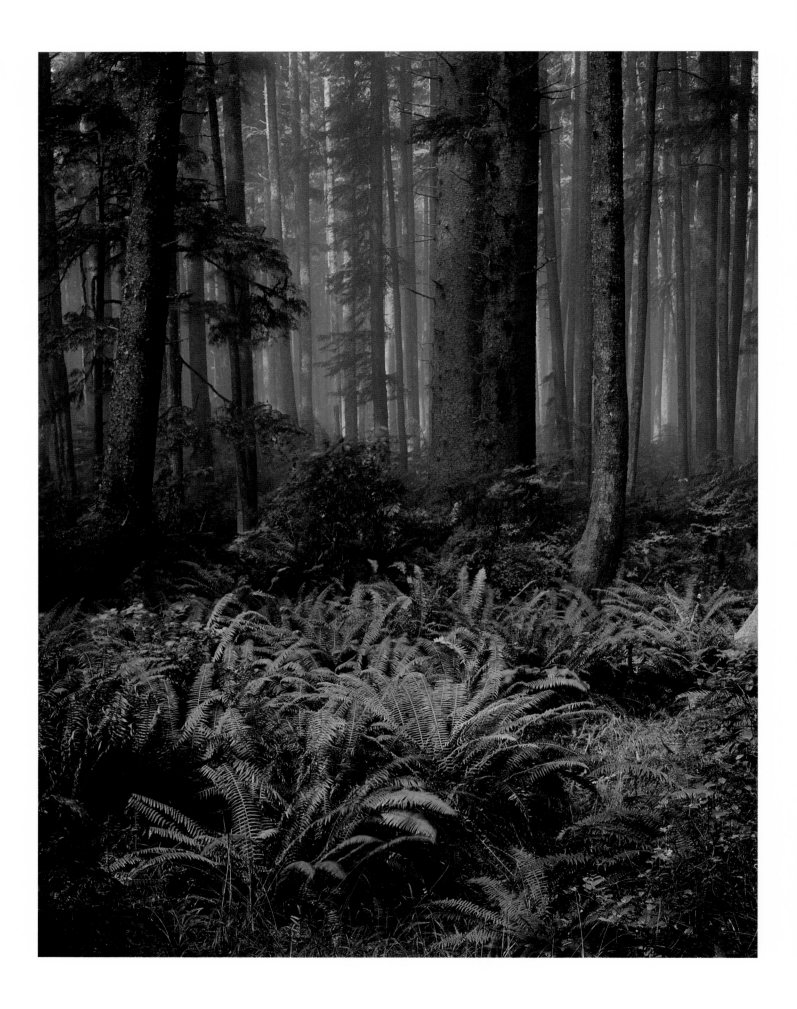

It was strange how his family let Joseph sit there all day, all summer at their special place on the Oregon coast, thinking. While they played on the beach, wading, messing with the kite, waiting for a good wind, they could see him up there on the hill, at the midden, the buried mound of shell where the Indians had lived for centuries.

"Don't dig," his father said, "but think all you like." And he liked to think. He liked to think how the people had lived there, inside the hill where he rested. Where rain had torn away a steep patch of sod, he could see into the mound, into the layers of charcoal and purple shell. He lay on his belly in the grass at the top, and studied every fragment. He saw the crescent rim of a mussel shell, the ivory tooth of a seal. He saw the leg bone of deer where it stuck out, the textured shell of the cockle woven in, the bead backbone of salmon. Then he looked down at his family on the sand.

His father was dressed in blue trunks and a flowered Hawaiian shirt, pink-rimmed shades, and a baseball cap. His mother had on her turquoise one-piece, a white shirt, and shades. She liked to let her blonde hair bleach, like when she was young. The baby lay in her basket in the shadow of a rock, asleep. He remembered his parents said the sound of the ocean soothed her.

He rolled over on his back and the sun closed his eyes. He tried to listen into the mound. He tried to hear the games of the children then, the cries of woman and man. The people had lasted season after season on this bench above the beach. Here they had carried their food from the sea, kindled fire, and lived in a cedar house. They lived naked in the rain and sun, with a cedar-bark cape for storms. They sat by the fire and made stories. Books told him something about them. The rest he knew. He knew one of them was a thinker, a boy who sat by a rock and they let him. He worked very hard, so when he sat alone, they let him. And there was a girl. She bathed alone at a pool. She dried her body with hemlock twigs and moss. They would have a house. They would have children. The house was flattened inside the mound, and the children were silent. Only the charcoal and the shells and bones remained, and he remained.

He alone had survived. They needed him to tell their story, or live their story. How could he do that? All the world had changed. People cut the forests and lamented. People scolded him and encouraged him. They told their stories loud. They had calendars so you didn't get confused, so you knew the century and the day of the week you were in. But the people in the mound had a quiet way in this place now. He would have a quiet way. He would be a peaceful man. He would be patient, a thinker. And maybe, when he was a little older, he could make a cedar house somewhere, at a secret place, lie down on a bed of fern there, and live alone.

The old land was beautiful in a plain green way, then foxglove came. Its purple spires, sometimes taller than a man, stood along the road. The seeds were tiny and black, and some said poison to the heart. Scotch broom came, too, covered the hillsides in a rush, yellow and sassy. Dandelion hitchhiked along the highways, and its winged seeds drifted up into the canyons. The brightest flowers all seemed to be foreigners. Local blooms of salal and huckleberry didn't give much show. Of course there was rhododendron. But it bloomed and was gone in the deep woods, in the fogs of spring. Foxglove taunted the summer days, right in the open.

A woman came from far away. Her hair flamed red, and she was a tall one, with sharp eyes and a laugh like sudden rain. Her name was Josephine Hamilton, and she was not used to our local ways. It took her some time to learn, and some said she took longer than she needed to. Some said she understood early, and changed her ways late, if ever. She always wore hats to protect her fiery hair and pale complexion, and a coat to her ankles when she worked out in the rain. She talked and hummed as she worked, even if you happened to be close enough to hear. Sometimes it was words of a song, sometimes lists of people names we didn't know, and sometimes a plain freshet of words we couldn't follow.

Anyway, she cultivated foxglove. She lined the split cedar fence by her house with purple that shimmered when a breeze shook the blossoms. Children liked to wear the fallen flowers on their fingers, and touch their own faces with their new, soft paws. And Josephine, she did the same.

She rode her bicycle up the North Fork road one Sunday afternoon, and Vern said he saw her talking to the trees while he was out surveying his hay, hunched down behind the willow hedge, watching her. She was standing by the road, he said, making a regular speech with elocutionary hand gestures and all, waving and reaching out toward the trees of the hill. It was only later, upon reflection, he realized she was probably scattering seed, foxglove seed. After a season or two, there was no doubt that's what she did. Everywhere she could reach by bicycle was never the same. Purple on all the side roads, spires taller than a man.

And we kept waiting for the man that could match her. The local boys simply quailed at the prospect, and strangers arrived, some said, but I guess they didn't last. She taught school awhile, then gave that up in favor of a substantial correspondence. She took in so much mail, she had to make her own mailbox out of a fancy crate, painted red. She took some occasional part in local culture, pageants and such, but kept mostly to herself. She seemed to be of independent means. Kept a big garden, lived a simple and a quiet life.

Sometimes in the evening, if you went walking just as the moon came up, out of the darkness you'd hear that laugh like sudden rain. That's Miss Josephine, we'd say, still not local, not quite accustomed to the delights of the world.

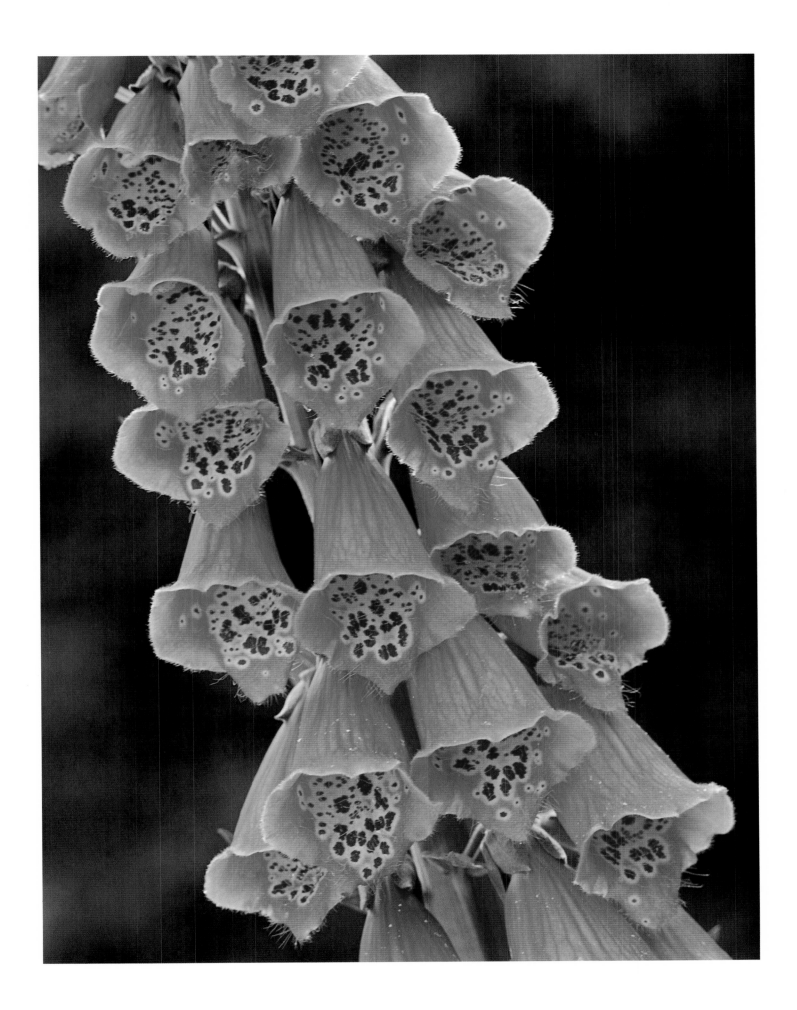

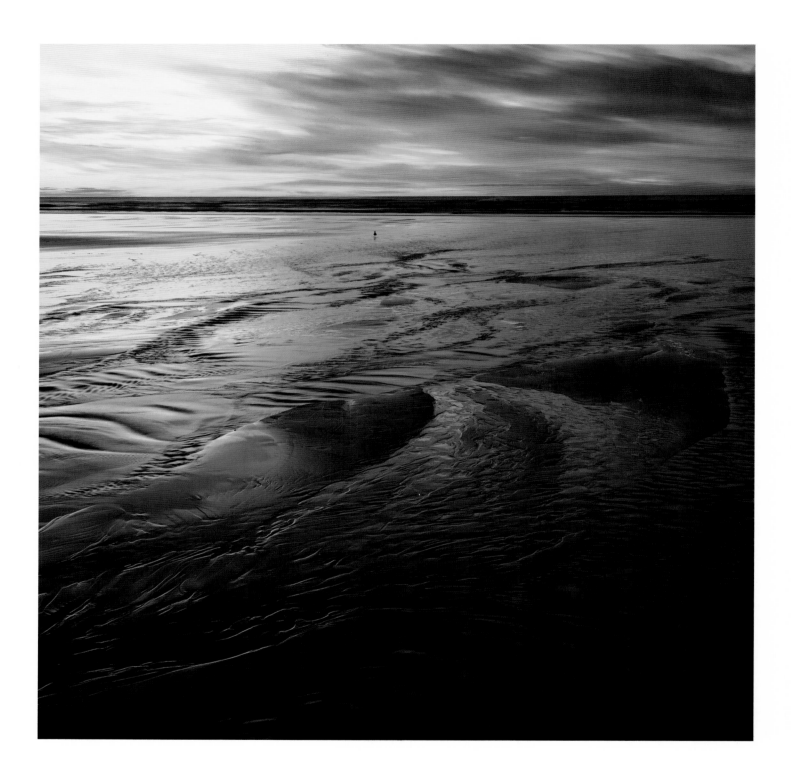

WHERE GOES THE WIND?

We had a boy named Stuart, said he could see the wind. He grew up mostly alone, after his mother died, and his father let him have his own way. When he was maybe twenty, he went to live in a little place he built up a side canyon, raising a few spuds and working out. He went higher from there often, into the crags, and came back talking about dancers, some kind of beings up there beckoning. He said he got the dust of man out of his eyes, and could see those wind women where they moved.

No one called him crazy to his face. It didn't hurt to listen. We all felt fond of the boy, so harmless and earnest. Way up in the mountains, he said, at a place in the crags, the wind begins. It takes a little turn, he said, and begins to spiral out. It's just the size of a feather at first, just a wisp and a whisper in a cave, then it begins to grow. And if you watch and are still, it turns to dancers without bodies or clothes.

Well that wasn't common, but nobody is, and people let him talk as he would. We've seen them turn cruel, and we call that crazy. But our boy Stuart, we liked his way about it, a hard worker and a dreamer all the same. What harm was it? When the hay was tall and the mowing crew working, sometimes a breeze would freshen, the hay would ripple like waves, and Stuart would hold up his hand to stop the crew. He'd be looking. The wind came in little whirls across the field. He'd smile. And when the wind went on down the canyon, he'd bend to his work again.

"What did you see, Stuart?" someone would ask.

"My dancers," he would say. "They move clean as rain."

He worked hard and kept to himself, a good hand. And for winter storms, when everyone else quit work and huddled by the stove, he often went down the canyon to the coast, would sit for hours on a drift log, watching wind come skipping over the waves. A gull's shadow was a precious thing to him when the sun broke through, and he'd turn his head when the sand rattled against his boots and cuffs. At sunset, when the sun dropped below our Oregon cloud cover and its light shot toward him, he might turn his hands over and over, washing them in that salty crimson light.

"Rayna," said Ojeda, "it's like this. Creative people are comfortable not knowing—yet." He leaned over the piano keyboard, wove the long fingers of one hand into the long fingers of the other. "You know what I mean: not yet? These two hands," he held them up palm out, "are two ways of knowing and saying things: baseline, melody. Creative people know it takes two, and that takes time."

"That sounds like the edge effect," Rayna said.

"Edge effect?"

"In biology, we call it the ecotone, the sparkish boundary between two different environments."

"Oh, like between blues and a lyric thing?"

"Or between a meadow and a dark forest."

"Between you a woman and me a man?" he said. "I got it."

"Between woman and man," she said, "between the sea and the land. You stand at the edge, you can send your mind both ways. Think of a seal."

"I'm thinking of a seal," he said, smiling, and running out a riff at the high end of the keys. "A seal in the waves, at play."

"Think of a seal," she said, "in the waves, right up at the ocean's edge, in danger. That seal can get hunted by a man, or battered by waves, when it comes to the edge. And when it goes past the edge, it's awkward out on the sand, flopping around. But when it pushes back, goes to the waves, then twenty flipper strokes out from the edge it's in deep water, safe."

"Down in deep water," Ojeda said, "safe," and he played the low notes, a sweet resolve. "I see what you mean," he said. "And say, say a little bird, a thrush bird, came out of the forest to the water's edge, right there in the open, in danger." He played the high twitter of the thrush. "Say that thrush is out where the hawk can see her, where the wind hits hard. At the boundary, at the open water's edge, that thrush is living tough, finding food, jumping around. That thrush is living on the streets. Gotta watch it. Anything can happen in the open." He played a rising threat on the black keys, softening to a question in the higher notes. "But twenty wingbeats into the forest, that thrush is safe." And he played the deeper notes of its hiding, a sweet resolve.

"The edge, Ojeda," she said, "is where things happen. The edge is a risky place, and the only place to be."

"I see what you mean," he said. "Little thrush, I see what you mean."

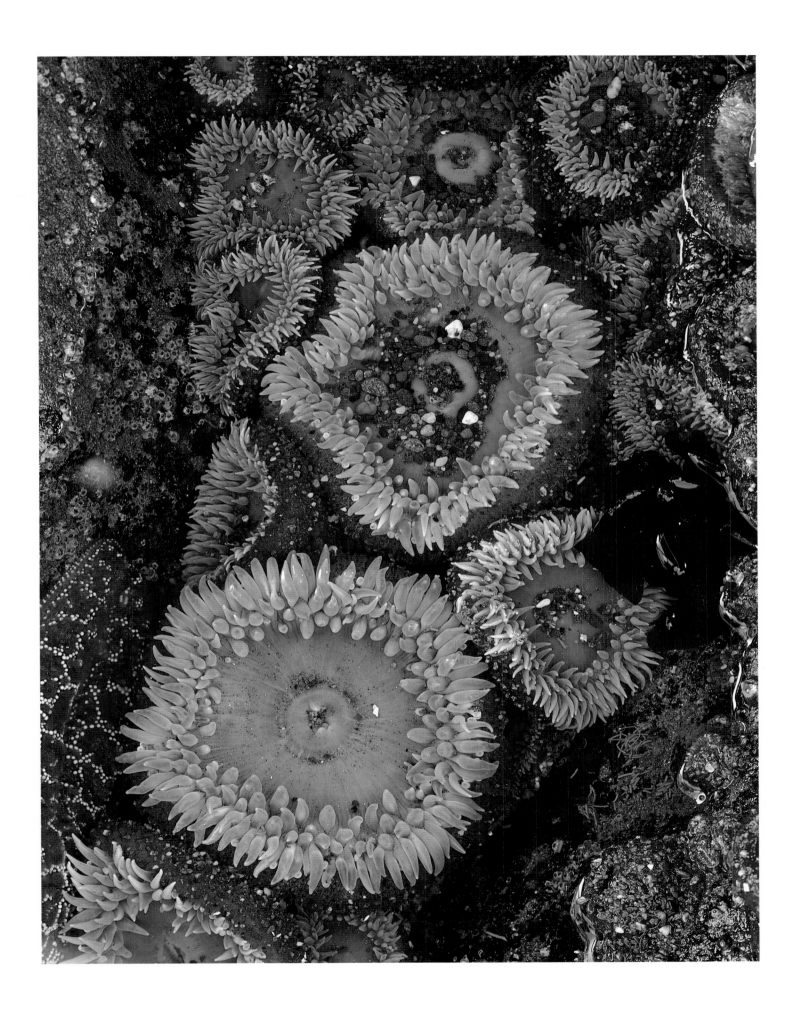

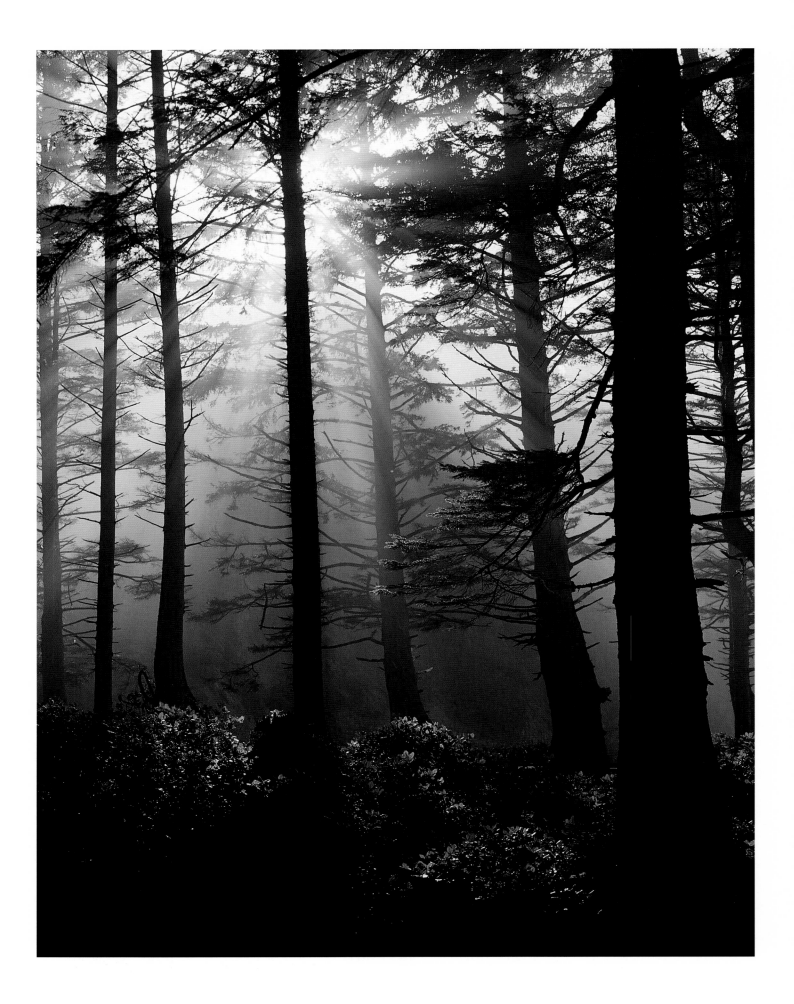

"But the finest house I ever saw," he said, "was a cedar hut by a creek, hidden at a cove south of here."

"Where was that?" she said.

"I couldn't tell you," he said. "It's pretty isolated from the road. I was lost when I came to it. I had a look around, spent some time, and got lost again before I found the road. I was just hitching through, that time. But sweet. It was a fragrant thing to be in. Some cedar pirate made it all from one log, looked like, one driftwood log sawn, split, whittled down. All handwork."

"And no one there?" she said.

"Just me. The walls were straight planks. You know that splinter texture of cedar heartwood? It was all like that, all a ripple to the finger's touch. The roof was shakes laid on rafters and anchored with smooth stones off the beach. Had a fire ring just outside the door, and a pile of mussel shells. Had a bed of fern at a corner inside, and a water dipper folded to shape out of cedar bark, hanging on a peg. It was the most amazing thing to stand inside and breathe deep. Cedar has a fragrance like burnt forest rain."

"Forest rain?"

"You could understand rain, living in a house like that. You could savor rain all winter."

"You want to savor rain?" she said. "Is that the best it could be?"

"I need to," he said. "I'm going to be on this coast all my life." He looked past her, out the cafe window to the ocean. "I knew early I will spend all my years on this coast. Rain has felt like a cousin, ever since I was in that hut."

She looked at him. "How many centuries ago did you say you found it?"

"When I was eighteen," he said, "a few decades back."

"And you built it yourself," she said, "didn't you? You built a driftwood house, and lived there." She touched his sleeve.

"I did," he said, "you got me. I built it all one summer, alone." He put his hands around his coffee cup, looked up at her. "And you," he said, "how did you survive those days?"

"By not saying a word sometimes. By walking on the beach. Just by going through years. I got worn down by a man for a time. We lived in a city house that was nothing like your cedar. It wasn't my style, but it was my life for a time. He couldn't get me out of his mind. I had to get him out of my life. I had to fill my life up with mountains and wind, up to the brim."

"Have you ever smelled cedar?" he said.

"Not from the inside," she said, "but I think I could." He reached in the pocket of his wool shirt, and pulled out a shaving of wood.

"Put that to your breath," he said, "and take it in. I haven't yet known a sweeter thing."

Me? I'm heading for L.A., or bust. Hope to ride this bike all the way down. It's downhill south, you know. All the way on the coast road. All I have in this world is my bike, my tent, my sleeping bag, and a tea kettle. I have a mission, too. I'm going to save street kids in East L.A., counsel them to stay straight, quit drugs, read the Bible, be citizens.

How do I know that's my mission? My Knower, right there in my head top. My Knower knows. My Knower told me to follow this highway until I came to the biggest city of trouble in the West, and serve there. My Knower woke me up one day, and sent me forth. Gave me a tail wind today.

Oh, I know it's raining. My Knower doesn't have to apologize for that. Trees need the rain, and I'm just passing through. Where would that ocean be without rain? Be lonely, that's where. Ocean wants to travel, too, you know. Gets bored just tossing a few waves around, getting them back. Wants to fly. You know the feeling, wanting that? The ocean wants to be an angel, too, same as all of us. Wants to slip away in secret, and be gone.

I get in a real thoughtful state, riding this road. My Knower keeps learning things to tell me. Now maybe I'll learn something from you.

How do I know, you say? If you'd stop asking me questions, I could learn something from you. Oh, how will I know when it's time to leave L.A., go back home? My Forgetter will tell me, my Forgetter right there in my head top on the *other* side. My Forgetter will wake me up one morning and say, *Mission accomplished, boy*. I'll come back up this road, maybe in the sunshine.

I used to need friends, before I tuned in on my Knower. I got lonesome, and lonesome made me follow some of life's odd little detours. You gotta watch those detours. My Knower got scrambled by sensation. You have a friend, and then you lose her, and what's the use of that? I'm on the straight road now, now that my Knower got my attention, got me connected. I don't need woman nor man, nor even a dog to chatter to. Strangers are enough. The Lord sends me plenty of strangers. But a stranger doesn't last long, I find. Here I'm already feeling you stop being stranger. You know so much about me, you're edging toward acquaintance.

No thanks, I don't need a ride. About the time you take a ride, the rain stops, and you miss that warm, steamy feel of the sun. I can't afford to miss that today, if it happens today. My Knower wouldn't forgive me, if I missed that change. My Knower saves little pleasures like that for me, just for me, all along the road.

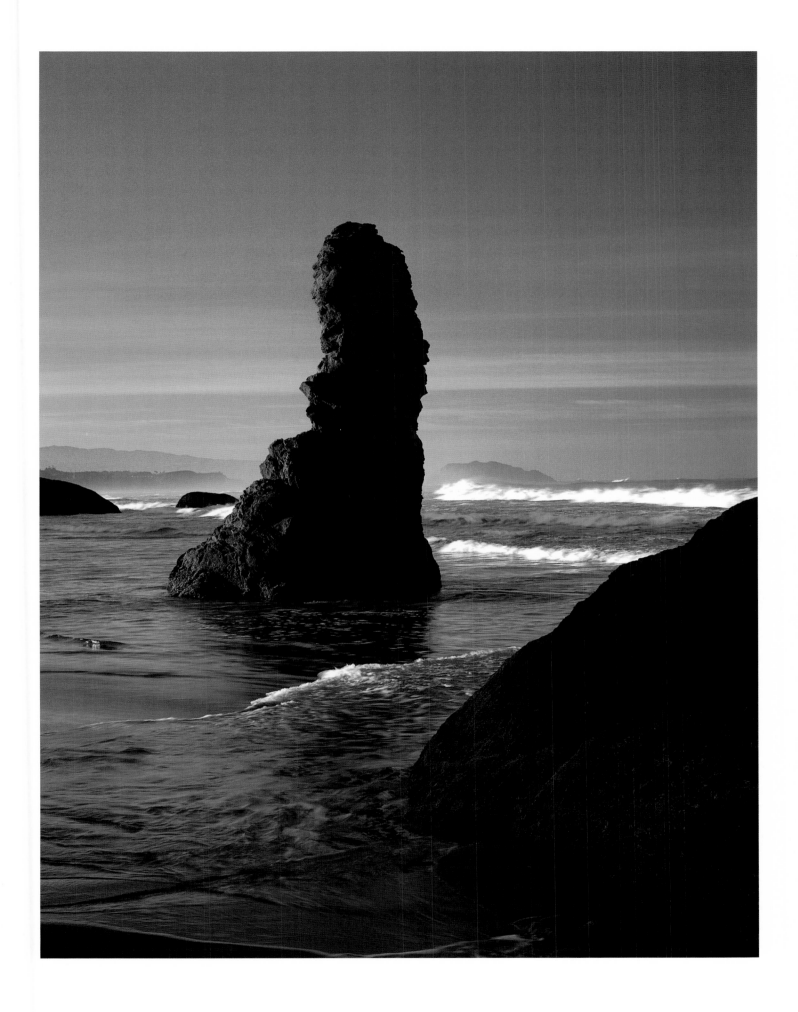

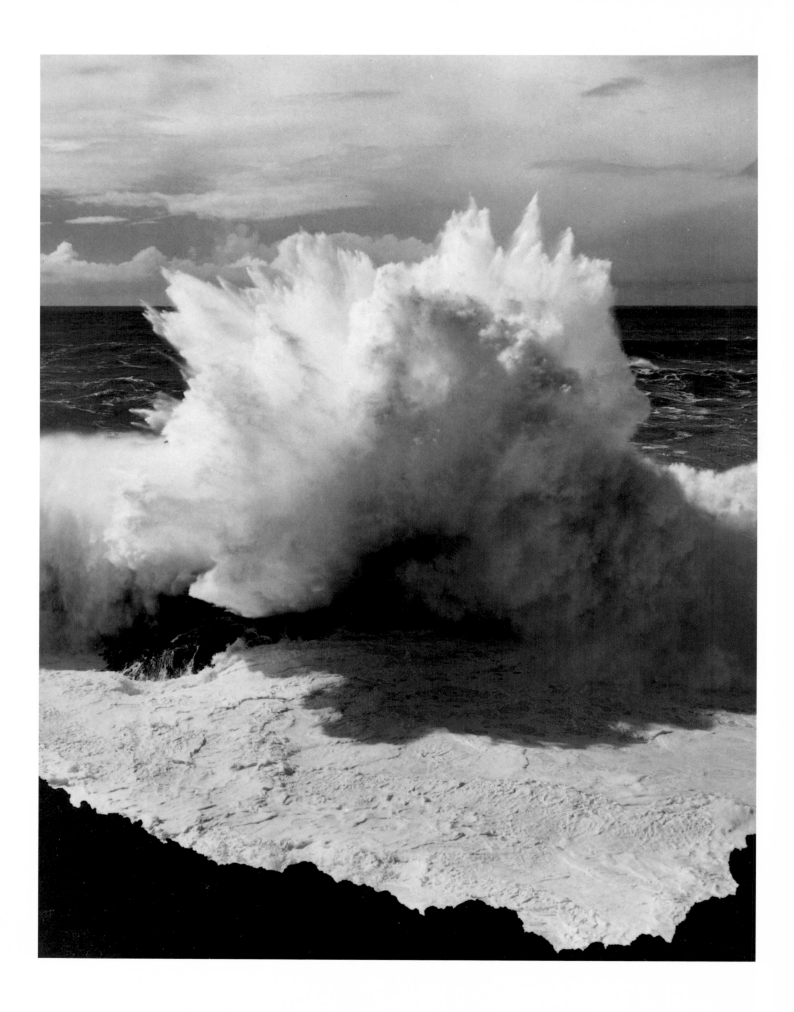

"You never felt it," he said, "so you don't know." Harold leaned back in his rocking chair and looked at me, the long white whiskers of his eyebrows tilting up. "You've never felt a ship catch wind," he said, "and heel over hard. I'm talking about a two-master, or a three with a good square mile of canvas set, the flying jib and spanker and all, all bellied fat in a fresh breeze."

"No," I said, "I'm ignorant. I haven't felt that, so you'll have to tell it to me in detail."

"Why do I have to tell you?"

"Your sister, Josie, says you're the last who knows it well."

"The last but not the best, by far. When I compare what I know about sail to what my mates knew, I feel foolish telling at all. But if Josie sent you, I guess there's no choice now, if the tale's to be told. Wind on the waves, now there's a story. When I felt a ship catch wind, crossing the bar for the open sea, I always had to dance a jig at the helm. No way to stop my feet when I felt it. "

"Your sister said I should ask about the time you sailed your schooner to the breakers."

"Now she's giving you teasers to my secrets. Just because I keep her ax filed keen doesn't mean she has to cut me back. That Josie. No wonder no man stayed. Life's an odd voyage, and the compass hard to read." He leaned back again, as if that were his last word on the subject. The clock ticked, and wind beat against the window. I had left my shoes at the door, and my feet were cold.

"And the breakers?" I said.

"The breakdown? No one dances that now. You never heard the staccato rattle of a good crew dancing on deck, so you don't know. You get a good piper and a drum, you get a well-oiled crew, you get a dance to sweat you. Fellow asked me once to teach him the steps. I couldn't do steps, I had to do it all in a rush, and I couldn't do any, so that one's gone."

"And the breakers?"

"What do you say? A fever on board when I was forty took the best of my hearing. Speak up!"

"The breakers?"

"The breakers," he said, "oh yes, the breakers. Josie always liked that story. I've brought her fancy things home, but she always asked for a story, no matter what else I had. I never did cross the pond to the Orient, but I knew the coast-wise run. We'd sail down to Escondido every season, then back home north. This wasn't so very long ago, maybe sixty years, no, seventy by now, when we sailed the Florence,

hundred-foot two-masted schooner. It was early evening, sailing wing on wing. I was just a boy of seventeen, but I had already been aboard three years, and I had the watch at the helm, with the rest of the crew below. There was a faint bit of fog, but it was still good sun, and we hadn't set our lights, so I felt I had an easy watch, when I looked ahead and saw a long, white line about a mile ahead across our bow.

"It looked to be surf, and I checked the compass: dead north. No breakers had a right to be there, square in the midst of the fairway, but we were closing fast on whatever it was. I couldn't drop the sail or swing the boom alone, without minding the stays, so I sung out for the crew. Had to bellow with all I could muster.

"They all turned out, and we put her about, just at the brink of the line. And you know what we had come to? A line of white porpoise, five deep, diving and leaping like waves in a long stripe. They never shied from us, but kept right on, and we tacked west to follow along-side. We went toward the sun, and they went with us, neat as a ship's straight wake.

"When the watch turned, I went up to hang in the bow pulpit, reach down and touch their backs. I know I told you there is nothing like the feel of a ship when it catches the wind, when you stand at the mast and feel it all take hold. Well, there was nothing like that either, the stroke of a hand on one of those white backs come surging out of the bow wave. My hands grew hard from a life at sea, but the feel of their skin was something I'll not forget.

"They stayed with us till dark, and then they scattered, and we tacked north again. I was off watch all that night, but I stood at the rail to hear the slap of water on the hull, the rattle of the haul-down against the mast, all the sounds of the living ship.

"That was the ship's last run, the Florence. We picked the wrong pilot coming into harbor, and he put her on the rocks. I haven't thought of the Florence for some years. Was a fine ship, and a handsome crew. We knew that coast, and we knew our boat. Things went easy, while our luck held good. Give us just a whisper of wind, we crowded sail and caught it. But that's all done. No more catching wind for me."

"So why don't you live at the coast all the time," I said, "if you love that wind on the waves so much?"

"It's all I can do to come here once a month," he said, "I crave it so bad. To see that wind flatten the waves in the bay, and not have a ship to ride, that's too hard on an old man." He looked down at his hands, then into my eyes. "The wife and I, once in a while we come to pay a call on Josie," he said, "we putter around a few days. Then we get back to the valley where life's a plain bore, and I can live it out."

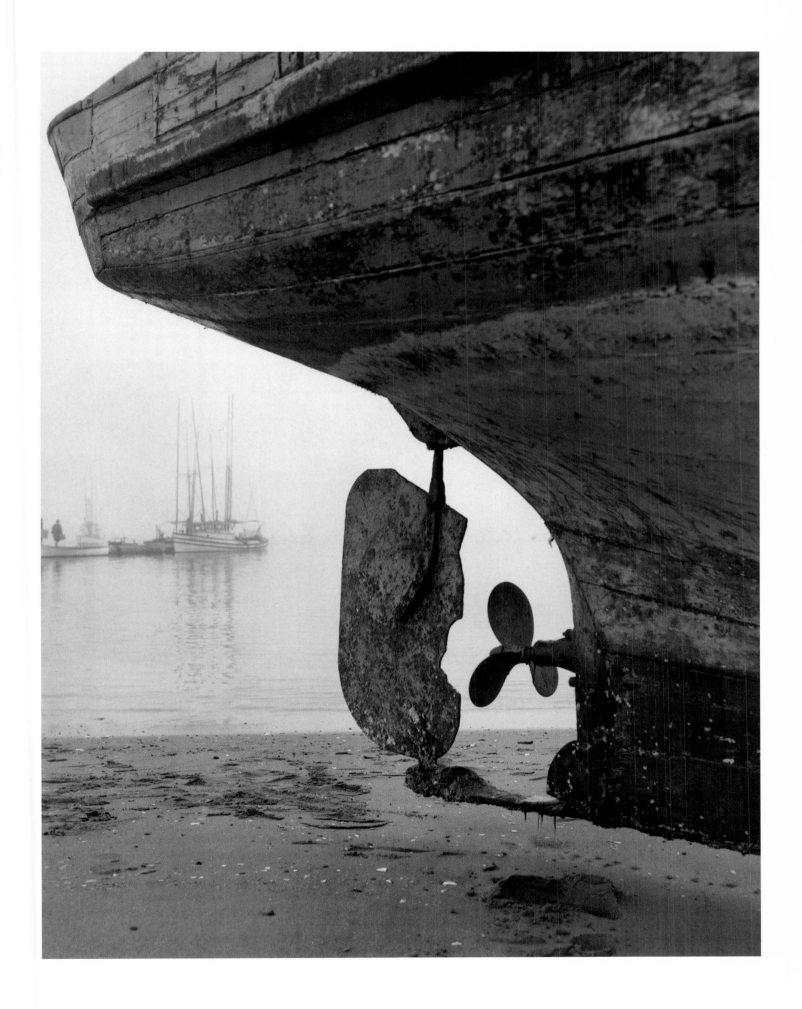

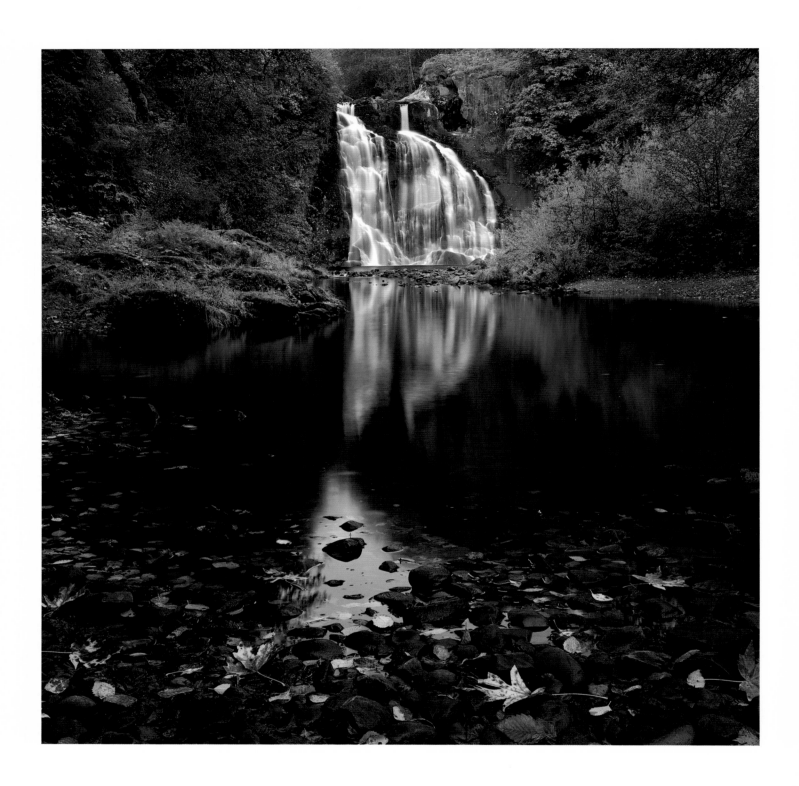

They all told Joel to go up Sweet Creek to the falls sometime in October, after a good hard rain, and he would see it. Lyndall and Pony and Pearl and Joe all said the same. He would see something of the power from the early days at that place.

He forgot about it. Some years passed, and he didn't see them often, then hardly at all. Business at the bookstore was moderate in the income zone and frenzied at the work level. Joel sat at the counter pricing books one day, when the October rain suddenly thickened on the skylight, pitched into a dense drum roll, and he remembered. He remembered the faces of those Sweet Creek people telling him. Joe and Pony were gone by then, and because they were gone, he remembered something in their faces he had not seen at the time. In his mind, Joe's face was telling him, without a word, why Sweet Creek had that name. It was a secret of the place.

If a customer did not appear in the next half hour, Joel decided, he would be gone. It was late afternoon, but maybe he could make it. The rain kept coming, but no customer. He called Susan and told her he was going for a drive. He'd be home late.

The road to Sweet Creek took him up the Siuslaw to Mapleton, across the bridge, down the south bank, and then off into the hills. He passed the homes of Pony and Lyndall and Joe and Pearl, where other people had taken up by now. New people had improved those houses, and the bright new paint make Joel heartsick.

He leaned forward at the wheel, and then he was into the green blur of the trees again. Farther up the canyon, he passed ragged orchards where homesteads had opened the narrow sunlight of a side canyon, then the road turned up into the shade of the firs, and he climbed. The road grew rutted, thinned to twin streams and mud. They hadn't mentioned the road. But Joel remembered a little glint in Pony's eye. Maybe this rutted mud was the translation of that.

He wasn't sure how he managed to find it. The salmon came back from the sea by some slender certainty of taste for water. His own way was more subtle and strange. No signs, just a hunch, a guess, a false turn on an unmarked road that turned out to be right, then off on another and backtracking from its dead-end that dwindled into scrub

growth, and then a pair of ruts through grass, a stand of alders, a fragment of meadow, and he was there.

Through the veil of rain, he saw falls jumping down a series of ledges into a pool. The rain came silver, everywhere threads of silver slanting down. He felt like a fish, climbing out of the car with water streaming off his green felt hat, blurring his glasses, fingering the yellow slicker he pulled tight around his shoulders. It was dusk, and he worked his way slowly along the bank, to where the pool seethed with a panic of silver.

A fish came lunging up, to thud against the rock wall of the falls, and drop back. Another hurtled up, struck, and fell back. It was not their strength that caught his breath. It was the punishment of the stone wall, where a few scales glinted silver, before the rain washed them away. The pool exploded as another fish came resonant through the air, dancing on its tail, then fell.

By full dark, he had not seen a single fish reach the upper stream. He leaned against the cliff there, felt the rain find a path in at his neck and down his back. It kept driving hard, soaking through his hat and softening the leather of his boots. He felt tired, felt the throb of fish hitting and falling where he leaned against wet rock. He had hit like that. When he heard the news about Joe, it was just that kind of soft thud inside him, because he thought of Pearl. And when Pony went, he thought of Lyndall. And then he thought of his own life, of Susan, the children, the bookstore, all the coming and going, and now the kids growing up. It was time to turn for home.

In the car, he cranked the engine. Again. Again. He listened to the rain on the car roof. He tried again, and just as the starter, crying, started to fade, it caught. He switched on the lights, the wipers, and started across the wet blur of the field.

Driving, he was lost again, trying to trace his own tracks, but the rain had changed it all over again, and his mind had no clear map. In the dark, in the twin ruts that turned and deepened, under the dim trees, his car hit bottom twice, and he battered down saplings that crowded the road when he slithered in mud. In all the drumming of rain and the road, a few syllables kept coming into his mouth: two good children, and Susan. Four in the world.

His hat still leaked rain. He tasted rain through his lips. The rain was sweet with the salt of his face. It was strange how much it mattered. Two good children, and Susan. Those were his words, and they tasted like rain.

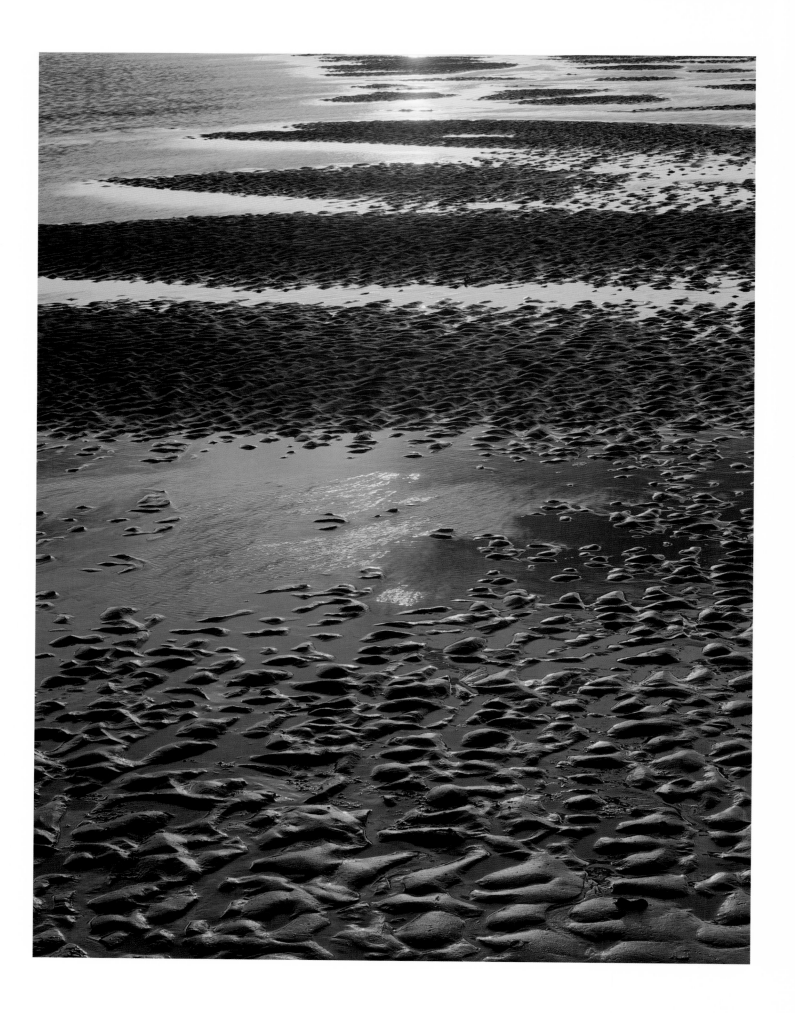

He'd been living a thrifty life lately, just work and the stereo, and a movie when he got the urge, and once in awhile a drive to the coast alone. Life had been quiet, and that was good. He kept to himself. He would cruise, in that meditative trance of the car, without a particular destination but Monday morning. He'd pass on through, town by town, passing time. But this day—maybe it was the funny play of sunlight and rain, or the glance that waitress gave him at the cafe in Wheeler, or the steamy recollections that crowded him of his more gregarious days—something started to pry him open. This day Miles couldn't resist breaking the rhythm of his drive, and checking out the estate sale as he was passing through Rockaway. The town felt to be four blocks wide and two miles long. It wasn't hard to follow the signs. Somewhere near the heart of it, he saw the sign with the arrow, and turned in at an old house with rhodies to the eaves.

Two women sat at a card table in the yard, collecting money and smoking. They had a shell for an ashtray, a conch with spikes and a pearly lip. The younger one flicked her ashes into the shell, and took a deep pull that wizened her face.

"Help yourself to a look around," she said. "Sale ends in an hour."

"Who was it?" said Miles.

"Two sisters," said the older woman, "who let things go for forty years. Lost their husbands at sea, the story is, and lived out their lives together. Have a look." She caught his eye. "Be sure to see it all," she said.

Linoleum peeled back at the threshold, where Miles stepped inside. The roof had leaked, and the ceiling had a map of stains. A heap of books, fattened by damp, lay in a corner where a bookshelf had stood. He could see the years where the couch had been, a rectangle on the wood floor without a scratch or a stain. Wires dangled from the ceiling where a chandelier had sold. Heavy curtain hung tattered by the sun.

In the first bedroom, he picked up the rumpled remains of a fine straw hat for a small head. Gauzy things hung in the closet, and a round mirror shocked him with his tarnished face. His face always looked older in an old mirror with silver peeling off the back. The bed had been stripped, and he could make out the shallow dent where a body had curled, facing the wall. He needed air.

Out the back door he found a heap of debris, swept off the porch to the grass. He sat on the cement step and squinted at the pile: skillet

with a splinter of plastic handle, yellow bath towel worn threadbare, brown rubber bands melted into a wad, a blue satin slipper with a hole at the toe. And papers, reams of junk mail spilling where the broom had fanned it out. He pulled a thin old ledger from the strata, pried it open, and read the columns of expenditures set down in pencil. Medical. Grocery. Contribution. $74.57. $27.19. $10. And on a page by itself he read two words in an old swirl script: "Lonesome Bliss." He looked up at the Scotch broom crowding the yard on all sides, the silver fur on its green pods shining, and the yellow flowers fiery in the sun.

Lonesome Bliss. He closed the book, climbed the steps, and sought out the second bedroom. Off the kitchen, around the corner, he followed a short hall to a blue door. Inside, the room was bare. No bed, no chair, no bureau, and a naked nail on each of the four walls where picture frames had left pale shadows. That must have been where the good stuff was, Miles thought. The quality. The closet held only two hangers, and a mousetrap, sprung.

Something made Miles reach to close the door, and as it swung away he caught his breath. In the corner behind it a wooden woman stared, an old ship's figurehead with climbing wooden waves that crested at her breasts, with long hair curling loose and thick across her shoulders and a coy tilted face that studied him. Only a few red chips of paint on the lips remained, and the fissured grain of the wood was salted white.

Outside, he addressed the older of the two women. "How much for the figurehead?" he said.

"We have three offers standing over a thousand," she said. "Want to make a fourth?"

"I don't make that kind of money," he said. "But I have to know, is that where it stood, in the corner of that room, when you first came in?"

"The older sister was the last to go," said the woman, "and that's just how we found it." She flicked her ash into the shell.

Driving south on Highway 101, Miles thought about lonesome bliss. He'd known his share of good times. He thought of high school, when he hitchhiked everywhere, just for the thrill of being gone. He thought of his surfing days, when bachelor felt good. He thought about rain at night. He thought about the conch filling with ash, the pearly shine at its lip, the cedar grain of that bold woman's face, her body smoothed by waves and years. He thought about that little flake of red at her lip.

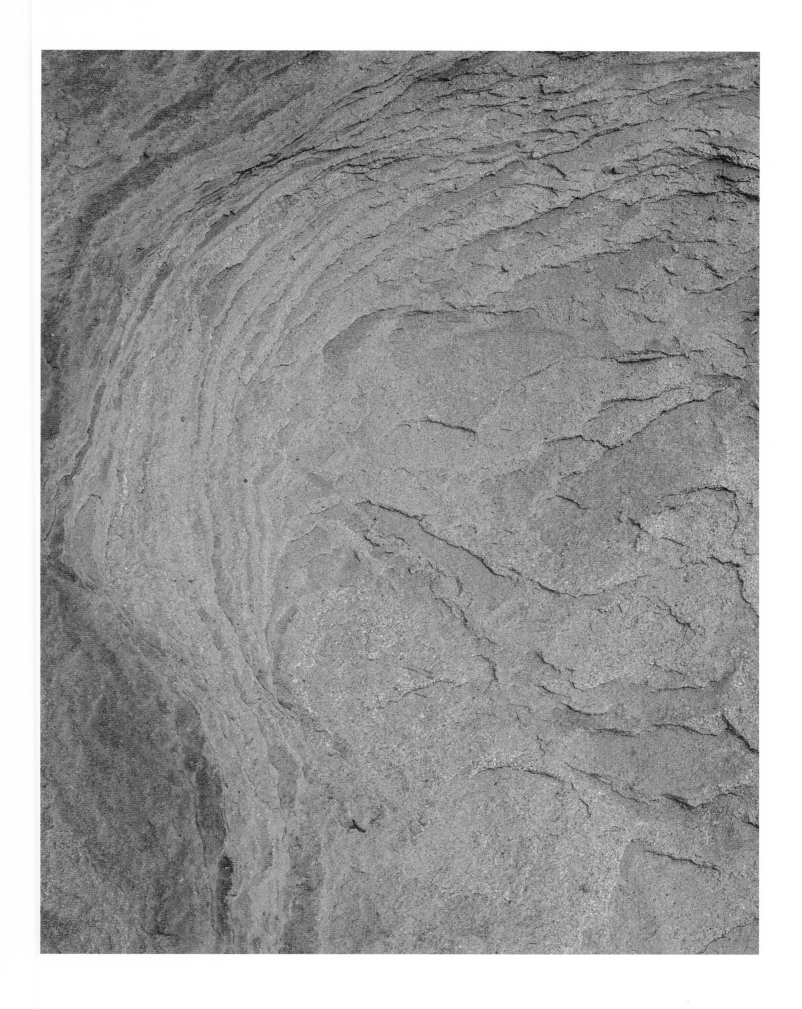

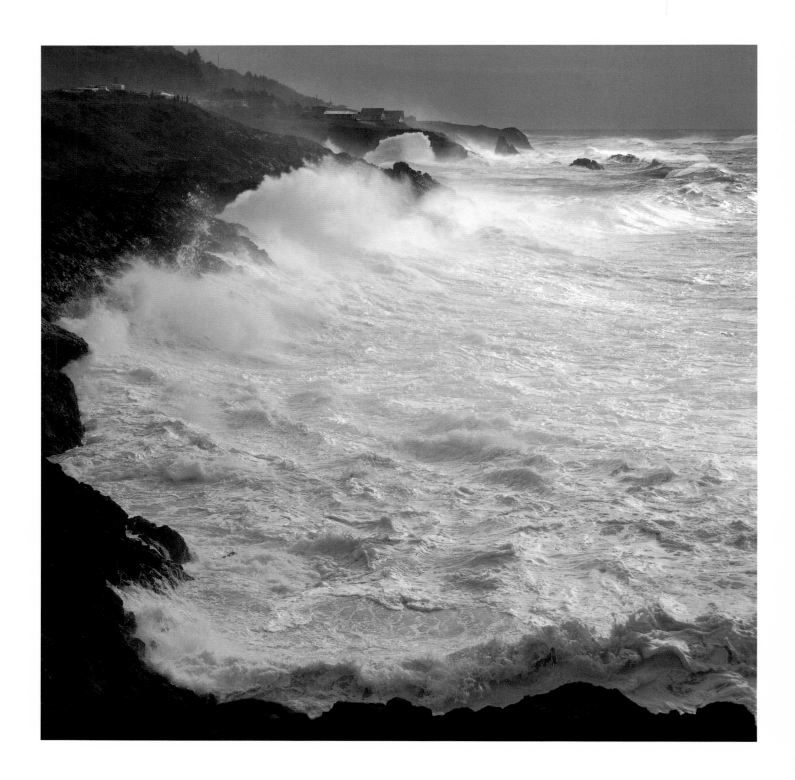

She came to the coast with her cat Plash. There was something fine about taking a long bath at a place you could hear the ocean, and she liked the cat there, purring beside her. She liked the motel because the walls were thin, the price cheap, and the tub, in room eight, on feet and huge.

In the evening, to the sound of the waves outside, she lay in the bath, with two candles burning, and Plash on the rug by the wall heater. The water was hot, and it came to her chin, and it reached into her bones. She closed her eyes and whispered, hummed a little scroll of song, felt the soft ringing of her own voice down inside the water. When she opened her eyes, all she could see was her nipples and her knees, and the candle light reflecting patterns of the water up through curling steam against the wall.

The faucet dripped, and that sent ripples out across the little sea of the bath. Plash purred, the twin flames of the candles spit and flickered, and the wave patterns on the wall reminded her she was a Queen of the Nile.

When she was a girl child, she was a Queen of the Nile. Back then, way back there, gold sun from the river waves flickered up onto the white bellies of the cottonwood leaves, where she lay in the shallows on a hot day with her best friend, another Nile Queen, in the heart of a summer before the years that divided them. The shallow water was warm there, and little waves would jostle them, where they lay hidden in their secret place, naked below the bank.

"What do you want to be," she asked her friend, "when you grow up and go away?"

"Honey, I just want to be."

"I want to be the Singer of Amen," she said.

"You want to be the Singer of Amen? Who's that, summer child?"

"I saw her in the museum, in the Egypt Room, made out of wood. She's the Pharaoh's best friend, but he leaves her alone to pray and sing."

"You want to be a nun, honey?"

"No. The Singer just sings. She's no nun, but she's beautiful. She lives in the temple, and she sings every dawn and every night. She sings for the moonrise, they said, and for the stars that turn. She sings when the Nile flood waters rise up to the steps of her temple, and then swims and sings, blessing the waters."

"Oh, you saw her museum face, and you read a little bit, and you thought she was beautiful?"

"She had blue by her eyes, and her hair was all in beads."

"And you *want* Pharaoh to leave you alone, honey? What kind of Nile Queen are you, anyway?"

"I told you, I'm the Singer of Amen. I want that life. But what do *you* want to be?"

"Summer child, you be the singer, I'll be the dancer. Honey, I'll be the song in his arms." She wrapped her arms around herself. "You stay up and sing for the moon," she said, "I'll be with him."

That was the last summer they had seen each other. Both families moved that fall, and they lost touch. One of the candles sputtered, and she felt the water of the bath holding her, and she wondered if some king had found her friend, if she was the song in his arms by now. Her friend had disappeared into the world, was gone, maybe, or maybe was living some life they had never planned.

The candle flames burned steady, side by side. She heard the staggered heartbeat of the waves outside, the syncopated drip of the faucet. She wondered where a wave started. Maybe it started way out there in a storm. But it came here, to this coast, in this moment. Tiny waves lapped her knees. A wave was like an old story, happening somewhere else, but happening here, too. It was like her friend, breaking against her from far away.

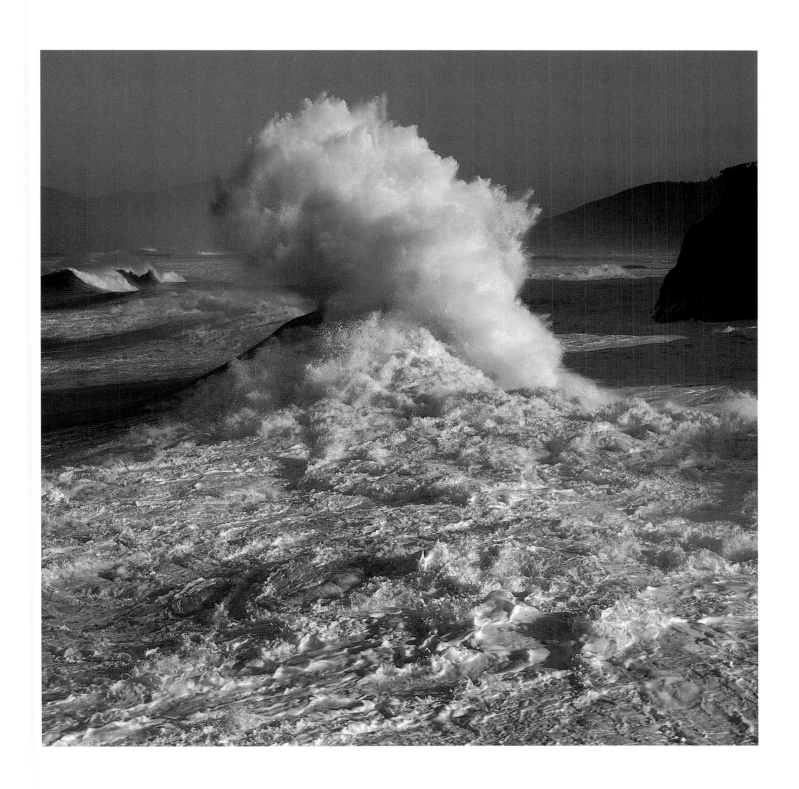

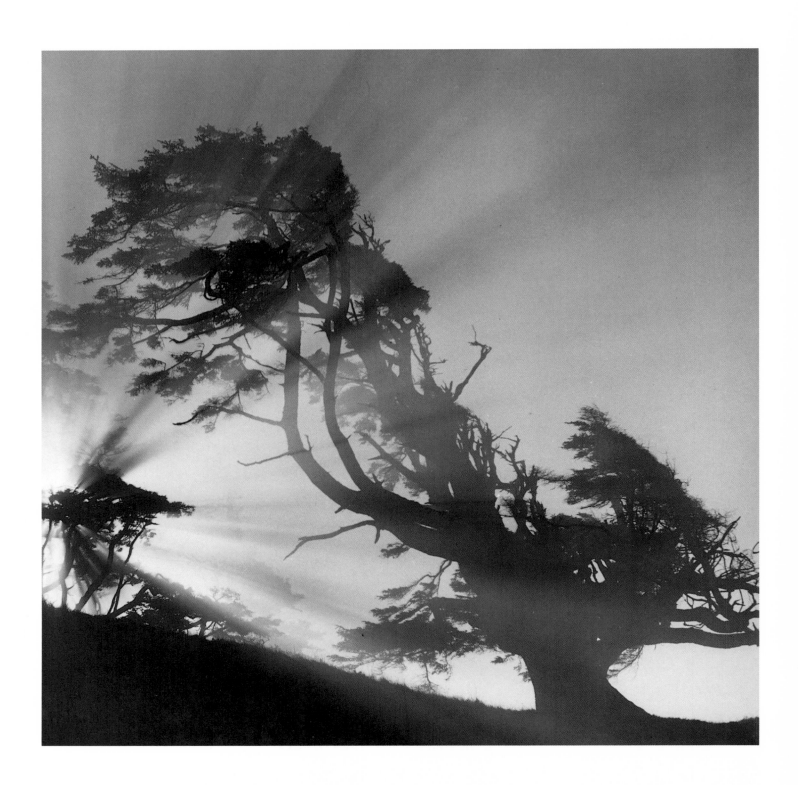

He was going along. He was looking for the power of the world. People said to him, "If you walk the path out that cape, if you follow that trail beyond the trees, you will come to the listening place." He asked them what was there. "Close your eyes there," they said. "It is a place to be still, and think of Loon."

"And if I think of her," he asked them, "will she appear to me?" He had heard stories about her, her gifts and warnings.

"That depends on whether you are afraid."

He left them. He went out that path, out beyond the huckleberry fields. It was raining, but he went. He went beyond the shelter of the forest. He went out to where the wind was strong. He had to watch his footing at the edge of the cliff. There he sat down and listened. He closed his eyes. The rain stopped, the sun warmed his shoulders. The wind touched his face like a wing.

He heard the waves against the rocks at that place. He heard the trees make a sound like water when the wind went through them. He started to feel the power of the world in everything around him. Pretty soon, he heard a bird calling from a sheltered place down by the water. He wondered if that could be Loon. He expected her to come out and greet him. He opened his eyes. All he saw was the place as it was.

"I wonder if I am being afraid," he thought. He looked around. Some trees had become twisted by growing against the wind. Their branches started to go up toward the light, but then they turned and went into the shadows. They had learned to be afraid. Below, the rocks were broken where the waves struck them. He watched a wave come through, climb over the rocks, and go on toward the land. The rocks did not look afraid, but they kept getting smaller. The biggest rock was only an ancestor of sand. It would have many children and be gone.

He looked into a little canyon to the side, a hidden place. Sometimes, a hazel bush shook by itself there, or a single spruce would quiver. Something touched it alone. He closed his eyes again. "I will

not open my eyes until I hear Loon," he told himself. And so, he sat there all that day, until it was night. He counted the waves, until he lost track. He grew thirsty. His throat swallowed nothing, again and again. He thought the moon must have risen. He listened to the wind rattling the salal leaves.

It happened that an old woman was living alone there, in the forest off the path. Because she was blind, she would go down to the beach in the dark to gather mussels, when no one would bother her. She only needed enough for herself, only what she could carry to her hut to steam. She would also gather seaweed to cover the mussels while they cooked. It only took a little to keep her alive. She had learned that secret young.

Coming back along the trail with her basket, she stopped to rest behind an old cedar tree. It was the place she always stopped. She did not know he was sitting below there.

He felt the power of the world come up like the tide. He felt it rising, heard steps. He opened his eyes. In the dark, one of the trees looked like Loon, a snag with a beak. He addressed it.

"I am not afraid," he said. "You are bigger and older than me, but I am not afraid. I have been waiting and fasting."

"Not enough," said the old woman. Her voice sounded like a raven's, not a loon's.

"You sound like a raven," he said.

"What do you want?" she said.

"I want the power of the world."

"And what will you do when you have it?"

"When I have it," he said, "I will know."

"You will teach it to others," she said. "Hold out your hands." She stepped from behind the tree, and placed the shell of a mussel in his right hand, and a hank of seaweed in his left. The clouds parted, and moonlight streamed over her face. She picked up her basket to go.

"You are only an old woman," he said, "and you have given me common things."

"You are holding the power of the world," she said. "I have given it. I will not explain it. That is all."

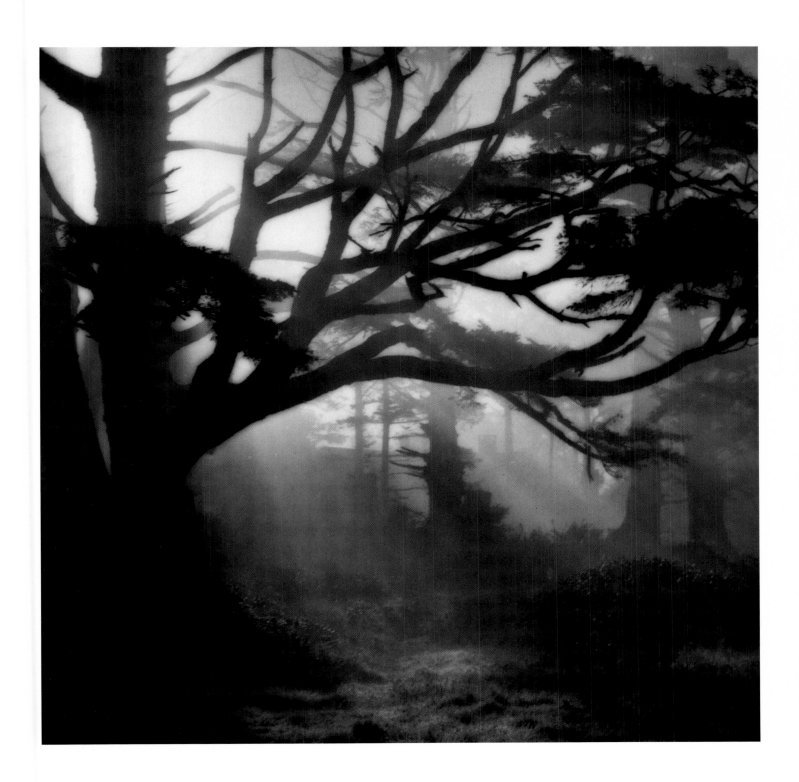

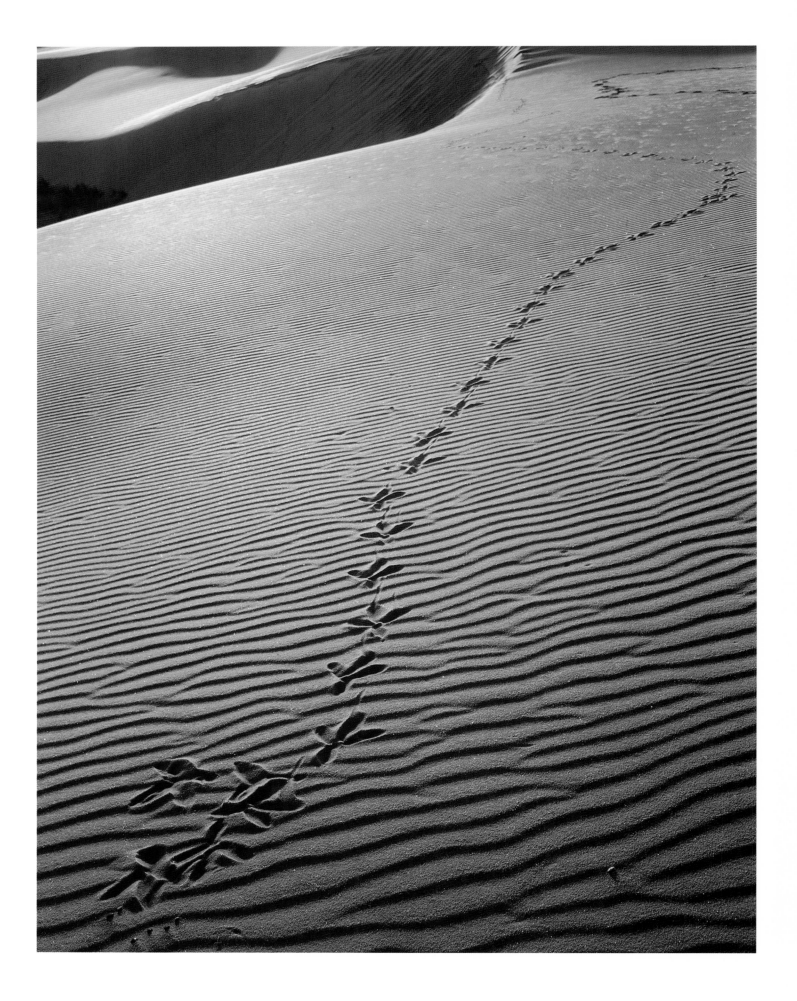

Adele Dewey, ornithologist, age 14, had never seen an osprey, and there were two. They came over the crest of a dune as she melted into a thicket. She wanted to see them unafraid, see them intimate. One settled at the top of a pine, and its mate soared tight circles over a dark pool in the dunes. As it looped and swung back against the wind, its call was filled with the sound of K.

She was afraid to move, though the tips of dune grass needled her back where she crouched. Her legs ached, from the way she had folded them quickly into low salal. Surely the ospreys knew she was there, where her eyes peered out through the leaves. But maybe not. Maybe this was a courtship display, and they had eyes only for each other.

The hawk in the pine shifted and bobbed, and the other flapped its wings, hovering exactly in place. Adele stared without blinking or breathing. She knew as long as the surface of the pool was wrinkled by wind, the hawk couldn't see fish. But then the wind stalled, the water flattened, and the hawk pulled its wings in tight and dove. It hit the water with a blow, then struggled out, flapped away in a rising spiral. Its wings scattered spray, and it muscled up to soaring space, and circled. Its talons held nothing. The wind had risen, and the hawk's wings bent tight at the elbow. Its mate hunched low on the bare branch.

Adele's breath came fast. That blow to the water, that rising with no grace, having nothing but wings and a cry and a mate all caught her by the heart. Was it better to do what you hate and be rich, she thought, or do what you love and be poor? She knew what she loved. She had no choice but the birds.

Her feet were wet. The others would be waking soon. She had almost trained them not to worry until noon. The dunes kept changing. She could get lost and not find a road. Then she could look at the sun, and figure out somehow how to find camp. When the hawks flew off, she would stand and ramble. She looked up at the osprey shuddering against the wind, and then at the dark clump of its mate. They trusted the wind, and each other. They were fully osprey. Someday she would be fully herself. Her body would be more like a woman. She would follow the birds wherever they lived. Maybe another would be on that path. Or maybe not.

Between the green rims of salal leaves, Adele felt the poised frenzy of the bird. In its blur, it was the size of her life. The wind grew still, and the osprey clenched its wings to dive.

Your surf launch is still one of the craziest ways to go, but it's the only way I choose to go. I want to be out there, and we live here, and there's no bay or river, so that's how we do it. We have our own kin now. Our families have mostly abandoned us, it's so wild. They see the launch once, and we're disowned. You're different. I could see it in your eyes, cousin, when we came skidding back onto the beach that first time. We're family, the ones that go out. You get your dory boat broadside, wave coming on, you got a problem. Motor dies, current sweeps your bow around, you get that feel in your gut for trouble. Lost the whole pulpit of the wheel one time. It only takes one wave.

I'm telling you this to get you scared. You shouldn't let Ryder come along unless you're sure. Coffee? Yeah, I guess, black. I used to surfboard, you know. That was in the years your side of the family got back to Texas, and stayed. I don't suppose they told you much about my surfing days. I used to play with waves, until a bull sea lion taught me respect. No, didn't hurt me. That was ten years back. Then I met Hannah. She knew more about the sea from a season fishing than I learned in a dozen years fooling around on my board. I put it in the nickel ads, and it was gone in a day. Some young fool. Hannah and me, we've had that boat now three seasons, our sixteen footer. The salmon season has got so unpredictable, though, it's hard to make a go.

Sure, I'll have pie, if you're buying. But listen, do you really think Ryder's old enough? I know he can swim, but does he scare easy?

Peach, I guess. Peach ala mode. I know he's twelve, and I know he's a worker. I've seen him stack wood. He's good, once he decides and gets going. But I have to know about him on a boat. We have some kind of trouble about one time in ten, take on water, or heel over at the launch and lose some gear over the side. The biggest trouble we ever had was when we caught too many fish, got loaded deep and hit the sand too early coming onto the beach. That hardly ever happens though.

Haven't I scared you yet? Yeah. Yeah, I know. I know life only happens once. I know I've just about made him crazy with my talk about out there. He never got over that about the sunfish. The way he stroked that big Chinook yesterday, I knew he was hooked.

Okay. I warned you. You win. The tide runs right at 6 A.M., and we launch sometime in that next half hour. That's what it'll be, then: Hannah, me, Ryder, and you.

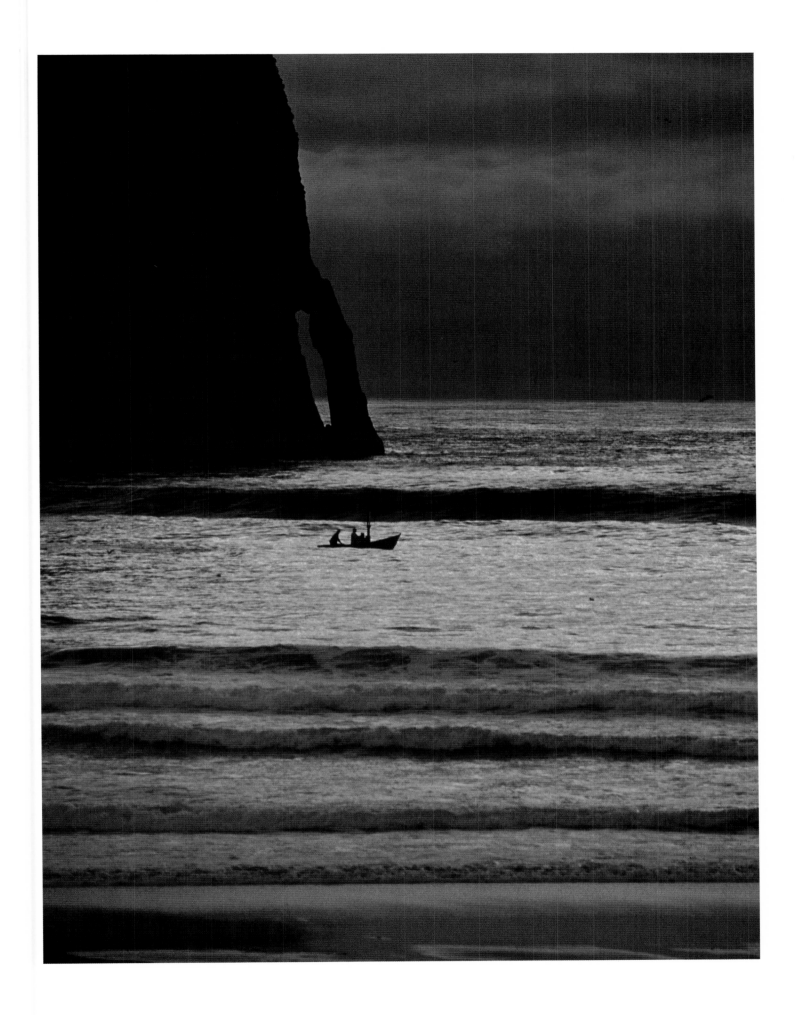

"Don't worry about that rain, honey. We're snug. What do you say we just keep cozy in bed, read field guides, and hope it lets up?"

"Fine, babe. You do eelgrass, I'll do clams. I'm thrilled. But why does room number two have to be the one with no TV?"

"TV? You're kidding. You'd come to the beach to watch TV? We're here for the ocean, not the soaps. The lowest tide isn't until tomorrow anyway. The tidepools ought to be great then. A motel day won't hurt us. We have books."

"I can't believe how small this room is. There's barely a slot to walk past the bed."

"Hey, sweetheart, come sit and burrow into a book. This isn't so bad."

"We drove all the way down here to sit and burrow into a book?"

"I did. Why fight it? Hop in bed. What's the matter with you?"

"I just find this little hideaway a bit bleak, that's all."

"Listen to this, crabby. The Thick-clawed Porcelain Crabs are 'usually found in pairs, living in a nook from which they have grown too large to escape.' Isn't that something?"

"What kind of nook?"

"'Under rocks, in kelp holdfasts and holes left by boring clams.' Want to see the photograph? *Pachycheles rudis.*"

"Boring clams? I've got to get out of here."

"Hey, relax. Be cool."

"No. You get out of bed and let's go eat."

"I brought plenty of snacks, honey. They're in that box, under the suitcase."

"I don't want snacks, I want food. I don't want to be cool, I want to sunbathe."

"Will you quit pacing? Come snuggle."

"I don't want to quit pacing."

"You don't have to go on a big power trip just because it's raining."

"You call this a big power trip? Baby, this is small time."

"Hey, Mister Big-Time, calm down."

"It's really coming down out there, isn't it? Room number two. I'll never forget this room."

"Look at this incredible photo of the Purple Urchin. The book says, 'These urchins often live in rounded depressions in the rock, which they slowly erode with their teeth and spines.' I want to see that. Think the tide tomorrow will go low enough?"

"Look around, Babe. Depression number two. Our little hideaway."

"No, you look around. Look at me for a change, Mister. We're in this together."

"Watch your step, sweetheart. The woods is slick after a rain." Last night's gale had snapped off the big hemlock trunk eight feet above the ground, leaving a fuzz of splinter that caught the sunlight. The old man led his granddaughter up from the yard to see it. Steam rose from the earth, and rainwater glittered from the leaves of the huckleberry.

They climbed over downfall, and waded through sword fern that spangled and swayed. "Just look at that trunk," he said. "All sound wood, but it just got too tall, I guess, and couldn't bend. Here, let's get you standing on one of these big roots. That's right. You're going to be tall as Grandpa in no time." He had lifted her into a patch of sunlight, and her hair shone. She squinted at the old man.

"Grandpa, what happened to mom?"

"Sylvia—your mother, your mother got tired, sweetheart. She worked so hard for you, for all of us, she just got to where she had to rest. And it's good to rest. She's getting a good rest now. They're taking real good care of her, you know."

"Will she be home tomorrow?"

"I can't say tomorrow, but before long. Pretty soon now, she'll be back with us. My golly, look at all these little trees. Didn't you think that fuzz was just moss? It's all little hemlocks reaching for the light." He brushed them like fur, and watched them spring back.

"Did you ever get tired, grandpa, like mom?"

"I got plenty tired lots of times, but not quite like your mother. She's strong, you know. I'd say she's stronger than I ever was. She's done things I never did. I'm sure she'll tell you about it, when you're older." He looked down at her, perched on the stump's root in her denims and tennis shoes. "Sweetheart, are you getting cold? Do you want to go back? We'll get grandma to fix us some hot chocolate."

"I don't want hot chocolate. I want mom."

"And she wants you, sweetheart. And she's going to have you, once she grows a little bit. That's the magic thing, you know—how things grow?"

She scrambled farther up the tree trunk toward where it ended. "Grandpa," she said, "this tree broke."

"Yes, little one, it did. Remember the wind last night? Look how it made a hole in the forest to let in the sun. The sun's all over us. That's its job. And it's our job to feel it. Now we're warm. Are you warm? I'm warm. Let's go back and start the day. See what happens."

"What happens if she doesn't grow?"

"She's gonna grow, sweetheart. She has to. If she doesn't . . . I guess you will. You'll grow up, and it will be up to us."

"I'm already grown up."

"I can see that, little woman. Now come on down before you fall."

"Not yet, grandpa. From up here, I can see everywhere."

"Can you see me waiting for you?"

"Yes," she said. She was looking far away.

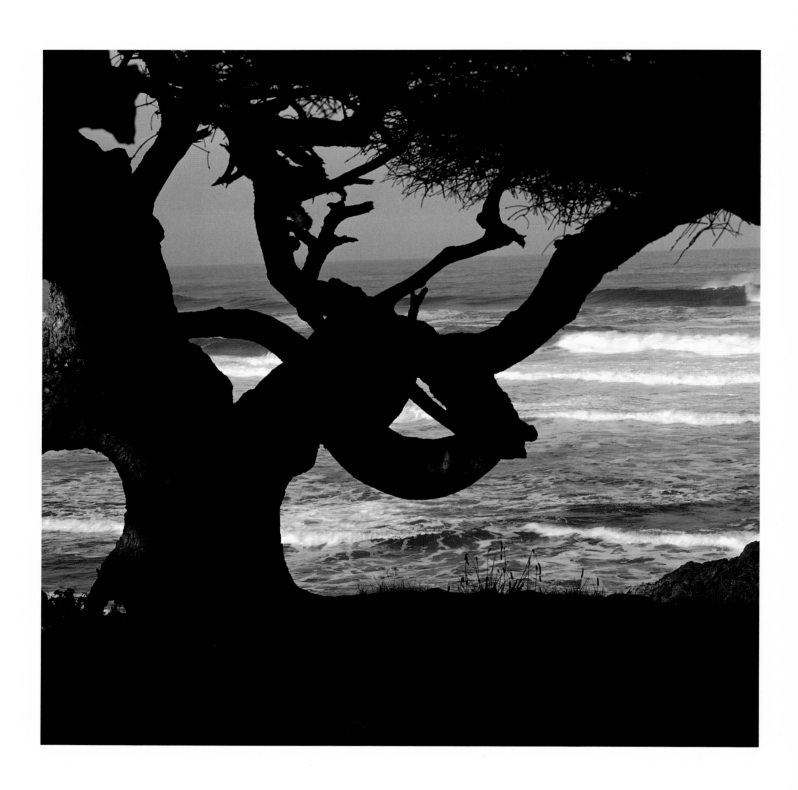

"So far," said the ornithologist to the four ladies in his party, "we know seven calls of the owl, seven messages. We know the owl tribe still has many secrets, but so far we have learned these first seven."

They stood in a circle about him, at the top of the headland, waiting. It was early summer, and the evening was warm. Butterflies flickered across the meadow, and far below the waves whispered against the cliffs. They were four women who had outlived their men, and found solace together, touring along the coast. The wind caught at their white hair, and they looked around at each other, and sometimes one would swivel on her ankles to look off into the darkening trees, or down the spine of the ridge to the sea.

"Sometimes," said the man, "a female owl says, 'Leave me–I will hunt alone.' This is in the fall, when there are plenty of mice, and the young have flown." The ornithologist raised his arms bent tight at the elbows, as if diving to attack. His face withered into anger, then softened.

"Then sometimes," he said, "the male replies, 'Are you sure you want to hunt alone?' He makes this call from a safe distance." He gave the nearest lady, Lyndall, a plaintive look. All the women laughed, except Lyndall, who closed her eyes, and lowered her head and smiled.

"Then, in deep winter, our owl woman says, 'Please feed me sweet things.' She's hungry then, and needs him."

"Then the male may reply, 'I have alighted.' This is his way of saying they are of one mind. Beginning in February along this coast, we hear that call pretty often in the wild." He looked around at the women. "I have alighted," he said. His voice was growing softer as darkness gathered, and the women moved closer about him.

"And then the female may say, 'I love what you have brought me.' He brings her a mouse, and she makes that soft call. We have to go out in the snow to hear her speak that. Then the female begins to brood, and we need to be very close to hear the call she makes over

the eggs. It seems to mean 'Hatch, little ones.' It's a very quiet and continuous call, from inside the hollow of the nest."

"And there is one last call. You may hear it when you walk in the forest alone where an owl has perched. It seems to mean, 'I'm over here. You're over there.' It's not a threat to an intruder, and it's not an invitation to a mate. It just seems to mean, 'I'm here, you're there, and that's how it is.' They make this call any time of the year, when they are in that mood. World-wide, it's a little-known call, my specialty. I've tried it so often here on the headland, the local owl population has taken a fancy to it. We can't tell anymore whether they use it often in the wild here, or if they have developed the frequent habit in response to me."

The four women looked at each other again, and one of them said, "Will you give the calls for us, what they sound like? Can you imitate the calls themselves?"

"I'd like to, ladies," said the man, "but I'm afraid I can't. You see, if these calls got into the wrong hands, some hunters would call in the owls and shoot them. That's been a problem here. So the scientists and the owls have to keep the language to themselves."

"Just one call?" The one named Lyndall touched his sleeve. "We won't tell."

"Promise?" He looked around the circle. They all nodded. He closed his eyes, brought his arms down to his sides, took a deep breath. Two little bell notes came out of him, then again. Then he opened his eyes. "I'm over here, you're over there," he said. He held out his hands for them to be silent. The sun was gone, and long shadows reached to where they stood. There was silence, and the wind whispered in the spruce, and then from down the slope, they heard two little bell notes answer back. Not all of them could hear, but a few could.

And after that day, whenever Lyndall had trouble falling asleep in her house alone, she would listen to the waves outside. She would listen to the waves, and think back, and try to give that little bleat, those two bell notes, murmuring in bed, "I'm over here, you're over there, and that's how it is."

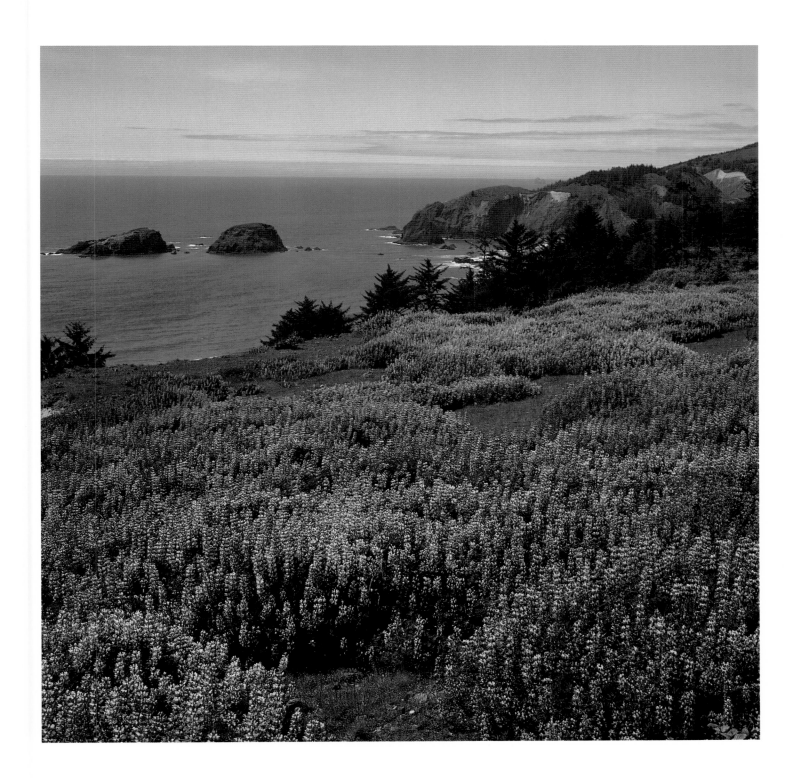

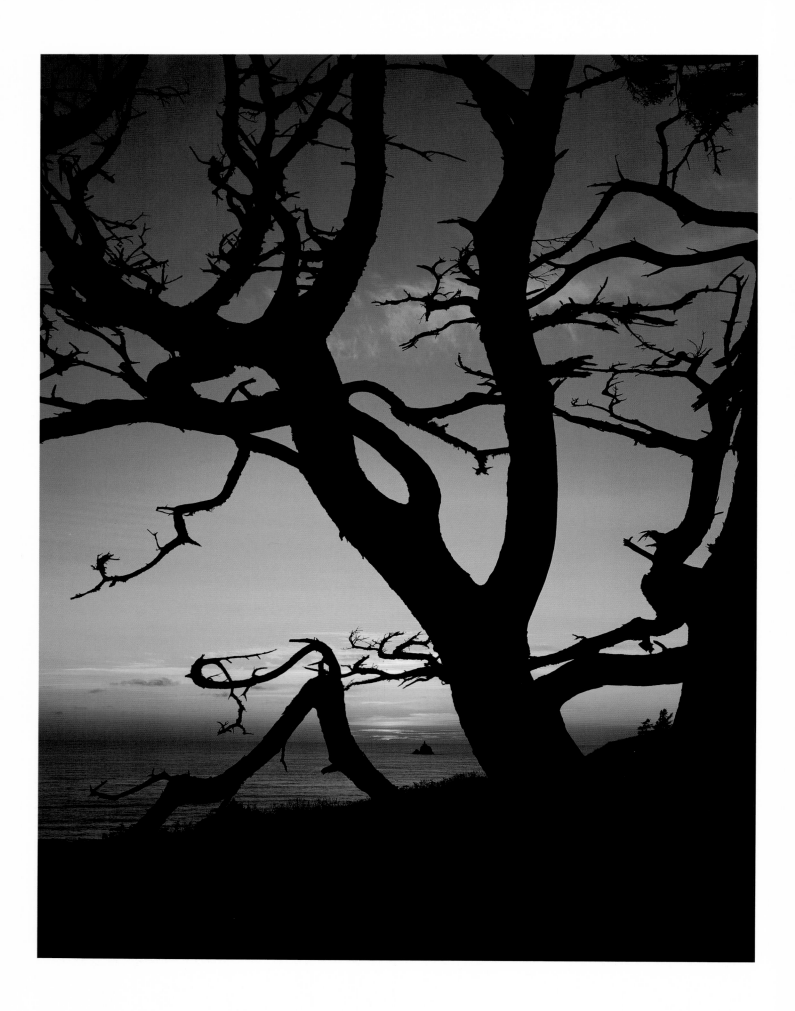

Sean had his green plastic soldiers arrayed on the sand, two lines facing each other, with here and there a stick of driftwood placed strategically for cover. "Okay," he said, "we're ready."

Susanna was not paying attention. She was scooping a hole in the sand, smoothing it, daydreaming. "Ready for what?" she said.

"War," said Sean. "We're all ready for war."

"Sean," she said, "you do the war. I'll do what I want."

"We didn't come here to play," he said. "Well, we did, but we didn't. It's war!" He brought two soldiers skimming over the sand to where they fell into the hole she had made. "Ahhhhhhh!"

"Sean, it's all yours." She stood up and backed away. "I'm going to worship the sun."

"Aw Susanna," he said, "don't you want to play? Sunbathing is so boring. Susanna was shaking out her towel, turning away. "Hey mom," said Sean, "where's dad?"

The mom looked up from her book. "He went for a walk," she said. "over there in the trees. He'll come back pretty soon."

"Mom, do you want to play war?" He couldn't see through her sunglasses to her eyes. "I have it all set up." His mother looked over at Susanna, who was lying on her towel with her eyes closed.

"Susanna," she said, "don't get a burn." Then she turned to Sean. "No thanks," she said, "you go ahead." She turned to her book. A character her own age was about to meet a stranger. She wondered what they would find in each other. They were so different, but circumstances had brought them together. She could tell something wild was going to happen in the next few pages.

Dad, meanwhile, was following the trail at a run. It was farther than he had remembered. Was that the tree? No. Maybe at the next bend. He had to watch his footing. This path was made for a stroll, and he was made for sitting at a desk, but he pushed himself harder. He looked for the tree with arms, the one that reached out with moss at the elbows and ferns at the wrists. The coast did things to trees like that. They didn't just grow straight. All he needed was a glimpse. He ran, dizzy. There was a pounding in his ears.

And on the sand, when Susanna closed her eyes, she heard the waves for the first time. Their sound was bigger than anything, or maybe it was older. She felt the hot sun on her body. She felt each part of herself, her attention roving like a hand. There was heat, and sound, and herself. The waves wanted her to be alone like this, knowing a few simple things. She felt like her body was exactly on the line of a boundary. On one side were roads, and telephone poles, and friends that changed, and a little brother. On the other side, there was that sound, and distance turned blue, and the person she would be. She was right there at the beginning. Her breath came slow. Her body drank the sun. She wanted to feel it all.

I quit high school for a thrill: pushed a car off a cliff and got directly into reform school. Didn't get reformed. I got deformed. Now I do it with my buggy. You ever dive off the cliff side of a dune on a set of macho wheels? You haven't lived, buddy. Oh, I've rolled, but that's what the roll bar's for. Usually land on my feet, too.

You get your beer keg gas tank strapped on tight, get a few beers under your own belt, and gun it for the highest dune. Scenery? Hey, it's great scenery, but I like being *on* the scenery. You want to look at it, buy a postcard. I want to be on it. It's another way to love the Earth, man. Bears leave a track, I leave a track. It's natural. I'm a natural man. You ever climbed up the long smooth flank of a dune, winding it out in second gear till your ears ring? It doesn't get more natural than that.

I always leave a big old yin-yang symbol on the sand before I quit. Chinese fellow taught me that. He was a boss mechanic, dude philosopher. Put a pair of superchargers on my engine, popped on a set of oversize cylinders and pistons to match, and laid this Tao stuff on me while he worked. I told him about my car theft days, reform school, all that stuff. He says, *"Tao Te Ching* 13: Accept disgrace willingly. Accept misfortune as the human condition." I can get into that. That's how it is. I been down.

Cranking on the shock mounts with a torque wrench, he sings out from the grease pit, "Tao 52: Yielding to force is strength. Using the outer light, return to insight, and in this way be saved from harm." I can buy that, too. I got him to write it all on the inside cover of my maintenance manual, so I could memorize it. This guy can really talk about the way it is.

So, at the end of a good long day, just at dusk, I go screaming out one last time, lock the steering wheel for a slow left turn and carve a circle more than a mile across. I go around five times to carve that circle deep, down to the wet sand, rip the wheels for a spin and dig down to the hubs. And then I climb out of that rut and run the long S curve across my circle, go back and forth across that curve till it's deep enough to last at least a week. You ever driven forty miles an hour in reverse? That's what he rigged my engine to do. I leave a crisp rut.

I love sand, you know. It takes my mark. Then it takes the wind to smooth it out, and next weekend it's ready for me. Virgin sand, over and over. I see that big circle in my dreams. I got it figured out. Tao 81: "The more he gives to others, the greater his abundance."

But I can see you're not buying this. You're one of these nature lovers thinks you have to leave it untouched to love it. Is that how you love your woman? Touch it, man. Touch it. Get into it. You won't know what I'm talking about till you ride a buggy top speed. Get to the center of experience. Don't knock it till you've tried it. That's Tao number 1: "The Tao that can be told is not the eternal Tao."

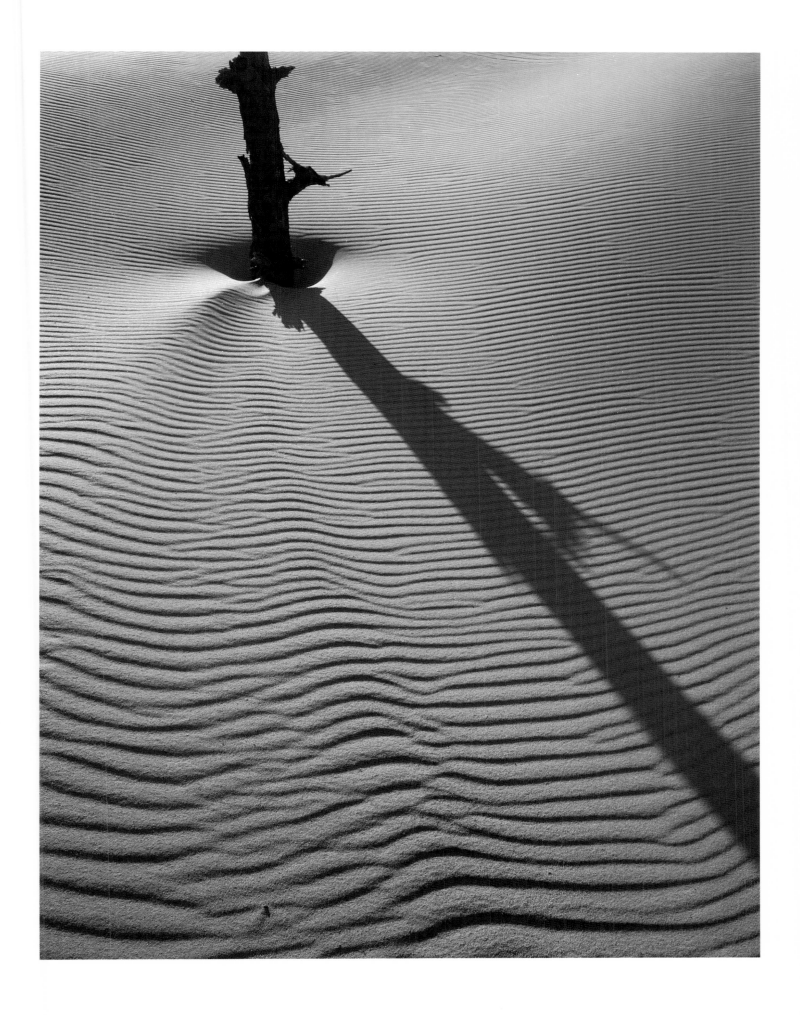

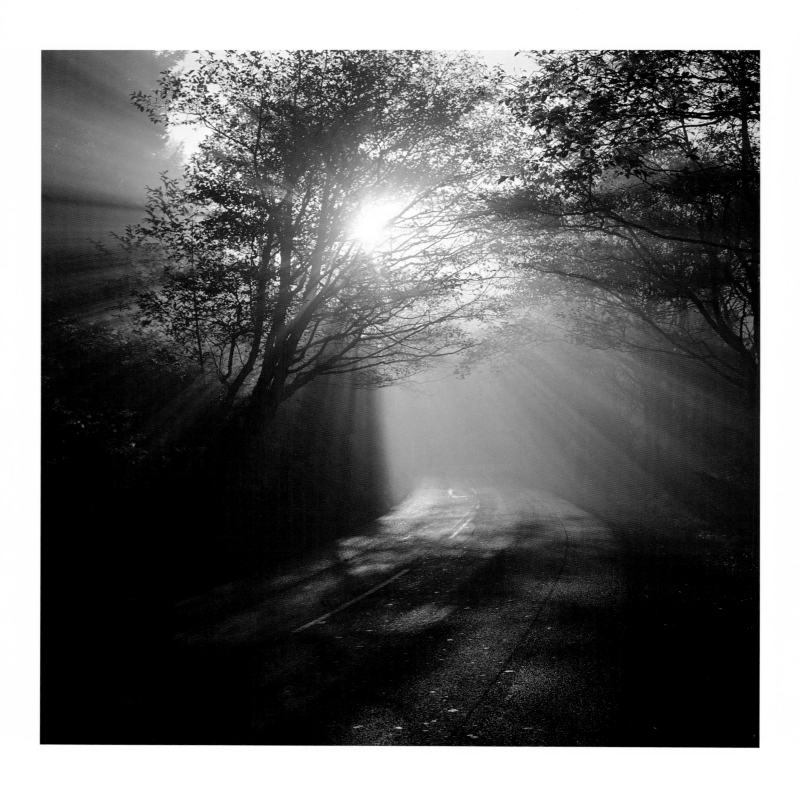

Lucille wanted stories bad. Nights followed days, her friends grew older, and she only had one life, so she wanted it in layers. She wanted days double, she wanted nights quilted with dreams, she wanted travel haunted by other lives, so she stopped at every bookstore along Highway 101 to browse and feed. She wanted human drama to kindle her rambling coastal road. She wanted a human quirk to spice the vistas of wave and headland. She wanted motive for local characters stooped on mossy porches, for the flare of oncoming drivers glimpsed and gone.

She had no memory for book titles, less for their authors' names, but she starved unless she stood at the bargain shelf in store after store to taste those perfect, random passages where the book fell open to its secret. Each book fell open like open arms, and took her in. Book by book, she seasoned her journey with romance, mystery, and bizarre memoir.

At the Paragon in Astoria, she haunted the back wall. The door rattled at its latch when the wind came knocking, and the roof took a buffeting. The book in her hand opened easily to a paragraph on paper soft as faded sheets. "Perhaps this old map will refresh your memory," she read there, "and if it doesn't, we'll try a visit to the sea cave." A chill ran through her belly. She had it then: the cavern of thunder and wave below each mile of cliff road awaited her. She took the wheel of her DeSoto, and headed south, riding it out as her car lurched and bounded through the storm. She had a fistful of words to make each curve resound, syllables to pound a rhythm on the straightaway. But then the storm faded, the sea cave story receded, and she needed more food.

In a Seaside book and junk shop, she filled her mind with the quiet rasp of a sailor's lament. "My lass, farewell," she read from the book in her lap, "far on the blue deep, will you not come try thy sweet jig in my dreams?" Filled with the musty smell of the back-room shelves and the brittle texture of old paperback, she stepped into her car and took to the road. She was a lass and the highway a sea lane forged on the briny deep. Under the dashboard, her knees twitched for a jig to please her

man, a mermaid frolic. At the overlook, she had to stand in the wind and let each gust become a wave brushing hair from her shoulders, tugging at her dress. She was a figurehead plunging through the waves, the heartache and the solace of every passing sailor.

"The foghorn sounded," she read in Cannon Beach, "and sounded again. Somewhere out on the water a lonely drama was about to be enacted, and she was helpless to stop it!" She squinted through the tiny panes of the bookshop window. Dark had gathered away the sun. Time to be gone. Was that the foghorn, or only the wind whining past the blunt hull of her car? Her road curved into fog past Neahkahnie, the little medallions along the shoulder twitching and shaking as they reflected her headlights. Her life was a lonely drama about to be enacted. She was helpless to stop it. And her road swooped down through Manzanita to the sea!

That night, she lay in a glorious welter of books, a feast without shame spread over the bed of her motel room. "Deep in the hold of the old schooner," she read from a crimson hardback, "Silky pulled her blanket close about her. The storm lifted the ship, and dropped her with a shudder into a trough. Where were these desperate pirates taking her? To what far port were they bound, if not the bottom of the sea!"

She dozed, she dreamed, and then it was dawn, and she was underway. In the long sweep around the Nestucca estuary, Lucille's mind swung outward to the open waves beyond the bar, bound for romance with a big-handed pirate and a storm. Her car swayed against the wind, and the sea rocked them in the fo'c's'le, where they had found each other at last. The car's heater sputtered, and she reached for the tiny flask of grog he offered her. His laughter rang out and the engine roared.

And so the good ship DeSoto ran before the wind, and Lucille traveled the high roads and withered pages of Tillamook, Depot Bay, Newport, Yachats, Florence, Coos Bay, Bandon, Port Orford, and clear down the dark voyage of the road to Brookings, where darkness caught her alone at the helm, driving toward the lee shore of the California line, the breakers booming just off the bow, and Lucille, fearless at the wheel, gritting her teeth against the passionate gust of that salty wind.

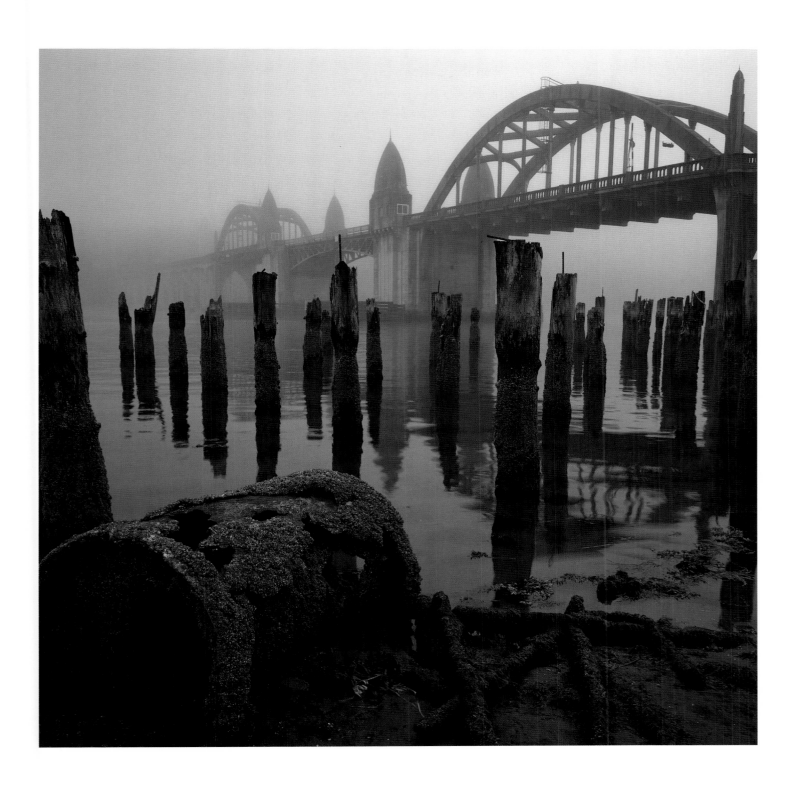

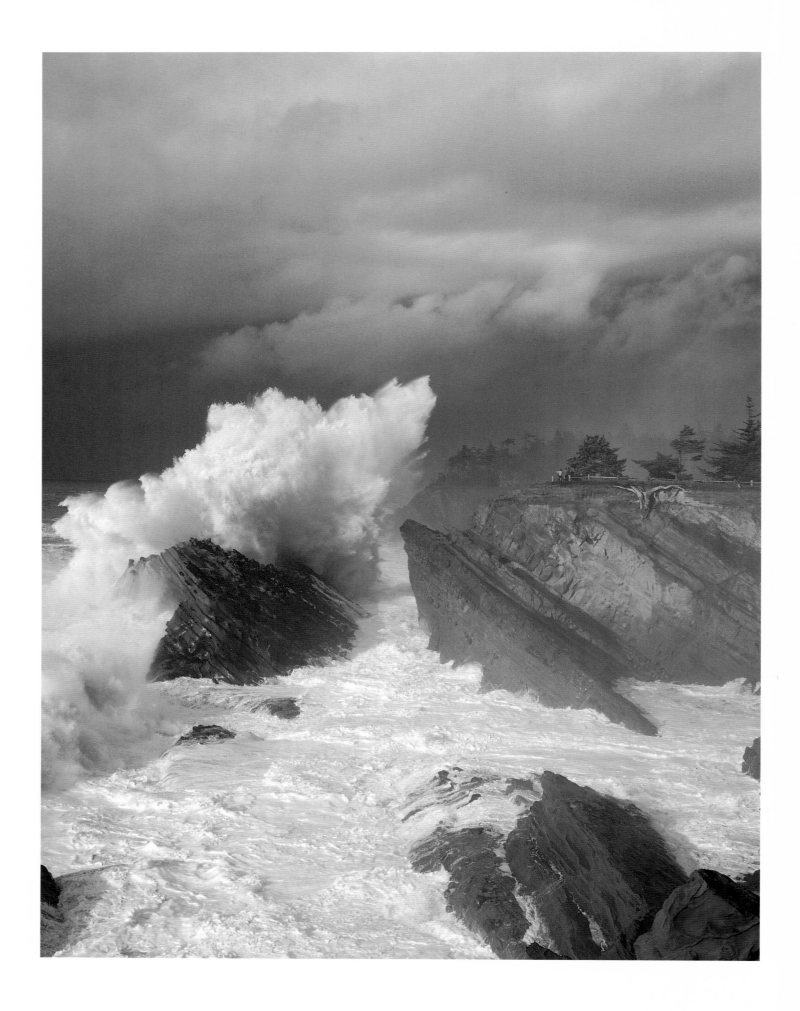

On a whim, driving the coast road north, George stopped at the Egyptian Theater for a horror feature. A storm was rising from the south. Wind sang through the wires. A loose newspaper twirled down the street, to flatten abruptly on the grill of a truck. No rain, just a big wind. No one expected him home in Portland. He could drive all night if he chose, feeling the storm at his back, taking the curves of the coast road slow, savoring every one.

He left his car on the main drag, and joined the throng at the Egyptian's ticket booth. People clutched their bills that flickered and snapped in the wind. It was bargain night, and half the crowd was family groups, the rest couples. He seemed to be the only single. The credits were rolling as he climbed down the steep rake of the small auditorium on the right, and settled into his seat. On the screen in front of him, a man with a hard face was about to cut a finger off the hand of another man, whose bravery was ebbing fast. There was a scream from the screen, and a laugh from behind him.

"Cool! How'd they do that?" He turned around to see the rapt and screen-lit gaze of a ten-year-old boy. "How'd they do that, mom?"

"I don't know, boy. Shhhh." In the movie, a walking fragment of bones had fallen in love with a woman while he stalked the city for revenge. The science lab blew up in a slow billow of flame. The gang didn't see his body shatter to safety out through the skylight, flying to some merciless survival. Some nights later, in the warehouse, his work went on. There could be no resolution.

Hunched in his seat of prickly velvet, George saw it all, death by death. The screen with its images ripped him like wind, until he was tatters. The boy behind him laughed, gasped, and munched his popcorn. The screen dreamed on.

In a blur he was north from Coos Bay, slowing to the side of the road, standing at the Yaquina lighthouse, wind slamming the trees while he watched the spokes of the light turn through the grove on the landward side, then shoot out into the dark. The storm came dry, all wind, and the trees swayed through that wheel of light. Way out on the water, a few boats glimmered in the gale, dropped behind waves, then rose and sparkled again. They might ride out the storm, or run for the harbor. There was a light for them. But what could save the citizens of Egypt? What could save that boy?

It was later, after a hundred curves, after midnight, after the rain began, somewhere up the coast he stopped in an all-night cafe. In the warm light of the place, just as he came through the door and the door slapped shut, he knew it came down to sensation at the root of thought. Saving fragile things would begin with the warmth of the mug against his hand, the tired, understanding smile of another driver, swiveling on a stool, turning away, the ring of the cook's tool scraping the grill somewhere out of sight. It was a late-night meditation, but he trusted it: sensation at the root of thought. The waitress looked up from her novel, hoping for the best.

The old man perched at the cafe counter, arching his eyebrows as he took his first hot sip of coffee. The elbows of his blue wool jacket gleamed smooth and shiny, and he straightened, turned slowly on his stool, recognized a regular customer but forgot his name, and began in a commanding voice.

"In the old sailing days," he said, "I was pilot, and then captain in these waters." His neighbor swiveled his own stool toward the speaker, grinned, and narrowed his eyes. "I don't know how many ships I've conveyed over the bar," the captain went on. "Funny how I forget the ones that found smooth water. But the wrecks, they're with me yet. I don't mean wrecks! I mean close calls." He glanced around. "One time we were coming in over the bar." He was talking to the whole room now, and the waitress stood with the coffee pot poised, and the tourists put down their real estate dream sheets, and a young couple looked in each other's eyes, and a child made a path through spilled sugar with her finger.

"We were coming in over the bar, with a bracer of a tail wind, and the swell running twice its usual peak, and the decks throbbing like thunder with the strain, full sail. We were coming in with the tide, of course, would be foolish to do otherwise, but just at the first of flood and the water was low with tall waves. Sounds odd, doesn't it?" He glanced around, and his gaze found a newcomer, with an open, listening face, and he directed his story to that face. "Sounds odd, but you often found yourself in an odd spot in the old sailing days.

"We were coming in over the bar, running fast with the wind, and we could see these jagged rocks on both sides of us, dripping with seaweed, awash in spray. The ship would ride high on a swell, then shudder down into one of those awful troughs, and everyone bracing for a blow. That's when you'd strike aground, if it was your fate, at the pit of one of those troughs. The crew was all in a sweat about it. Tense. Everybody tense! Many a ship went to the bottom in that bay with all hands. It's a graveyard, littered with shattered hulls and crab-gnawed sailor bones.

"'Well,' I shouted to the crew, 'Boys, don't you worry! I'll find our passage. Why, I know every rock in this harbor!' Just then, BANG, we scrape hard on a good one. 'See?' says I, 'there's one now!'"

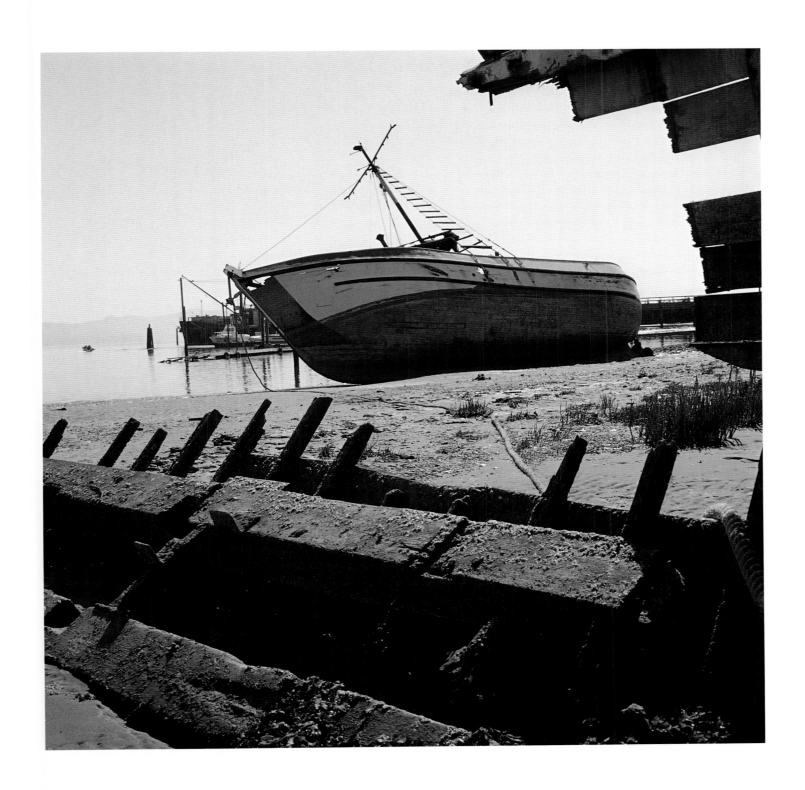

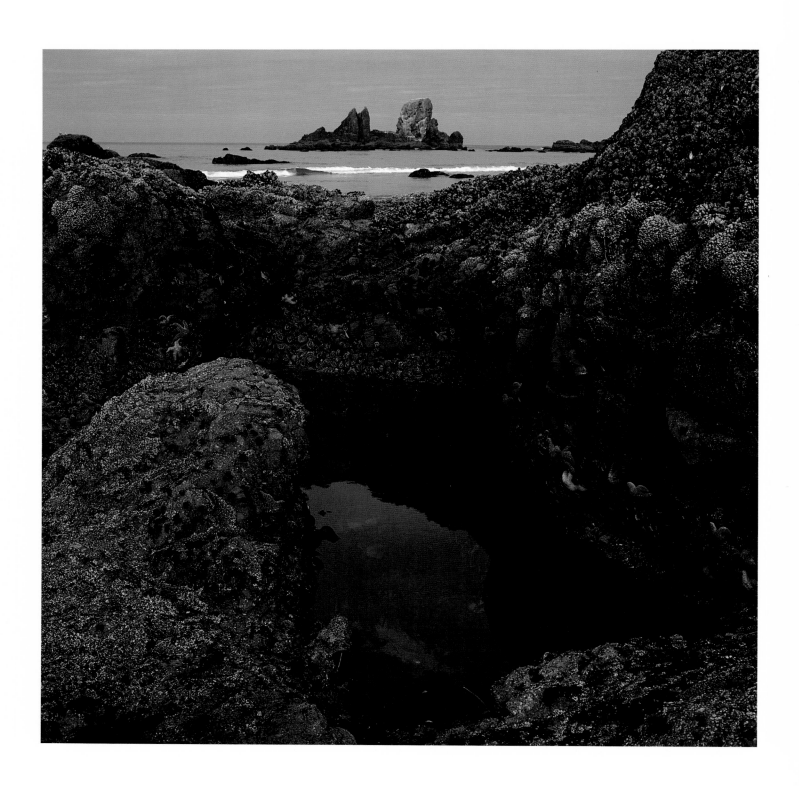

"You ask me what's wrong?" he said. "I'm down. I'm just worn down, that's all. You know how rocks get smaller? They get ground down. It's like the home scar of the limpet," he said, "the way I keep seeing her face out of nowhere."

"Brother, talk sense. What's this home scar stuff? Don't lay your biology on me. Tell me what's happening."

"You know what the home scar is? It's where the limpet lives on a boulder in the waves. My uncle told me once. Tide comes up, the limpet moves around, gnawing across that rock with its little razor tongue, feeding on scum. But before the tide drops, my uncle said, that limpet finds its home scar, the dent on the rock it has gnawed to fit it perfectly. My uncle lost a good woman, too. He ought to know. Amanda left a dent like that on my mind, and her face floats into that place and stays."

"Man, that makes you her rock. Maybe you deserve to be chewed up a little."

"Thanks, friend. Thanks for the sympathy. I'm touched. Here's another one. You know the porcelain crab?"

"Can't say as I do."

"Well, my uncle was crazy about the porcelain crab. You don't have to know it all, just this: in a fight, the porcelain crab's pincer gets torn away? That claw just keeps pinching on its own. Somehow, the muscle keeps working, grabbing and crushing. And that's Amanda, too."

"Poor boy. You saying you don't pinch back? Seems like you did Amanda some grief, in your own way."

"Hey, be my friend, feel sorry for me. You're riding on me, just like Amanda. She beat me up and took to the road."

"Yeah, she's gone, brother. And I have to tell you something. You have the knowledge, but not the wisdom yet. Let your uncle's stories go, for now. Just look around. By your own telling, there's a lot that happens in the sea just to give us a hint what the heart can do. Let it pound, let it pinch awhile, friend. If you can feel it, let it bite. Hurt has a reason. I've found that's what it feels like when you grow."

Tourists never saw the old man go. He got up too early, or they too late. His boat motor's chug sometimes ended their dreams, but he and his nephew had the Otter out of sight through the fog before they could pull the curtain back to see.

In the evening, though, when he returned dockside, he would talk as long as you listened, while the boy unloaded fish. Sometimes longer.

"Ralph, what did you catch today?" someone would ask, and Ralph would take it from there. We all wondered what he was reading, to talk the way he did. But they say his lingo was rooted deep in his past, the schoolteacher father, the eavesdropping mother working operator on the telephone.

"I got a nice tomcod juvenile," said Ralph, "with an inferiority complex, serious antisocial tendencies, and a very slim chance of survival at forty cents a pound." The nephew stepped down on the dock.

"Just one, Ralph?"

"Just one individual beauty until she sells, or smells, and then another unique and surprising specimen until he's gone, and so on one by one to the end of twelve."

"Any salmon?"

"Two silvers, pretty naive, just out of high school. Caught 'em shallow on chrome and feathers trolled. They'll go for a dollar a pound, just to keep the arithmetic simple and the strain on an old man light. Two of them. Might as well gold-plate 'em, for what they cost me to catch."

"You fish for salmon and cod in one pass?"

"I have my secrets." He looked at the boy.

"See any whales?"

"Didn't see 'em, but they saw me, scratched their ears on the Otter's keel, and sounded. Left me a note, though: twenty-seven bubbles and a swirl of luck. We did okay."

"Will you go out tomorrow, Ralph?"

"Don't know till I wake and lick my finger in the breeze. If the wind blows from the south, it blows the bait in their mouth. If it blows from the east, they bite the least. If it blows from the west, the fishing is best. If it blows from the north, the fishermen never go forth."

"What was the wind today, Ralph?"

"Blew from the north."

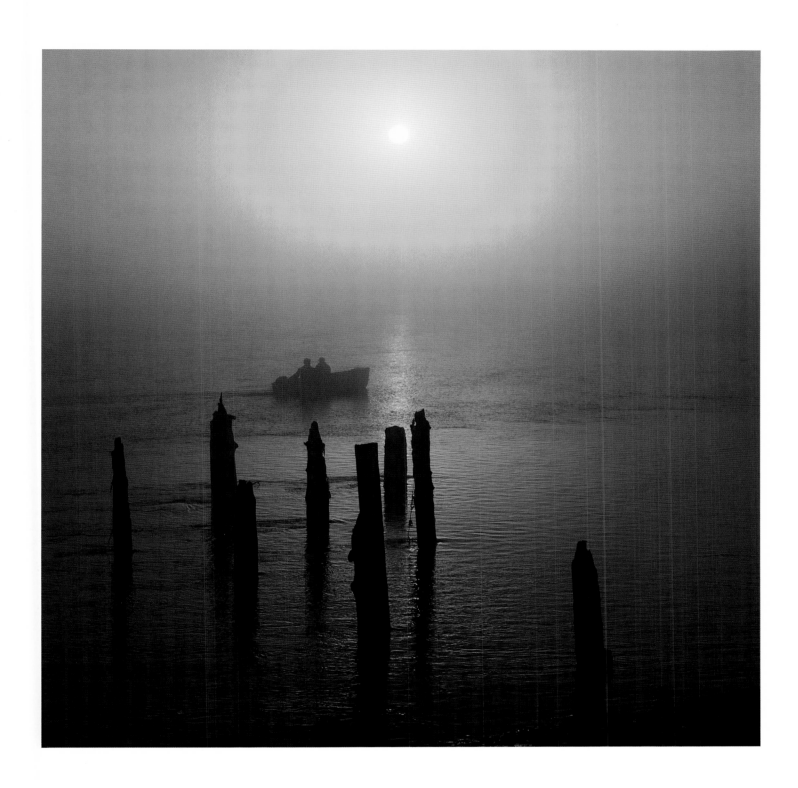

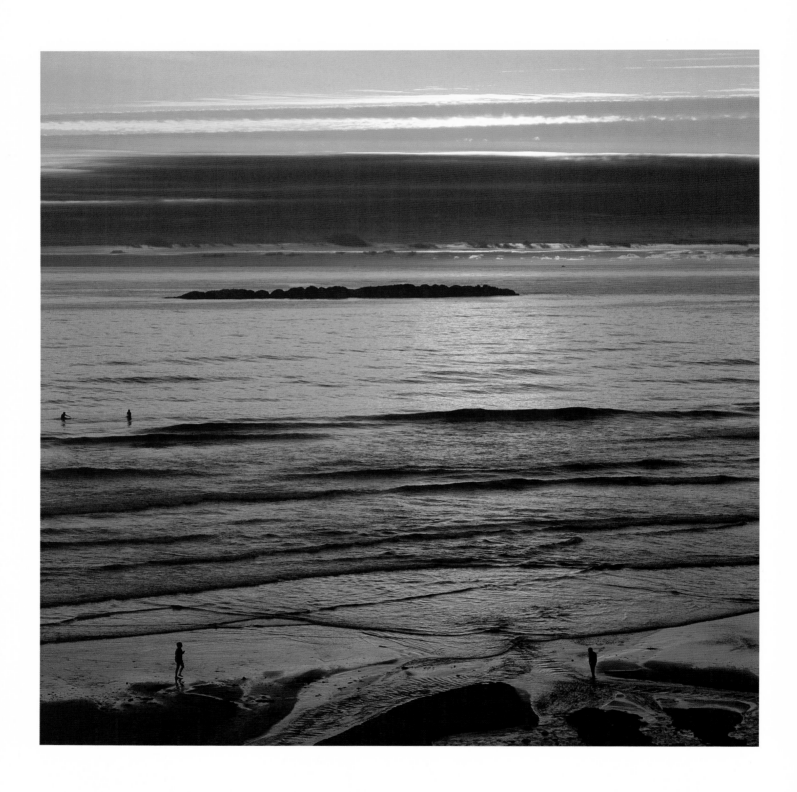

"Oh we had wild times. Seems like every year somebody got killed or married on a whim. But you couldn't blame the redheads. They just drew foolish men."

The old woman sat in her rocking chair by the light of the rain-filled window, arranging the knitting on her knee, a tiny pair of socks. She tucked her white hair back with bobby pins, and patted the top of her head with its thick white bun held in place by a pair of knitting needles thrust crossways. She stroked the cat that curled and purred on her lap. The young oral historian leaned close to fiddle with his tape recorder, and then to consult his notes.

"So," he said, "the Redhead Roundup, was that a beauty contest?"

"More like a beauty free-for-all, young man. They called it a pageant, but it was really a pure weekend of wild times. Once they didn't even get around to the parade, and some years the formal pageant was rather lightly attended, considering the overall population increase of the weekend. Took this town a good month to recover every year, and every year it got bigger.

"The fame of it kind of spread around. These redheads came from as far away as California and Montana to be judged for the flames of their hair and the salty texture of their personalities, and this whole town caught fire. Imagine, if you can, a couple hundred redheads roaming the streets of a little coast town like this. Talk about a sunset! Bay street was one strip of neon, all natural, all long hair, dancing along as they wiggled and they walked.

"Girls would link arms and walk down the middle of the road, two, four, seven redheads in a row, just drunk on being young and pretty and wild, singing, and carrying on. Imagine those seven girls closing in on a young fellow like yourself, surrounding him, laughing with each other, and him turning red, bright as their hair, until they let him go."

"What year was this?" The oral historian was consulting his notes again, his prepared questions.

"Year?" said the old woman. "It wasn't a year, young man, it was a way of life. When people really live by their wits—logging, fishing,

injured, living alone, dying alone—once in a while they had to take a few days and be dangerous on purpose. And it wasn't just here. The whole country was having hard times then. That's when the motorcycle races came in. The redheads drew the men, the kind who liked that wild way. Those men came here on their motorcycles—some of them didn't own another thing to save them—and pretty soon they were having races on the beach, flat-out, long, and fast. The drunker they got, the faster they went. The survivors had a pretty good party at the end.

"Then they started the custom of the mock wedding. The city fathers didn't have a thing to do with it, it was the redheads and the racers organized it all. After the contest, after the race, out on the beach at night these crazy people held a wedding of the most beautiful redhead and the fastest racer.

"It was one heck of a whoop-de-doo. Built up a big fire in the driftwood, and held that wedding by its light. It wasn't supposed to mean anything permanent, but it would make your heart go—to stand there by your man and the fire, with all those solemn faces and beautiful souls."

"And when did this custom end?" The young man held out the microphone. "I'm not aware that it continues today."

"Young man, I don't care to talk about how it ended. In fact, I'm a little tired right now, and I'm sure you will be busy with other interviews. The Redhead Roundup is just a small part of this town's past, and you needn't give it too much play." She turned to her knitting, and the young man attended to his tape recorder. He noticed that the customary green light was not lit, and he now saw he had forgotten to flip a crucial switch, and the machine had not been recording.

"Miss Hamilton," he said, "I feel very foolish. I've just realized my machine hasn't been working. Can we have that part about the Redhead Roundup again?"

He looked at her. She had pulled the two needles from her hair, which now hung loose on her shoulders. It was long, and the tips were tinged with red.

"No, young man," she said. She smiled into his eyes. "I'm sorry, but once is enough."

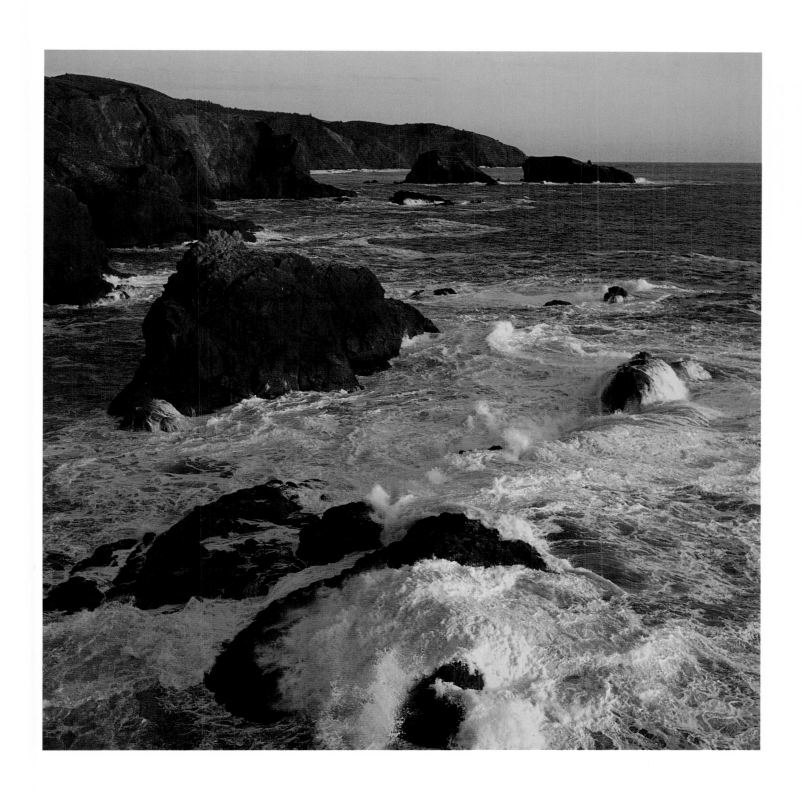

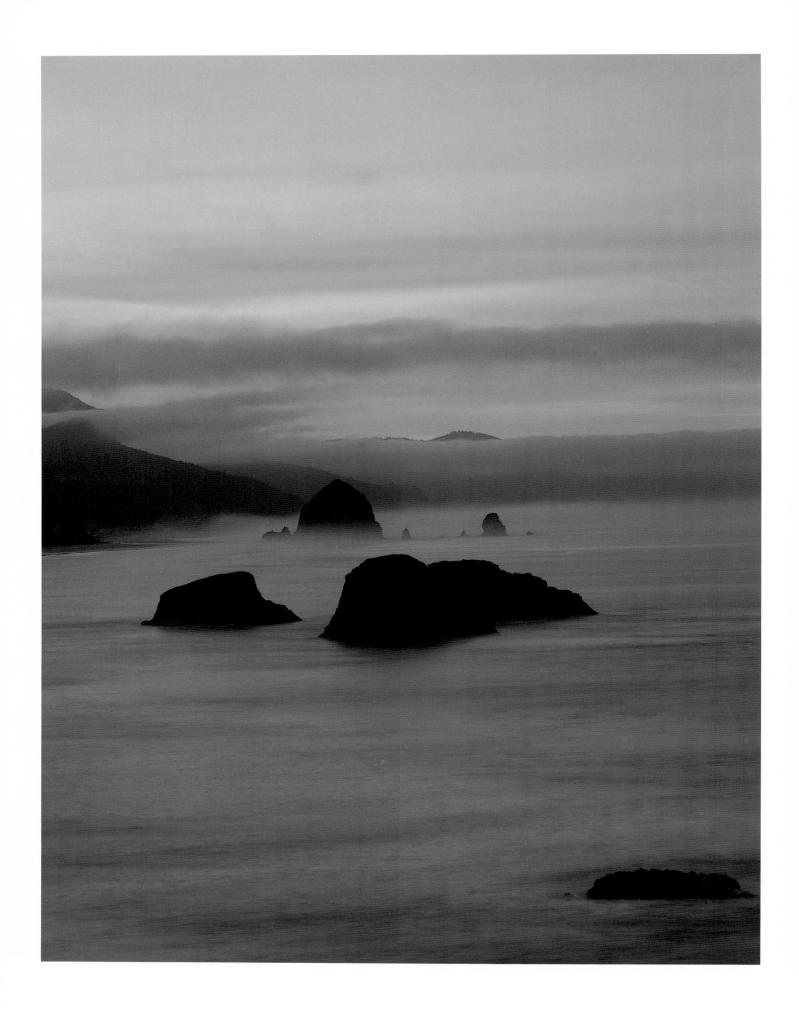

"That question is always at the edge of my attention," said Steve, "no matter what I'm working on. How do they find each other? There's echolocation, of course. We have porpoise sonar, whale pod interactive signals. They count for something."

"They count for everything," said Bob, "for social species." It had been a long, rich summer of field study, and the two shared a last pot of coffee for the road.

"Gaskin showed ten years ago," Steve went on, "that blindfolded *Eschrichtius robustus* can become seriously disoriented, but the toothed whales, our *odontocetes*, do better. We seem to be getting the basic vocabulary down for that system. But I just wonder what it's like to live by those pings and groans and chatters way down deep."

"And *Onchorhynchus,*" said Bob, his spoon ringing in his mug as he stirred in honey, "the salmon system, the olfactory imprinting and homing from headwater geologic sources. The studies by Hasler and others established that basic mechanism early, and their findings hold. The deep ocean must be quite a blend to untangle. Think of the pinhole nostrils of the fish, and all that water."

"What about the basaltic map and home scar grid of the limpet?" said Steve. "Who's doing the work on that?"

"*Acmaea digitalis?*" said Bob. "Was it Haven who did the basic work in the early 70s? Later studies have supported those findings. But that's not social. They're loners."

"What was the octopus species they just divided?" said Steve. "Wasn't it *bimaculatus?* They found what they had been calling the Two-spotted Octopus was actually two distinct species. The biologists working on the problem had to resort to an analysis of their kidney mesozoa to distinguish between them. But then they noticed the males and females of the two had no trouble keeping with their own kind. That's still mysterious."

"Yeah," said Bob, "you get an inkling they have their own ways of knowing. I read somewhere that even humans can identify a scent by inhaling as few as eight molecules from a distant source. Eight!"

"I'll miss the salt air. You coming back next summer?"

"Too early to say," said Bob. "I may do the Arctic, someplace empty."

"Well, keep in touch. I'd better hit the road. Barb will want me home, and neither of us will make it before dark as it is. It looks like rain."

"It does. It's been good working with you." They shook hands, rinsed their cups and the glass globe of the pot, and took to the road, one south, one north, with a wave and a honk.

And after dusk, each crossing a different mountain pass of the coast range, Steve's world sparkled dark with the storm's ozone molecule, with sweat and the hanker for Barbara's touch. Bob's road glowed with the last light of summer, with some impossible preliminary scent of kerosene lamp, the cabin's rafter knuckle popping when the wind comes up, and the sulphur scratch of a wood match struck at the moment he was home.

WIND ON THE WAVES

My friend, you wanted to be wind on the waves—not the schooner, or even the sail that bellied and caught it. You wanted to be the wind itself. You wanted to dance and scamper, to be the spiral that hugs the planet, the wisp of travel that nudges sand, the local everywhere, tireless, fervent, invisible, unstoppable you.

After the waves have told their story, they flatten under the ocean's pelt and go away. They sound their note, leave their mark, and recede. You will go with them, and beyond them. After the wind has died here, it rises at another place. It tapers down to a whisper against the rock, and slips away. A ray of sunlight shimmers at the water's working edge, then blinks. The sun, going down, pulls the whole wheel of color into that deep place, past the pale shoulders of the waves, into the dark old eyes of the seal that dives, into the white light of stars.

My friend, maybe you are sleeping at the coast, under the shingled eaves, and you hear the rain begin. Or maybe it is only the waves, breathing out there at the edge of your hearing. Or maybe it is your breathing. Maybe you are in the city, dreaming, and you arrive at the salt edge, tasting it. When wind lays a paw on the wave, and combs, you shiver. You feel how it is to yield, to skim away without a road, only an impulse. You want to be wind on the waves, because you love too many to stay one place. You are homesick for the world even while you are in it, so you travel. Hello, we say. Good-bye, we say. Grow old. Stay young. Live each day. Storm rising? Guess the weather. Please your lover. Honor yourself. Are you ready? Yes.

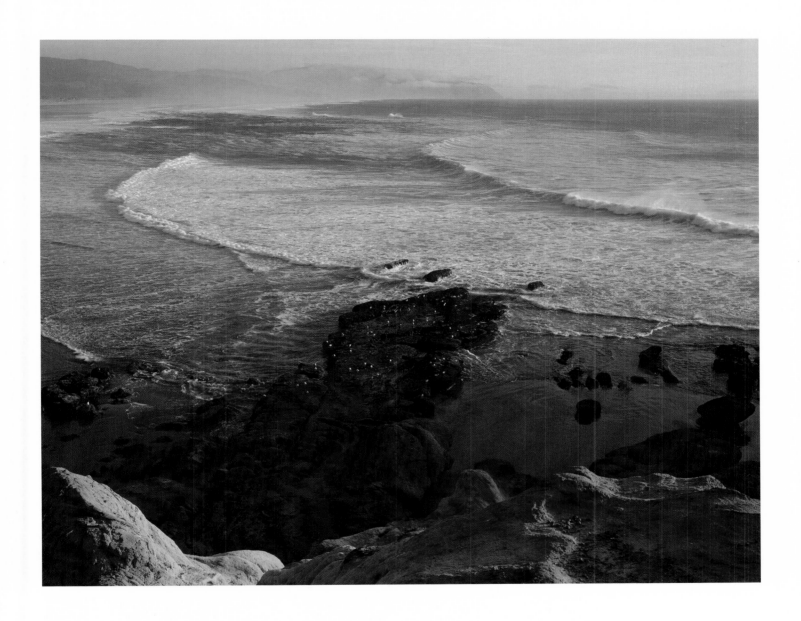

ACKNOWLEDGMENTS

Although it was the lure of the mountains that brought Ray to the Northwest, he was also captivated by the Oregon Coast, from its serene tranquility to its crashing, turbulent surf. In his latter years, most of his photography was done at the coast. This is the last book featuring Ray's photos in which he had personal input. If he were here today, he would want to express his gratitude to the many friends who enabled him to pursue his love of photography.

Ray spent more than ten years teaching his stepson, Rick, the patience, discipline, and hard work that goes into the art of photography. I believe he would have felt pride in a job well done as Rick completed this project.

The photo on page 4 was the last picture Ray took. Rick discovered it in the camera after Ray's death. We felt it appropriate to include it in this book.

It is difficult for me to write about Ray Atkeson, the photographer. I wish more people could have known him for the man that he was. He was one of the kindest, gentlest people I have ever known.

DORIS ATKESON

I would like to thank friends on the coast who gave me generous thoughts and kind hospitality as I worked on the stories for this book, particularly Jane and Howard Glazer, Stuart and Joanne Henderson, Stu and Mary Johnson, Peter Lindsey, Don and Vi Thompson, and the woman long ago we called Grandma Dewey. I am also grateful to the friends, hitchhikers, and strangers through the years who trade stories as a way of strengthening our kinship on the planet. As a philosopher once told me, the Universe is not made of atoms and molecules, but of stories. Through stories, we remind each other of the continual courage it takes to be a human being, a seeker, and happy.

Special thanks go to the Sitka Center at Otis, the Coos Head Writers, and the Haystack Program of Portland State University for the opportunity to work with coast writers at various seasons, and to Sharon Morgan and the Oregon Coast Council on the Arts in Newport, for inviting me to take part in many programs where stories were welcomed. Thanks also to Goody Cable of the Sylvia Beach Hotel for her hospitality to the life of books at the coast, and to the coastal bookstores where meditative rainy afternoons have seasoned the inklings from which this book grows. Special thanks in this regard to John Buckley at the Cannon Beach Book Company. The coast's greatest gift to me has been my experience conducting an oral history project in and around Florence in the mid-1970s, when I was a guest of sixty wise and generous citizens. Threads from their stories are woven here, though the real tellings can be found in the oral history collections of the Florence Public Library and the Siuslaw Pioneer Museum.

Several books have been of particular help to me: Willard Bascom, *Waves and Beaches* (Doubleday, 1980); Eugene N. Kozloff, *Seashore Life of the Northern Pacific Coast* (University of Washington, 1983); Bayard H. and Evelyn McConnaughey, *Pacific Coast* (Knopf, 1985); Manabu Miyazaki, *The Owl: A Photographic Essay* (Chronicle Books, 1990); Jarold Ramsey, Ed., *Coyote Was Going There: Indian Literature of the Oregon Country* (University of Washington, 1977); Stewart T. Schultz, *The Northwest Coast: A Natural History* (Timber Press, 1990); and Lao Tsu, *Tao Te Ching*, translation by Gia-Fu Feng and Jane English (Vintage, 1972). Readers will also notice my debts to James Thurber, and the Old English poem "The Seafarer."

I would like to express my gratitude to my friend Adele Sommer and my daughter Rosemary Stafford. The stories in this book arise in the spirit of playful attention they have brought me. Each day is an adventure, and a sacred one.

KIM R. STAFFORD

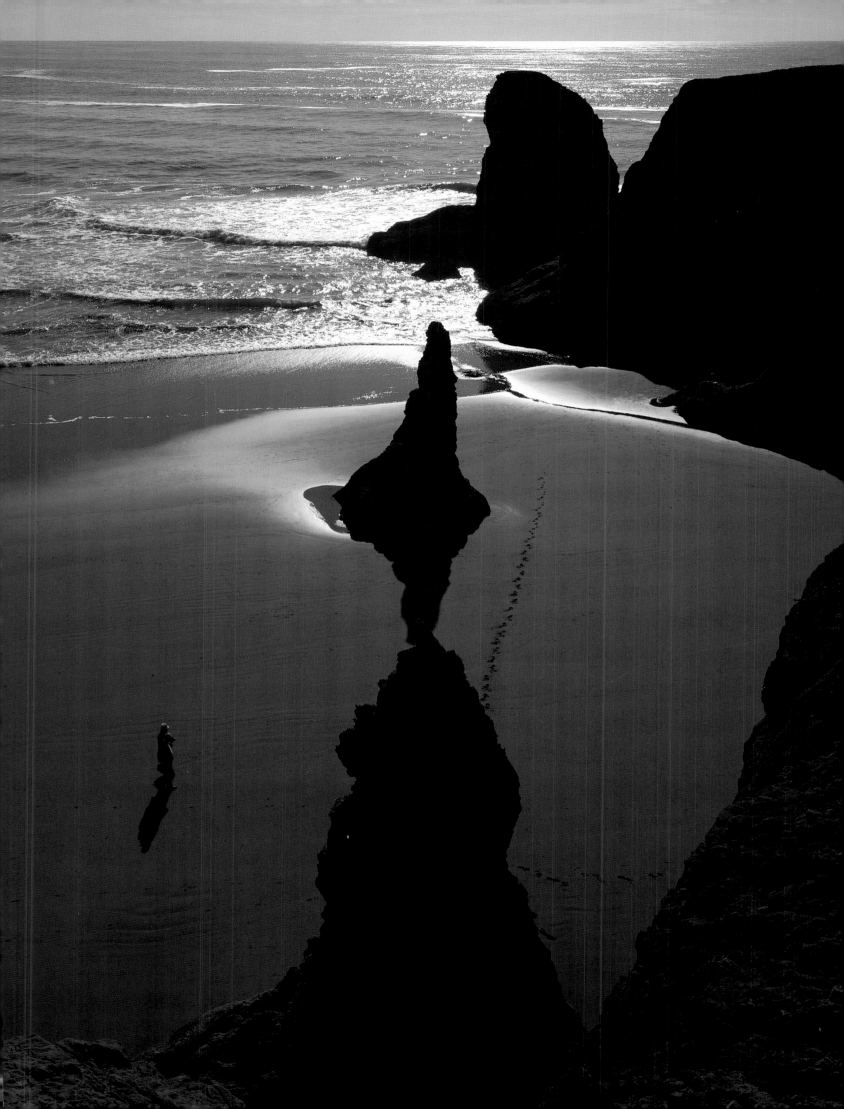

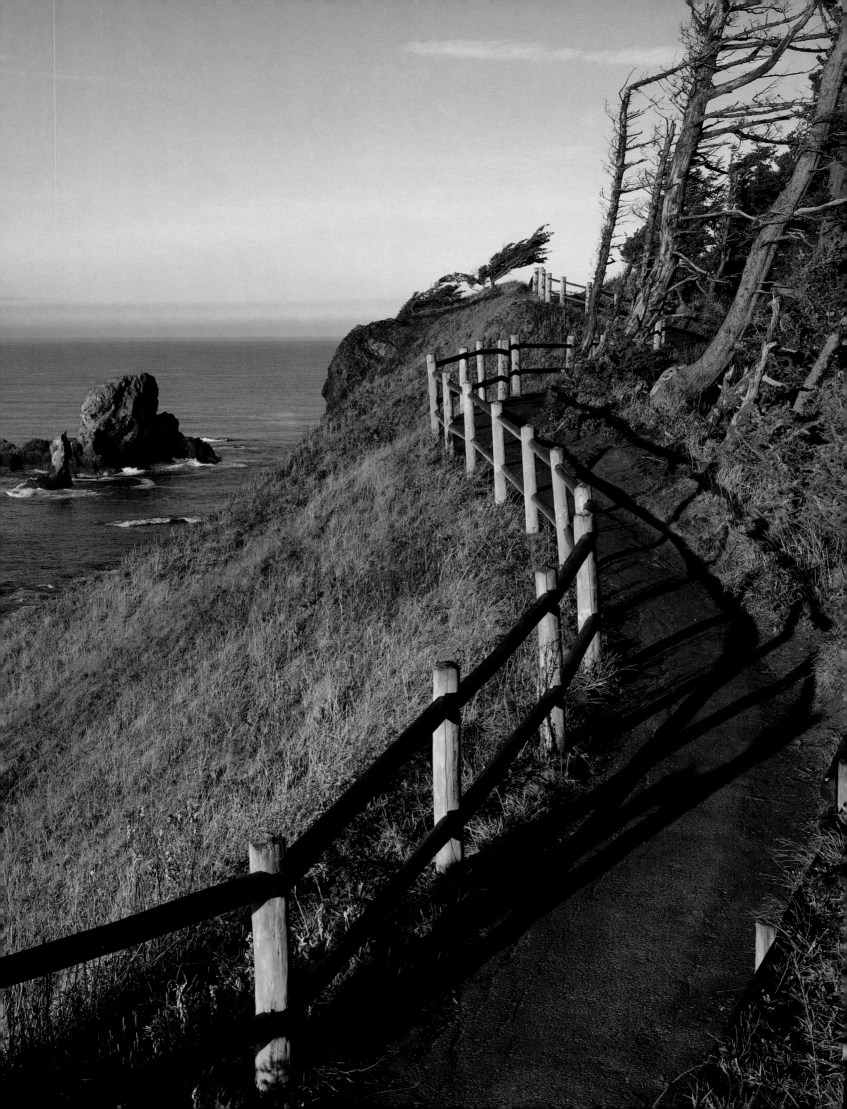

PHOTOGRAPHIC INFORMATION

Page	Photograph	Photographer	Page	Photograph	Photographer
Jacket	Wind on the waves	Ray Atkeson	72	Cape Lookout State Park	Ray Atkeson
1	Pacific breakers with spindrift	Ray Atkeson	75	Foxglove	Ray Atkeson
2	Fog near Neahkanie Mountain	Ray Atkeson	76	Fort Stevens	Ray Atkeson
4	Ecola State Park	Ray Atkeson	79	Sea anemone at tidal pool	Ray Atkeson
6	Huge breakers	Ray Atkeson	80	Misty seashore trees	Ray Atkeson
8	Harris Beach State Park	Ray Atkeson	83	Bandon Beach	Ray Atkeson
11	Spindrift and rainbow colors	Ray Atkeson	84	Wave crashing on Oregon Coast	Ray Atkeson
12	Picnic, Indian Beach	Rick Schafer	87	Beached boat	Ray Atkeson
15	Surfers at Indian Beach	Rick Schafer	88	Youngs River Falls	Rick Schafer
16	Morning surf, Bandon	Ray Atkeson	91	Willow and alder leaves	Rick Schafer
19	Yaquina Bay Bridge and Harbor	Rick Schafer	92	Surf-rippled sand	Ray Atkeson
20	Nye Beach in Newport	Rick Schafer	95	Sandstone sculpturing	Ray Atkeson
23	Haystack Rock at Cannon Beach	Ray Atkeson	96	Rocky Creek State Park	Ray Atkeson
24	Weathered snag at sunset	Ray Atkeson	99	Cape Kiwanda	Ray Atkeson
27	Shoreline trees and cliff	Ray Atkeson	100	Wind-sculpted tree	Ray Atkeson
28	Surf and sunset	Rick Schafer	103	Coastal fog and trees	Ray Atkeson
31	The water's edge	Ray Atkeson	104	Bird tracks at Nestucca Estuary	Ray Atkeson
32	Rhododendron in Allegany	Ray Atkeson	107	Fishing dory and Haystack Rock	Ray Atkeson
35	Siberian miners lettuce	Ray Atkeson	108	Starfish at Cannon Beach	Rick Schafer
36	Bigleaf maple in Coast Range	Rick Schafer	111	Lady fern and Japanese knot weed	Rick Schafer
39	Marsh grass at Nestucca River	Rick Schafer	112	Weathered shoreline tree	Ray Atkeson
40	Spindrift at Ecola State Park	Ray Atkeson	115	Lupine at Samuel Boardman State Park	Ray Atkeson
43	Repeating surf at Manzanita Beach	Ray Atkeson	116	Tillamook Head Lighthouse	Rick Schafer
44	Autumn fog and sunburst	Ray Atkeson	119	Sand dunes	Ray Atkeson
47	Tillamook Bay	Ray Atkeson	120	Oregon Coast Highway	Ray Atkeson
48	Coastal forest	Ray Atkeson	123	Bridge over Siuslaw River, Florence	Rick Schafer
51	Tillamook Head Lighthouse	Ray Atkeson	124	Shore Acres State Park	Ray Atkeson
52	Sea foam left by receding wave	Ray Atkeson	127	Old fishing boats	Ray Atkeson
55	Lava rock spires at Bandon Beach	Ray Atkeson	128	Starfish and anemone	Ray Atkeson
56	Exploring the surf	Ray Atkeson	131	Tillamook Bay	Ray Atkeson
59	Boiler Bay	Ray Atkeson	132	Beverly Beach State Park	Ray Atkeson
60	Crescent Beach from tidal cave	Ray Atkeson	135	Boardman State Park	Ray Atkeson
63	Forest trail at Cape Lookout	Ray Atkeson	136	Ecola State Park	Rick Schafer
64	Gulls at Cannon Beach	Ray Atkeson	139	Central Oregon coastline	Ray Atkeson
67	Tidal pool at Crescent Beach	Ray Atkeson	141	Rock spires at Bandon	Ray Atkeson
68	Sea kelp at Short Sands Beach	Rick Schafer	142	Sea Lion Rocks Bird Sanctuary	Rick Schafer
71	Hemlock in Oswald West State Park	Ray Atkeson			